Exposure:
From
Snapshots to
Great Shots

Jeff Revell

Peachpit
Press

Exposure: From Snapshots to Great Shots
Jeff Revell

Peachpit Press
1249 Eighth Street
Berkeley, CA 94710
510/524-2178
510/524-2221 (fax)

Find us on the Web at www.peachpit.com
To report errors, please send a note to errata@peachpit.com
Peachpit Press is a division of Pearson Education

Editor: Ted Waitt
Production Editor: Lisa Brazieal
Interior Design: Riezebos Holzbaur Design Group
Compositor: WolfsonDesign
Indexer: James Minkin
Cover Design: Aren Straiger
Cover Image: Jeff Revell
Back Cover Author Photo: Scott Kelby

ISBN-13 978-0-321-74129-5
ISBN-10 0-321-74129-3

9 8 7 6 5 4

Printed and bound in the United States of America

DEDICATION

For my sweet little angel Elizabeth. I'm so glad God brought you into our lives.

And for my sister-in-law Rae. Thanks for being you!

ACKNOWLEDGMENTS

Back in April of 2009, I celebrated the publishing of my first book in the *From Snapshots to Great Shots* series and shared copies with many of my friends. Everyone was so supportive, but I always remembered what my friend Mike told me. He said that the book would work as a great photography-learning tool even if I took out all the camera-specific stuff. I always kept that in the back of my mind, with the thought being that one day I would take all the good stuff from the books I was writing and create something for all the folks out there who didn't happen to own one of the cameras that I happened to be writing about. I knew that the real key to making great photographs had more to do with knowledge and less to do with the camera technology. I have always felt secure in the fact that I could pick up pretty much any camera and make a good photo because the principles are always going to be the same.

I shared this thought with my editor, Ted Waitt, and we both agreed that it would be a great idea to expand on the series by creating this book along with some others, like the recently published *Composition: From Snapshots to Great Shots*. So thanks to everyone who supported the idea behind this book, and all the help you provided along the way.

Contents

Introduction

I have written quite a few camera-specific books in the *From Snapshot to Great Shots* series (six in total). Unfortunately, I can't write one for every camera out there, but what I can and did do is take all of the great information from those other books and place it into this book. If you already own one of my books, you might want to take a pass on this one since it will seem very familiar. If, however, you don't have one of the earlier books, then this one is for you.

I have tried my best to give everyone reading this book a good foundation of photographic knowledge and then build on it in order to create better photographs. If you still aren't sure if this book is for you, read the Q&A below.

Q: DOES THE MATERIAL IN THIS BOOK APPLY TO ANY CAMERA?

A: You will probably take away some good stuff no matter what camera you have, but to get the most benefit you need something that will let you take control. The automatic modes are okay but most of the material in this book is geared towards taking control over specific camera functions such as shutter speed and ISO. To really get the most out of the book you will need something like a digital SLR or, at the very least, an advanced point-and-shoot.

Q: IS EVERY CAMERA FEATURE GOING TO BE COVERED?

A: Nope, just the ones I felt you need to know about in order to start taking great photos. It would be pretty difficult for me to cover every possible feature in every camera (actually it would be near impossible). What I did want to write was how to harness general camera functions and photographic principles to truly benefit your photography.

There may be times in the book where I mention a camera function that might not have the same name for your specific camera, like the Shutter Priority mode. If you have a Canon, you have the same shooting mode; it's just referred to as Time Value (Tv). The function, however, is the same for all cameras. I tried to be as generic as possible but you may still have to do a little investigating to associate your camera's terminology with that used in the book.

Q: SO IF I ALREADY OWN A CAMERA MANUAL, WHY DO I NEED THIS BOOK?

A: The manual does a pretty good job of telling you how to use a feature or turn it on in the menus, but it doesn't necessarily tell you why and when you should use it. If you really want to improve your photography, you need to know the whys and whens to put all of those great camera features to use at the right time. To that extent, the manual just isn't going to cut it. It is, however, a great resource on the camera's specific features. You should use it like a companion to this book.

Q: WHAT CAN I EXPECT TO LEARN FROM THIS BOOK?

A: Hopefully, you will learn how to take great photographs. My goal, and the reason the book is laid out the way it is, is to help you understand the basics of photography and all the elements that you need to really start creating great images. From there, you can begin to utilize your knowledge of exposure as it relates to different situations and scenarios. By using the features of your camera and this book, you will learn about aperture, shutter speed, ISO, lens selection, depth of field, and many other photographic concepts. You will also find plenty of large full-page photos that include captions, shooting data, and callouts so you can see how all of the photography fundamentals come together to make great images. All the while, you will be learning how your camera works and how to apply its functions and features to your photography.

Q: WHAT ARE THE ASSIGNMENTS ALL ABOUT?

A: At the end of most of the chapters, you will find shooting assignments, where I give you some suggestions on how to apply the lessons of the chapter to help reinforce everything you just learned. Let's face it—using the camera is much more fun than reading about it, so the assignments are a way of taking a little break after each chapter and having some fun.

Q: SHOULD I READ THE BOOK STRAIGHT THROUGH OR CAN I SKIP AROUND FROM CHAPTER TO CHAPTER?

A: Here's the easy answer: yes and no. No, because the first four chapters give you the basic foundation that you need to know for creating proper exposures. These are the building blocks for making photographs with your camera. After that, yes, you can move around the book as you see fit because the later chapters are written to stand on their own as guides to specific types of photography or shooting situations. So you can bounce from portraits to shooting landscapes and then maybe to a little action photography. It's all about your needs and how you want to address them. Or, you can read it straight through. The choice is up to you.

Q: IS THAT IT?

A: One last thought before you dive into the first chapter. My goal in writing this book has been to give you a resource that you can turn to for creating great photographs with your digital SLR. Take some time to learn the basics and then put them to use. Photography, like most things, takes time to master and requires practice. I have been a photographer for more than 25 years and I'm still learning. Always remember, it's not the camera but the person using it who makes beautiful photographs. Have fun, make mistakes, and then learn from them. In no time, I'm sure you will transition from a person who takes snapshots to a photographer who makes great shots.

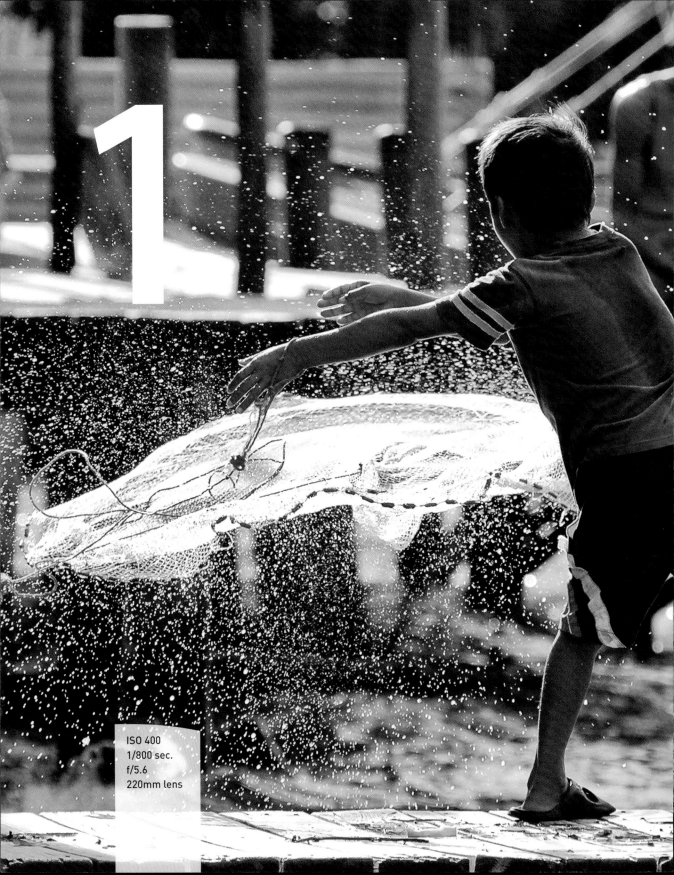

1

ISO 400
1/800 sec.
f/5.6
220mm lens

What Is Exposure?

LEARNING THE BASICS

It doesn't matter what camera model you own, what brand it is, or even what type of camera it is. They all have a singular purpose: to create a properly exposed photograph. But what exactly does "properly exposed" mean? And how do we know that the camera is getting it right? It all begins with a basic understanding of exposure and how to make adjustments to get the results you want, so that's where we will begin.

PORING OVER THE PICTURE

While walking through the Old Town Alexandria waterfront, I came upon these parrots hanging out with their owner. The skies had started turning a little overcast but that didn't dampen my spirits, since I knew I would get some nice, soft light for my picture. The bright background behind the parrots was fooling my camera into making a disappointing image. It only took me a couple of seconds to make an adjustment and get the shot that I wanted.

The bright background was fooling the camera meter, so I added some overexposure to compensate.

Because the depth of field is so narrow, the bird in the rear is just a little soft but still within the limits of acceptability.

The background has lost detail but is providing a nice contrast to my subjects.

The aperture helped to blur the background and keep the emphasis on the birds.

ISO 400
1/80 sec.
f/6.3
125mm lens

PORING OVER THE PICTURE

I was wandering through a market in Kuala Lumpur with some friends, just grabbing the occasional picture here and there. It was crowded and tough to really get a picture that I was happy with. We decided to cut through a back street to a different part of the market when I found this small prayer alter perched on a wall. I loved the colors of the alter, in contrast with the wall and the vegetation, and I knew I had found something special. So I guess the lesson is this: never be afraid to stray from the beaten path.

The overall scene was dark, so the camera meter was trying to lighten things up.

My close distance to the subject meant that I needed an aperture of f/8 to ensure that everything stayed in focus.

Because the area was in heavy shade, I needed to raise the ISO.

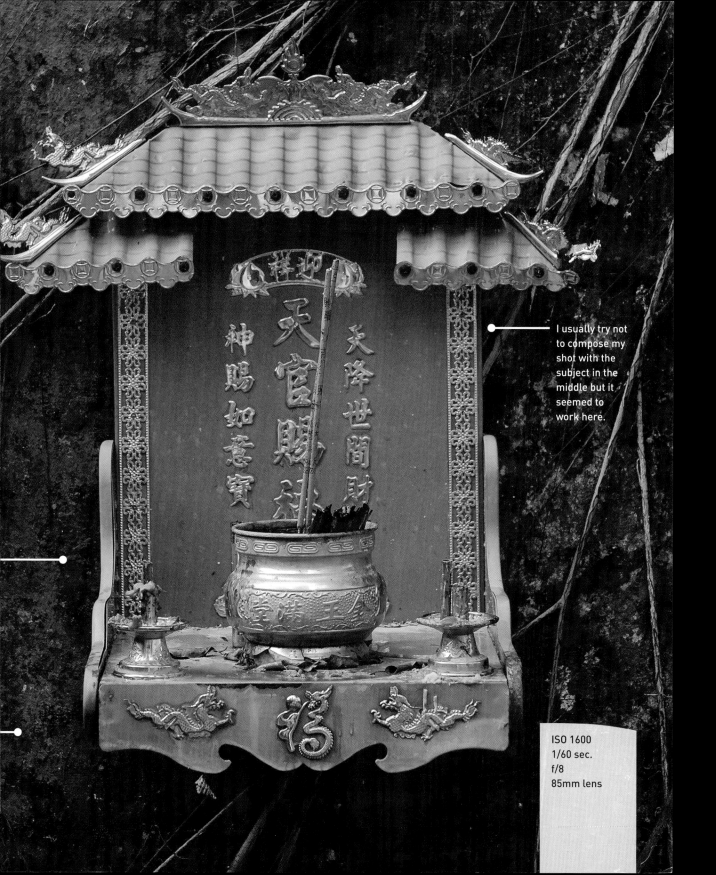

I usually try not to compose my shot with the subject in the middle but it seemed to work here.

ISO 1600
1/60 sec.
f/8
85mm lens

THE BASIC DEFINITION

Exposure is the process whereby the light reflecting off of a subject reflects through an opening in the camera lens onto the camera sensor for a defined period of time. Just how large of a lens opening and how long the light is allowed to pass through is determined by the sensitivity of the sensor. The proper combination of shutter speed, lens opening, and sensor sensitivity results in a properly exposed photograph. There is a relationship between these factors that is sometimes referred to as the Exposure Triangle.

At each point of the triangles lies one of the critical components that comprise a correct exposure (**Figure 1.1**):

- **ISO:** This is the numeric value assigned to the sensitivity level of your camera sensor

- **Aperture:** The opening of your lens, which controls the volume of light entering the camera

- **Shutter Speed:** This controls the length of time that light is allowed in through the lens

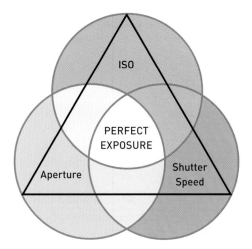

So you can see that we now have the three points of our triangle. By combining just the right amounts of each one, we can achieve a proper exposure.

FIGURE 1.1
By combining the three primary elements of photography—ISO, aperture, and shutter speed—you can achieve a proper exposure.

Here's how it works. The camera sensor has a level of sensitivity (or how sensitive it is to light) that is called the *ISO*. To get a proper exposure—not too much, not too little—the lens needs to adjust the *aperture* diaphragm to control the volume of light entering the camera. This diaphragm is a circular opening in the lens that can be made large or small, depending on how it is set. Once set, the *shutter* is opened for a short period of time to allow the light to hit the sensor long enough for the light to record an image.

A change to any one of these factors will require changing one or more of the other two. This is referred to as "reciprocal change." If you let more light in the lens by choosing a larger aperture opening, you will need to shorten the amount of time the shutter is open. If the shutter is allowed to stay open for a longer period of time, the aperture needs to be smaller to restrict the amount of light coming in.

In order to better understand each of these key exposure components, let's dive in a little deeper.

ISO

We already covered a brief definition of the term ISO, but what exactly does it mean to you? Well, it's the starting point for defining how much exposure will be necessary for you to get a good picture. The term ISO stands for International Standards Organization and dates back to the days of film cameras. At one point there was more than one way to determine how sensitive film was, by using either the ASA (American Standards Association) scale, which was based on an arithmetic scale, or DIN (German Institute for Standardization), which used a logarithmic scale. In order to make things easier for the international photography market, most film manufacturers switched to the ISO scale.

So why the history lesson? Because the scale that we use in today's digital cameras is based on this definition of sensitivity. The actual method of determining this number is calculated differently because we are using digital image sensors rather than film, but the actual ISO numbers and the way they are used are such that you would obtain similar exposure results. The ISO scale uses an arithmetic progression to change the sensitivity of your camera, based on the lowest determined ISO level achievable. Every time the number doubles, so does the sensitivity of the sensor. Most digital cameras today have ISO settings that range from anywhere between 50 to 126,000 (although most cameras top out around 6400). The ability to actually change that sensitivity level has given the photographer great flexibility in achieving a greater range of exposures.

Just as it was with film, the greatest level of image quality will come from using the lowest ISO number. This is also the setting that takes the most amount of light to produce a good image. As you raise the ISO level on your camera, you decrease the amount of light necessary to make a good exposure; however, your image quality might decrease slightly with each rise in ISO (**Figure 1.2**). This is due to the process of amplifying the signal from your sensor. It is this amplification that decreases the signal-to-noise ratio. So, the higher you set the number, the more digital noise you will have in your image. This image noise is less of a problem in today's cameras due to advances in signal processing and noise reduction, but it can still be an issue.

The bottom line here is that the ISO gives you a starting point for determining how much light you will need for a proper exposure. Pick a lower number and you have better quality and the need for more light. A higher number lets you work with less light but can diminish the quality of your image.

FIGURE 1.2
The high ISO setting was necessary to enable handholding the camera during exposure. The downside is that there is a lot of digital noise in the image.

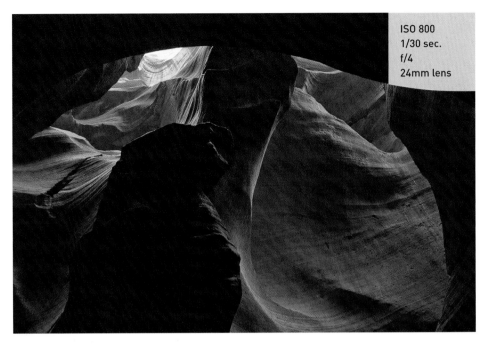

ISO 800
1/30 sec.
f/4
24mm lens

TURNING OFF THE AUTO ISO SETTING

The ISO setting in your camera allows you to choose the level of sensitivity of the camera's sensor to light. The ability to change this sensitivity is one of the biggest advantages of using a digital camera. In the days of film cameras, you had to choose the ISO by film type. This meant that if you wanted to shoot in lower light, you had to replace the film in the camera with one that had a higher ISO. Not only did you have to carry different types of film, you also had to remove one roll from the camera to replace it with another, even if you hadn't used up the current roll. Now all we have to do is go to our menu and select the appropriate ISO.

Having this flexibility is a powerful option, but it's important to remember that the ISO setting has a direct bearing on the quality of the final image. The higher the ISO, the more digital noise the image will contain. Since your goal is to produce high-quality photographs, it is important that you get control over all of the camera controls and bend them to your will. When you turn your camera on for the first time, the ISO will probably be set to Auto. This means that the camera is determining how much light is available and will choose what it believes is the correct ISO setting. Since you want to use the lowest ISO possible, you will need to turn this setting off and manually select the appropriate ISO.

Which ISO you choose depends on your level of available or ambient light. For sunny days or very bright scenes, use a low ISO such as 100 or 200. As the level of light is reduced, raise the ISO level. Cloudy days or indoor scenes might require you to use ISO 400. Low-light scenes, such as when you are shooting at night, will mean you need to bump up that ISO to 1600...or more. The thing to remember is to shoot with the lowest setting possible for maximum quality.

APERTURE

The aperture of the lens allows you to control the volume of light coming into the camera. Through the use of a diaphragm of movable leaves, the opening in the lens (or aperture), which light passes through, can be changed. The largest opening possible for a given lens is called the "maximum aperture," and it is determined by dividing the focal length of the lens by the diameter of the aperture. The result is known as an f-number, or f-stop. As the aperture gets smaller, the f-stop will actually go up. This can be confusing, but know that each f-stop is a fraction—though it is expressed without the numerator. Also, as the number gets larger, the amount of light it lets through is about half that of the preceding larger opening.

Sounds confusing, right? Well, it can be if you think of it in terms of a math problem. Think of it like this: you are outside watering your plants with a 1" garden hose. Let's say the hose breaks and now you need to use a ½" hose. It's going to take you longer to get the same volume of water on your plants. If they were lenses, you would be switching from an f/1 lens to an f/2 lens.

You might also be wondering why, if everything is doubling or halving, there are numbers like f/2.8, f/5.6, and f/11. It's because the numbers are fractions based on the area of the hole in the diaphragm. Just remember that when you increase the number, you're actually allowing less light in because the diaphragm is getting smaller.

WHERE DID THE TERM "STOP" COME FROM?

Before the time when photographers had adjustable diaphragms, they inserted metal plates with pre-cut holes into their lenses. By using a plate with a smaller hole, the photographer was able to "stop" some of the light from reaching their film. Each plate had a numeric value, which was determined by dividing the lens focal length by the diameter of the hole in the plate. This term moved from plates to the click-stops on a lens ring as camera lenses became more evolved. If the photographer needed to add another stop of exposure, they just moved the aperture ring one click, or *f-stop*, to the larger aperture setting. Nowadays, photographers use the term any time they are talking about halving or doubling the exposure—not only for aperture, but also for shutter speed and ISO. So you might hear a photographer say, "My lens was wide open and I needed to get a couple more stops so I increased the ISO by a stop and slowed down one stop with the shutter speed."

SHUTTER SPEED

We've just determined that the ISO sensitivity will dictate how sensitive the camera is to light and that the aperture will control the volume of light. Now we need to explore the final factor in achieving our exposure, which deals with controlling how long the light is allowed to strike the sensor. Controlling the shutter speed does this. Every camera has a shutter whose purpose it is to control the flow of light. Most shutters are actually made of two separate curtains that travel vertically across the camera sensor. As the shutter release button is depressed, the first curtain will begin to travel across the surface of the frame, allowing the sensor to be exposed. After a predetermined amount of time, a second curtain will begin to close over the sensor, terminating the exposure process. It is the predetermined time that is referred to as shutter speed.

The speeds that you will be working with are typically going to be just fractions of a second, and they are a little easier to figure out than aperture settings. Most cameras have the ability to select shutter speeds ranging from 30 seconds to as fast as 1/8000 of a second. Each time you change from one shutter speed to the next, you are going to be effectively doubling or halving the duration of the shutter. This means that if you change your setting from 1/125 to 1/250 you will be getting half the amount of exposure. But, if you go from 1/60 to 1/30, you will double your exposure time.

HOW IS EXPOSURE CALCULATED?

We now know about ISO and shutter speeds and f-stops, so it's time to put all three together to see how they relate to each other and how you can change them as needed. But before we do that, I should tell you how the exposure is actually calculated. Don't worry; this won't be overly complicated, but it is important.

When you point your camera at a scene, the light reflecting off your subject enters the lens and is allowed to pass through to the sensor for a period of time as dictated by the shutter speed. The amount and duration of the light needed for a proper exposure is dependent upon how much light is being reflected and how sensitive the sensor is. To figure this out, your camera utilizes a built-in light meter that looks through the lens and measures the amount of light. That level is then calculated against the sensitivity of the ISO value and an exposure value is rendered. So here is the tricky part: there is not just one perfect exposure because the f-stop and shutter speeds can be combined to allow the same amount of exposure using different settings. I told you it was tricky.

Here is a list of reciprocal settings that would all produce the same exposure result. Let's use the Sunny 16 Rule, which states that on a sunny day, you can use a shutter speed that is roughly equal to the ISO at f/16 and achieve a proper exposure.

For simplification purposes, we will use an ISO of 100.

RECIPROCAL EXPOSURES: ISO 100

F-STOP	2	2.8	4	5.6	8	11	16	22
SHUTTER SPEED	1/8000	1/4000	1/2000	1/1000	1/500	1/250	1/125	1/60

If you were to use any one of these combinations of aperture and shutter speed, they would each have the same result in terms of the exposure. Also take note that every time we cut the f-stop in half, we reciprocated by doubling our shutter speed.

Now that we know this, we can start using this information to make intelligent choices in terms of shutter speed and f-stop. Let's bring the third element into this by changing our ISO by one stop, from 100 to 200.

RECIPROCAL EXPOSURES: ISO 200

F-STOP	2	2.8	4	5.6	8	11	16	22
SHUTTER SPEED	—	1/8000	1/4000	1/2000	1/1000	1/500	1/250	1/125

Notice now that we doubled the sensitivity of the sensor so now we require half as much exposure as before. We have also reduced our maximum aperture from f/2 to f/2.8 because, depending on your camera, you probably can't use a shutter speed that is faster than 1/8000 of a second.

So why not just use the exposure setting of f/16 at 1/250 of a second? Why bother with all of these reciprocal values when this one setting will give us a properly exposed image? The answer is that the f-stop and shutter speed also control other aspects of our image that we may need to control so that our images look how we want them to look.

OVER- AND UNDEREXPOSURE

Typically, since there is a proper exposure, you can also guess that there are improper exposures, as well. These are called overexposed and underexposed images. Overexposure is when too much light is allowed to fall on the sensor. This could be due to too large of an opening in the lens aperture setting or too slow of a shutter speed. The resulting image is one that looks too bright and tends to have blown-out highlight areas (**Figure 1.3**).

FIGURE 1.3
The figure on the left is overexposed, has blown-out highlights, and is too light overall. By adjusting the exposure by two stops, the image is darkened and there is now more detailed information in the highlight areas.

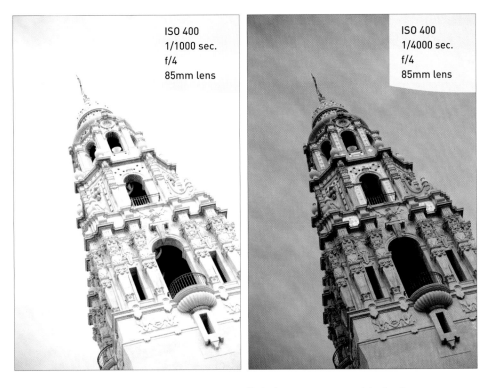

ISO 400
1/1000 sec.
f/4
85mm lens

ISO 400
1/4000 sec.
f/4
85mm lens

An underexposed image will have an overall dark appearance with shadow areas that are completely black and contain no detail. This happens when the sensor has not had enough light fall on it to properly record all of the tones. This generally happens when the lens aperture is too small or the shutter speed is too short (**Figure 1.4**).

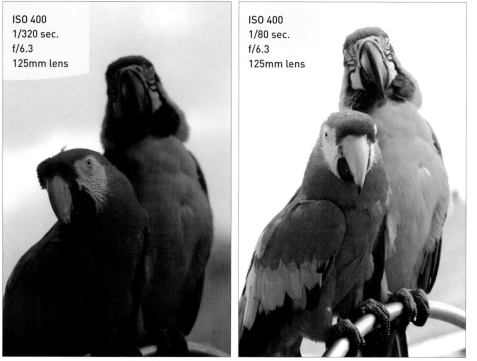

ISO 400
1/320 sec.
f/6.3
125mm lens

ISO 400
1/80 sec.
f/6.3
125mm lens

FIGURE 1.4
The picture on the left is too dark and the shadow areas are losing detail. By adding more exposure, I was able to see more detail in the shadows and the parrots are much brighter and more vibrant.

WHAT IS A PROPER EXPOSURE?

If "too dark" is underexposed and "too light" is overexposed, how do we know exactly what is the proper exposure? That in itself is a tricky question, but once you know, you will be well on your way to being a better photographer. That's because there are two answers to this question, and neither is wrong. The first answer has to do with the camera's light meter and how it interprets the scene. Once you point your camera at a scene and press the shutter release slightly, the camera light meter springs into action. It immediately assesses all of the light and dark areas that the camera is viewing and makes an exposure value (EV) based on that information as well as the ISO setting for the sensor. We'll cover the light meter more extensively in the next chapter.

The second way of knowing what is a proper exposure is based solely on the outcome that you desire. As the photographer, it's up to you to decide if you want the image to be light or dark. It's your interpretation, and that is something that you will develop over time. That's why it's so important to understand just what exposure is and how to manipulate it so that you can render predictable results. Once you have

accomplished that, you can begin creating your own vision—not just the one that the camera has chosen for you.

In **Figure 1.5**, you see two different interpretations of the same subject. The image on the left is the exposure that the camera felt was correct for the subject. It's not bad, but it doesn't quite meet the vision I had for the shot. I decided to underexpose the scene by one stop by increasing my shutter speed from 1/30 to 1/60 of a second. The result is a slightly darker appearance to the image and colors that are slightly more saturated.

FIGURE 1.5
The image on the left is the result of the camera's light meter. By altering those settings, I was able to get an image much closer to what I intended.

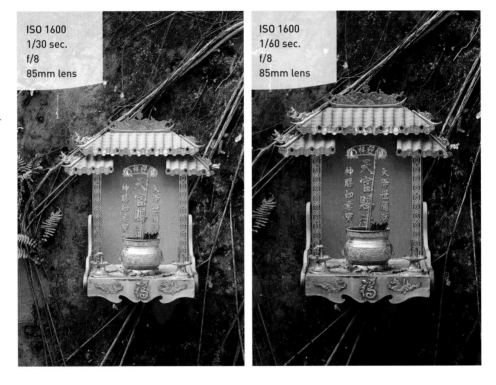

ISO 1600
1/30 sec.
f/8
85mm lens

ISO 1600
1/60 sec.
f/8
85mm lens

Chapter 1 Assignments

Gaining an understanding of the basic concepts of exposure will help you make smarter decisions down the road. It's not enough to know how your camera works; you also need to know how to make it work for you to achieve a desired result. Try these few exercises to start getting control over the exposure process.

Changing your exposure

Put your camera in Program mode, point it at a subject, and then activate the meter. Take note of the aperture and shutter speed. Now try moving the mode to Aperture Priority or Shutter Priority mode and set the camera to the same settings. Now turn your shutter speed or aperture to something else and watch the other setting change automatically to compensate. Get a feel for how one setting affects the other.

Learn to compensate

Finding that sweet spot of exposure for your subject is what it's all about. The camera meter will give you a starting point but you need to adjust to suit your needs. Find your Exposure Compensation function and try doing some over- and underexposure tests to see how they affect the camera settings as well as the final image.

Put your camera in Manual mode

If you really want to learn how things work, step away from those semi-automatic modes and give the Manual mode a spin. Try making a change to the ISO and then make some reciprocal changes to your other camera settings. Remember that there is a meter reading in your viewfinder so you won't have to do all the guesswork.

Share your results with the book's Flickr group!

Join the group here: flickr.com/groups/exposure_fromsnapshotstogreatshots

2

ISO 200
1/400 sec.
f/5.6
300mm lens

Exposure Tools

HOW YOUR CAMERA DETERMINES EXPOSURE... AND MORE

Knowing about the different components of exposure is a good start—
as covered in the previous chapter—but knowing how to control them
is where the money is. This chapter explores some of the different tools
for determining and then controlling your exposure so that you get the
results you want, right out of the camera.

My focus point was placed on the eye of the statue and then I recomposed before taking the shot.

The cloudy skies created a very diffuse light source, which minimized harsh shadows.

This image was taken while strolling through a garden in Antigua, Guatemala. Although it was mid-day, the sun was being completely obscured by a heavy cloud layer. In fact, it was raining off and on as I walked around. This isn't necessarily a bad thing because vegetation can take on a much more lush appearance after the rain.

Care was taken not to overexpose and lose detail in the white statue.

I cropped the image in-camera just as I would if shooting a live person, making sure not to intersect at the knees.

ISO 400
1/125 sec.
f/7.1
35mm lens

PORING OVER THE PICTURE

When it comes to long exposures, your camera meter is invaluable for figuring out a good exposure. It's possible to use a Spot meter setting, but I prefer to use the Matrix mode so that the camera is getting information from the entire frame. Sometimes you might get some overexposure if you have a lot of black sky in the shot. This scene had the benefit of some clouds that were illuminated by the lights coming from the buildings.

Due to the long exposure, I made sure I had a sturdy tripod with me.

At f/13, this image has plenty of depth of field to keep all the buildings looking sharp.

Long exposures can also introduce noise, which is why I had my noise reduction activated.

The ISO was set low to keep the digital noise to a minimum.

FRASERPLACE

ISO 200
8 sec.
f/13
98mm lens

MEASURING LIGHT

Be it a point-and-shoot or a digital SLR, pretty much every camera that you use today has a built-in light meter to determine exposure settings. Some metering systems are much more complicated than others, but they all work on the same principle: to measure the light being seen by the camera and then average it out. Okay, that's a pretty simplified explanation but it still holds true. Here's how it works:

1. Light hits your subject and bounces into your camera (that's called reflected light).

2. The meter then measures the luminance (brightness) of the light and averages all of the values.

3. Finally, based on the camera's ISO setting, the meter determines what shutter speed and aperture combination would work to produce a photograph that averages to a middle shade of grey.

So why grey, you ask? Well, if you average out all of the light and dark values, you get something in the middle—and that would be grey.

Take **Figure 2.1** for example. It is a fairly typical scene with bright values, dark values, and lots of tones in between. When the camera looks at the scene, it measures all of those tonal values and averages them out (**Figure 2.2**). The result of averaging black, white, and everything between them is grey. So when you point your camera at a subject, the camera is giving you an exposure that it thinks is the best average for all of the tonal values in the scene, from dark to light.

FIGURE 2.1
When you look through your viewfinder, you see a normal scene.

ISO 200
1/400 sec.
f/9
28mm lens

This averaging is also why it's important for you to understand just what the meter is trying to accomplish. The meter isn't always going to be right, especially when the scene is predominantly dark or light. If the meter tries to average a scene where everything is dark, it will offer an overexposed setting because it's trying to make the scene average out to grey, not black. The same thing is true for a scene that is predominantly light or white. Once again, the meter thinks that the average of the tones is middle grey; therefore it renders an underexposed setting, forcing the light values to go dark (**Figure 2.3**). If you can anticipate how the meter is going to interpret a scene, then you can make modifications to the exposure setting and get a more properly exposed image (**Figure 2.4**).

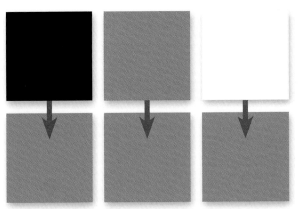

FIGURE 2.3
The meter is always trying to adjust the exposure to a middle grey. This means that very dark or very light subjects may fool the meter.

ISO and with the same aperture setting. The white church and bright skies fooled the light meter into underexposing the image on the left. The image on the right is with the corrected exposure. There is a loss of detail in the skies but the building is now much closer to where the exposure should be.

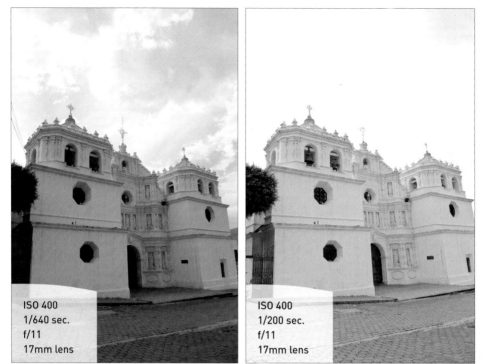

ISO 400
1/640 sec.
f/11
17mm lens

ISO 400
1/200 sec.
f/11
17mm lens

METERING MODES

Light meters have come a long way since I first started taking photos over 25 years ago. Back then, my meter was only capable of taking an overall average of what was displayed in my viewfinder. Then it was up to me to turn the aperture ring and the shutter speed dials until a line and a circle matched up, which meant that I should have a proper exposure setting. Ah, the good old days (**Figure 2.5**). Nowadays, there is some pretty incredible technology to lean on. In fact, most cameras have multiple metering modes that you can select based on the shooting situation.

FIGURE 2.5
My first 35mm camera, the Canon F-1, had a meter system that looked something like this.

MATRIX/EVALUATIVE METERING

The concept of matrix, or evaluative, metering is pretty straightforward, but the results can be highly accurate. The idea is to split the viewfinder into smaller pieces, with each segment being metered and averaged. The results from all the different segments are analyzed by the camera's computer to deliver an overall exposure setting. Different cameras use different types and numbers of zones, with more zones offering a more accurate result (**Figure 2.6**).

Some of these metering systems have grown so sophisticated that they actually use the information from the metered segments and compare that data to a database of photographs. Nikon claims that the database they use in some camera models contains exposure information from over 300,000 different photos. By using the comparisons, the computer can better determine what the subject matter is and render a more appropriate exposure setting, all in a fraction of a second.

CENTER-WEIGHTED METERING

Center-weighted metering has been around for quite a while but is still handy in some situations. When using this metering mode, the objective is to place more emphasis on the center of the frame and not so much on the edges. How much preference depends on your camera make and model, but the average is about 60–80% on the center portion with the other 20–40% from the edges. This type of metering can be especially useful when determining the exposure for a portrait or when your main subject is near the middle of the frame and there are dark or light areas on the edges that are unimportant (**Figure 2.7**).

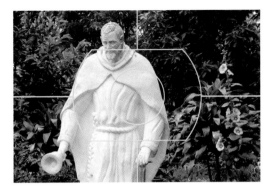

FIGURE 2.6
This is a representation of the different areas of coverage for a 6-segment matrix meter.

FIGURE 2.7
A center-weighted meter uses the middle of the frame for the majority of its metering. It doesn't ignore the areas around the edge, but it does give them less influence over the final reading.

SPOT METERING

Spot metering is the most selective of the metering modes, and when used correctly it can provide very accurate readings. Depending on the camera, the spot meter uses an area that is only about 1–5% of the total frame, hence the term "spot." Some cameras lock the spot meter location to the middle of the frame while others use the active focus point so that the reading can be moved around to different parts of the frame without having to take a reading and then recompose the shot. The advantage of using the spot meter is that bright or dark areas of the frame outside of the spot are not influencing the meter reading, meaning you can get a very accurate reading for a specific area.

Typically, spot metering is used to meter an area of the scene that is predominantly comprised of middle tone values. The best way to use it, though, is with a grey card. By placing a grey card in the scene and then placing the spot on the card, you can measure the light that is only reflected off the card (**Figure 2.8**).

Once a meter reading has been established, you can use the suggested camera settings or a reciprocal of them to get a very accurate exposure of your scene. See **Figures 2.9** and **2.10** for an example of when spot metering can come in handy.

USING A GREY CARD FOR EXPOSURE AND COLOR-CORRECTION

There are other benefits to using a grey card beyond just getting an accurate light meter reading. If the card is truly neutral in color (grey) it can also be used to color-correct your images in post-processing. Most image-processing programs have an eyedropper tool that can be used to click on a neutral portion of the photograph to help render proper colors in the scene. By providing a card that you know is neutral, the process of color-correcting is just a click away. You can then use the same color balance settings for any photograph that was taken in the same light as the grey card.

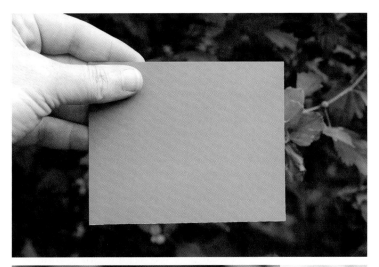

FIGURE 2.8
A spot meter is most effective when used with a grey card or neutral-toned object.

ISO 400
1/500 sec.
f/4
85mm lens

FIGURE 2.9
The matrix meter setting does a decent job of picking an overall exposure setting, but the flower is a little light because the meter was also reading the dark areas in the background and trying to average them all out.

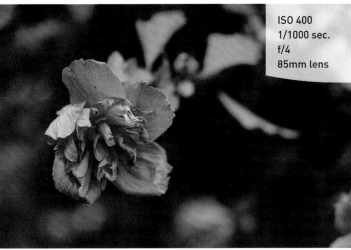

ISO 400
1/1000 sec.
f/4
85mm lens

FIGURE 2.10
By taking a spot reading from my grey card (as seen in Figure 2.8), I am able to get a more accurate exposure setting for the flowers, uninfluenced by the darker areas of the background.

THE VALUE OF THE HISTOGRAM

Most digital SLR cameras and some point-and-shoots have the ability to display a histogram of the captured images while you review them on the rear LCD display. Using this graphic information can help you quickly assess whether or not you are getting decent exposures.

Simply put, histograms are two-dimensional representations of your images in graph form. You might have more than one type of histogram on your display, but the luminance histogram is the one that you should pay attention to most of all. Luminance is referred to as "brightness" and is most valuable when evaluating your exposures. In **Figure 2.11**, you see what looks like a mountain range. The graph represents the entire tonal range that your camera can capture, from the whitest whites to the blackest blacks. The left side represents black, all the way to the right side, which represents white. The heights of the peaks represent the

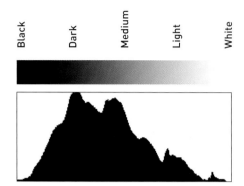

FIGURE 2.11

This is a typical histogram, where the dark-to-light tones run from left to right. The black-to-white gradient above the graph demonstrates where the tones lie on the graph and do not appear above your camera histogram display.

number of pixels that contain those luminance levels (a tall peak in the middle means your image contains a large amount of medium-bright pixels). Looking at an image, it is hard to determine where all of the ranges of light and dark areas are and how much of each I have. If I look at the histogram, though, I can see that information quite a bit easier. In most cases, look for a histogram where the largest peak of the graph is in the middle, with the peak trailing off as it reaches the edges. This type of histogram indicates that you captured the entire range of tones, from dark to light, in your image. Knowing that is fine, but here is where the information really gets useful.

When you evaluate a histogram that has a spike or peak riding up the far left or right side of the graph, it means that you are clipping detail from your image. In essence, you are trying to record values that are either too dark or too light for your sensor to accurately record. This is usually an indication of over- or underexposure. It also means that you need to correct your exposure so that the important details will not record as solid black or white pixels (which is what happens when clipping occurs). There are times, however, when some clipping is acceptable. If you are photographing a scene where the sun will be in the frame, you can expect to get

some clipping because the sun is just too bright to hold any detail. Likewise, if you are shooting something that has true blacks in it—think coal in a mineshaft at midnight—there are most certainly going to be some true blacks with no detail in your shot. The main goal is to ensure that you aren't clipping any "important" visual information—such as skin tones in a portrait—and that is achieved by keeping an eye on your histogram. Take a look at **Figure 2.12**. The histogram displayed on the image shows a heavy skew toward the left with almost no part of the mountain touching the right side. This is a good example of what an underexposed image histogram looks like. Now look at **Figure 2.13** and compare the histogram for the image that was correctly exposed. Notice that even though there are two distinct peaks on the graph, there is an even distribution across the entire histogram.

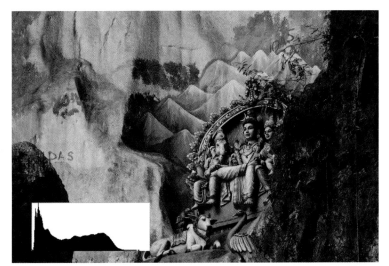

FIGURE 2.12
This image is about two stops underexposed. Notice the histogram is skewed to the left.

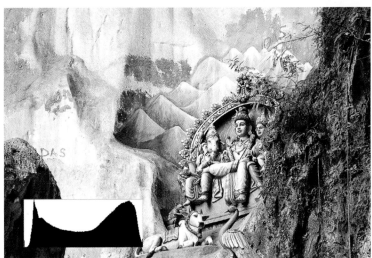

FIGURE 2.13
This histogram reflects a correctly exposed image.

CHECK YOUR "BLINKIES"

Another useful tool that I use all the time to check my exposure is the highlight warning, otherwise known as the "blinkies." When this setting is turned on in your camera, it will cause any area that is too bright to blink between black and white while viewing it on the rear LCD screen (**Figure 2.14**). This warning lets you know that there is a possibility that some of the highlights in your image might be clipping important details. This can be especially important if you are shooting in JPEG, since there is less of a chance that you can recover the detail in post-processing (see the discussion on RAW vs. JPEG on page 32). Just like the histogram, it is important for you to decide if the blinking area is worth paying attention to and adjusting your exposure, or simply not to worry about. Either way, it's a valuable tool in helping to quickly check your exposure.

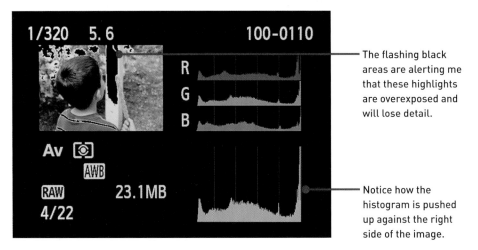

The flashing black areas are alerting me that these highlights are overexposed and will lose detail.

Notice how the histogram is pushed up against the right side of the image.

FIGURE 2.14
The highlight alert screen on the Canon T2i.

SETTING THE CORRECT WHITE BALANCE

White balance correction is the process of rendering accurate colors in your final image. Most people don't even notice that light has different color characteristics because the human eye automatically adjusts to different color temperatures—so quickly, in fact, that everything looks correct in a matter of milliseconds.

When color film once ruled the earth, photographers would select film depending on what their light source was going to be. The most common film was balanced for daylight, but you could also buy film that was color-balanced for tungsten light

sources. Most other lighting situations had to be handled by putting color filters over the lens. This process was necessary for the photographer's final image to show the correct color balance of a scene.

Digital cameras have the ability to perform this same process automatically, or you can choose to override it and set it manually. Your photography should be all about maintaining control over everything that influences your final image.

Luckily, you don't need to have a deep understanding of color temperatures to control your camera's white balance. The choices are given to you in terms that are easy to relate to and that will make things pretty simple. Your white balance choices are typically:

- **Auto:** This setting evaluates the colors in the scene and then applies a white balance correction. While fairly accurate, it can be fooled on occasion. However, it is useful when there is more than one type of light source in the image.

- **Daylight:** Most often used for general daylight/sun-lit shooting.

- **Shade:** Used when working in shaded areas that are still using sunlight as the dominant light source.

- **Cloudy:** The choice for overcast or very cloudy days. This and the Shade setting will eliminate the blue colorcast from your images.

- **Tungsten:** Used for any occasion where you are using regular household-type bulbs for your light source. Tungsten is a very warm light source and will result in a yellow/orange cast if you don't correct for it.

- **Fluorescent:** Used to get rid of the green-blue cast that can result from using regular fluorescent lights as your dominant light source. Some fluorescent lights are actually balanced for daylight, which would allow you to use the Daylight white balance setting.

- **Flash:** Used whenever you're using the built-in flash or using a flash on the hot shoe. You should select this white balance to adjust for the slightly cooler light that comes from using a flash. (The hot shoe is the small bracket located on the top of your camera, which rests just above the eyepiece. This bracket is used for attaching a more powerful flash to the camera.)

- **Custom:** Indicates that you are using a customized white balance that is adjusted for a particular light source. If you know what the color temperature of your light source is, you can manually create a white balance setting that is specifically for that light source. Some cameras also allow you to create a custom white balance by taking a picture of a white card, which the camera will then analyze and produce a customized white balance setting.

USING THE RIGHT FORMAT: RAW VS. JPEG

When shooting with your camera, you probably have a choice of image file formats that your camera will use to store the pictures on the memory card. JPEG is probably the most familiar format to anyone who has been using a digital camera. If you do have the ability to shoot a RAW file, you might want to read on to see why it is so valuable for getting your photos to look just right.

See, there is nothing wrong with JPEG if you are taking casual shots. JPEG files are ready to use right out of the camera. Why go through the process of adjusting RAW images of the kids opening presents when you are just going to email them to Grandma? Also, for journalists and sports photographers who are shooting nine frames per second and need to transmit their images across the wire, again, JPEG is just fine. So what is wrong with JPEG? Absolutely nothing—unless you care about having complete creative control over all of your image data (as opposed to what a compression algorithm thinks is important).

UNDERSTANDING JPEG

The JPEG format has been around since about 1994 and stands for Joint Photographic Experts Group. JPEG was developed by this group as a method of shrinking the size of digital images down to a smaller size for the purpose of reducing large file sizes while retaining the original image information. (Technically, JPEG isn't even a file format—it's a mathematical equation for reducing image file sizes—but to keep things simple, we'll just refer to it as a file format.) The problem with JPEG is that, in order to reduce a file size, it has to throw away some of the information. This is referred to as "lossy compression." This is important to understand because, while you can fit more images on your memory card by choosing a lower-quality JPEG setting, you will also be reducing the quality of your image. This effect becomes more apparent as you enlarge your pictures.

The JPEG file format also has one other characteristic: to apply the compression to the image before final storage on your memory card, the camera has to apply all of the image processing first. Image processing involves such factors as sharpening, color adjustment, contrast adjustment, noise reduction, and so on. Many photographers now prefer to use the RAW file format to get greater control over the image processing.

As I mention in the "Understanding JPEG" sidebar, JPEG is not actually an image format. It is a compression standard, and compression is where things can go bad. When you have your camera set to JPEG—whether it is High, Medium, or Low—you are telling the camera to process the image however it sees fit and then throw away enough image data to make it shrink into a smaller space. In doing so, you give up subtle image details that you will never get back in post-processing. That is an awfully simplified statement, but still fairly accurate.

SO WHAT DOES RAW HAVE TO OFFER?

First and foremost, RAW images are not compressed. (There are some cameras that have a compressed RAW format but it is lossless compression, which means there is no loss of actual image data.) Note that RAW image files will require you to perform post-processing on your photographs. This is not only necessary; it is the reason that most photographers use it.

RAW images have a greater dynamic range than JPEG-processed images. This means that you can recover image detail in the highlights and shadows that just aren't available in JPEG-processed images.

There is also more color information in a RAW image because it is a higher bit image (12- or 14-bit depending on the camera), which means it contains more color information than a JPEG, which is almost always an 8-bit image. More color information means more to work with and smoother changes between tones and colors—kind of like the difference between performing surgery with a scalpel as opposed to a butcher's knife. They'll both get the job done, but one will do less damage.

Regarding sharpening, a RAW image offers more control because you are the one who is applying the sharpening according to the look and detail you want to achieve. Once again, JPEG processing applies a standard amount of sharpening that you cannot change after the fact. Once it's done, it's done.

Finally, and most importantly, a RAW file is your negative. No matter what you do to it, you won't change it unless you save your file in a different format. This means that you can come back to that RAW file later and try different processing settings to achieve different results and never harm the original image. By comparison, if you make a change to your JPEG and accidentally save the file, guess what? You have a new original file, and you will never get back to that first image. That alone should make you sit up and take notice.

ADVICE FOR NEW RAW SHOOTERS

Don't give up on shooting RAW just because it means more work. Hey, if it takes up more space on your memory card, buy a bigger card or more smaller ones. Will it take longer to download your images to the computer? Yes, but good things come to those who wait. As for processing your RAW files, there are many options available to you. Some cameras actually come bundled with software, such as Canon's Digital Photo Professional software, that will let you perform processing to your RAW files and then save them in other formats. There are also numerous programs such as Adobe Photoshop Elements, Adobe Photoshop Lightroom, Apple Aperture, Apple iPhoto, and many others that will offer you professional-level image editing for your RAW as well as JPEG images (**Figure 2.15**).

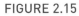

FIGURE 2.15
Adobe's Camera Raw software is one of the more powerful software tools for processing RAW image files.

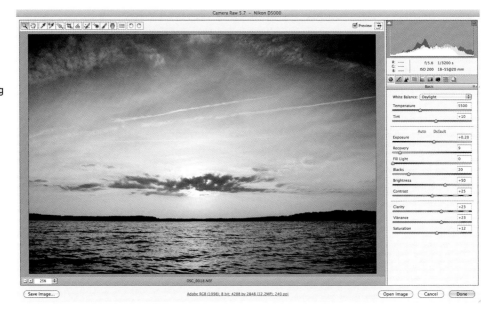

My recommendation is to shoot in JPEG mode while you are using this book. This will allow you to quickly review your images and study the effects of future lessons. Once you have become comfortable with all of the camera features, you should switch to shooting in RAW mode so that you can start gaining more creative control over your exposures and image processing. After all, you took the photograph—shouldn't you be the one to decide how it looks in the end?

Chapter 2 Assignments

Now that you have a better idea of how your camera is delivering exposure information to you, let's see how to put it to the test and pick the right features for the job.

Which meter mode?

With so many metering modes to choose from, how do you know which one to use? The answer is as simple as putting them to the test. First, consult your manual and find out how to change between the various modes. Then find a scene that has a variety of brightness values in it. Now take a picture using Matrix, Center-weighted, and Spot modes, and compare the results.

Black wall, white wall

Remember that your camera's meter is always trying to give you a balanced, average exposure. That means it wants everything to be grey. Find yourself a white wall and take a photo and check out the result. Chances are that it will look a little dark. Now find a black or dark wall and do the same thing. The result should be something that is lighter than the original.

Reading your histogram

Find the display mode for your camera that shows you the image histogram and look at it as you review some images on your camera. You should be able to identify how the tones in your image are being displayed. Do you have a histogram with a lot of peaks on the right side? That would mean you have a lot of bright areas. Now take a photo of some mid-toned subject, like the street or a lawn. When you review the histogram again, you should see a predominant hump in the middle with low points on each end.

Share your results with the book's Flickr group!

Join the group here: flickr.com/groups/exposure_fromsnapshotstogreatshots

PORING OVER THE PICTURE

Sometimes you can plan everything right and still not have very much control over your shooting situation. That is usually the case when you are doing an outdoor landscape shoot—like I encountered on this trip to the San Francisco coast. We had a knowledgeable guide to show us the great spots, but the skies just weren't cooperating. But sometimes, if you have a little patience, you'll get rewarded for it.

The fog was fooling the light meter, so I switched to Manual mode and made adjustments to the shutter speed to darken things up.

Even though there was plenty of light, I used a tripod to help steady the camera in the windy conditions.

The white balance was set to the Daylight setting to match the overall light conditions.

I chose a small aperture for extended depth of field.

ISO 200
1/750 sec.
f/14
45mm lens

PORING OVER THE PICTURE

I'm not a master when it comes to working in a studio, but I do have a pretty good foundation and really enjoy experimenting. Having a good knowledge of lights and how to use them is one of the essentials to getting good quality portraits. One of the things I like to do is shoot high-key portraits on white backgrounds. It doesn't require a lot of extra equipment, just a white paper background, three studio strobes, and a great subject.

When working with studio lights I always set my camera to Manual mode and then make changes to my lights, not the camera.

The third light is illuminating the background and is about 1 ½ stops brighter than my main light so that the background is completely overexposed—but not so bright that it affects the rest of the exposure.

The main light is reflecting in the subject's eyes, creating a great catchlight.

A rim light was placed off camera so that it would light the right side of his face.

The main light on the subject is coming from a softbox placed to his left at about 45 degrees.

ISO 200
1/200 sec.
f/13
60mm lens

PROGRAM MODE

There is a reason that the Program mode is usually only one click away from the automatic modes; with respect to apertures and shutter speeds, the camera is doing most of the thinking for you. So, if that is the case, why even bother with the Program mode? First, let me say that it is very rare that I will use Program mode because it just doesn't give as much control over the image-making process as the other professional modes. There are occasions, however, where it really comes in handy, like when shooting in widely changing lighting conditions and there isn't time to think through all of the exposure options, or if there isn't a big concern with having ultimate control of the scene. Think of a picnic outdoors in a partial shade/sun environment. I want great-looking pictures, but I'm not looking for anything to hang in a museum. If that's the scenario, why choose Program over one of the automatic modes? Because it gives me choices and control that the automatic modes just can't deliver.

WHEN TO USE PROGRAM MODE INSTEAD OF THE AUTOMATIC SCENE MODES

- When shooting in a casual environment where quick adjustments are needed (**Figure 3.1**)

- When you want more control over the ISO

- If you want to make corrections to the white balance

- When you want to change the shutter speed or aperture to achieve a specific result

FIGURE 3.1
Casual travel/ vacation pictures are the perfect time to forget about creativity and just capture the moment.

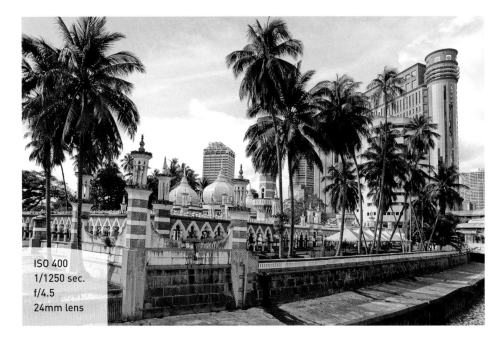

ISO 400
1/1250 sec.
f/4.5
24mm lens

Let's go back to our picnic scenario. As I said, the light is moving from deep shadow to bright sunlight, which means that the camera is trying to balance our three photo factors (ISO, aperture, and shutter speed) to make a good exposure. Well, in Program mode, you can actually choose which ISO you would like the camera to base its exposure on. The lower the ISO number, the better the quality of our photographs, but the less light-sensitive the camera becomes. It's a balancing act with the main goal always being to keep the ISO as low as possible—too low an ISO, and we will get camera shake in our images from a long shutter speed, and too high an ISO means we will have an unacceptable amount of digital noise. For our purposes, let's go ahead and select ISO 400 so that we provide enough sensitivity for those shadows while allowing the camera to use shutter speeds that are fast enough to stop motion.

With the ISO selected, we can now make use of the other controls built into Program mode. By rotating one of the camera dials we now have the ability to shift the program settings. Remember, your camera is using the internal meter to pick what it believes are suitable exposure values, but sometimes it doesn't know what it's looking at and how you want those values applied. With the program shift, you can influence what the shot will look like. Do you need faster shutter speeds in order to stop the action? Do you want a smaller aperture so that you get a narrow depth of field? Then rotate the dial until you get the desired camera settings. The camera shifts the shutter speed and aperture accordingly in order to get a proper exposure, and you will get the benefit of your choice as a result. That's something that most automatic modes just can't do.

STARTING POINTS FOR ISO SELECTION

There is a lot of discussion concerning ISO in this and other chapters, but it might be helpful if you know where your starting points should be for your ISO settings. The first thing you should always try to do is use the lowest possible ISO setting. That being said, here are good starting points for your ISO settings:

- 100: Bright sunny day
- 200: Hazy or outdoor shade on a sunny day
- 400: Indoor lighting at night or cloudy conditions outside
- 800: Late-night, low-light conditions or sporting arenas at night

These are just suggestions, and your ISO selection will depend on a number of factors that will be discussed later in the book. You might have to push your ISO even higher as needed, but at least now you know where to start.

SHUTTER PRIORITY MODE

Shutter Priority mode—most likely labeled as S or Tv (which stands for "time value") on your camera—prioritizes or places major emphasis on the shutter speed above all other camera settings.

Just as with Program mode, Shutter Priority gives you more freedom to control certain aspects of your photography. In this case, I'm talking about shutter speed. The selected shutter speed determines just how long you expose your camera's sensor to light. The longer it remains open, the more time your sensor has to gather light. The shutter speed also, to a large degree, determines how sharp your photographs are. This is different from the image being sharply in focus. One of the major influences on the sharpness of an image is just how sharp it is based on camera shake and the subject's movement. Because a slower shutter speed means that light from your subject is hitting the sensor for a longer period of time, any movement by you or your subject will show up in your photos as blur.

FAST AND SLOW SHUTTER SPEEDS

A *slow* shutter speed refers to leaving the shutter open for a long period of time—like 1/30 of a second or less. A *fast* shutter speed means that the shutter is open for a very short period of time—like 1/250 of a second or more.

WHEN TO USE SHUTTER PRIORITY MODE

- When working with fast-moving subjects where you want to freeze the action (**Figure 3.2**)
- When you want to emphasize movement in your subject with motion blur
- When you want to use a long exposure to gather light over a long period of time
- When you want to create that silky-looking water in a waterfall (**Figure 3.3**)

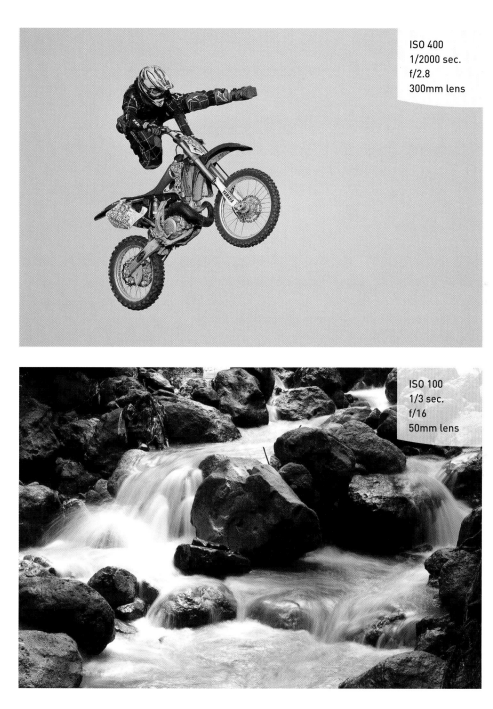

ISO 400
1/2000 sec.
f/2.8
300mm lens

FIGURE 3.2
When shutter speed is critical for stopping the action—like in this shot of a motocross jumper—using Shutter Priority mode is the only way to go.

ISO 100
1/3 sec.
f/16
50mm lens

FIGURE 3.3
To get that silky smooth look for running water, you need to use a tripod and a long shutter speed.

As you can see, the subject of your photo usually determines whether or not you will use Shutter Priority mode. It is important that you can pre-visualize the result of using a particular shutter speed. The great thing about shooting with digital cameras is that you get instant feedback by viewing your shot on the LCD screen. But what if your subject won't give you a do-over? Such is often the case when shooting sporting events. It's not like you can go ask the quarterback to throw that touchdown pass again because your last shot was blurry from a slow shutter speed. This is why it's important to know what those speeds represent in terms of their capabilities to stop the action and deliver a blur-free shot.

First, let's examine just how much control you actually have over the shutter speeds. Most digital SLRs have a shutter speed range from at least 1/4000 of a second all the way down to 30 seconds. With that much latitude, you should have enough control to capture almost any subject. The other thing to think about is that Shutter Priority is a "semi-automatic" mode. This means that you are taking control over one aspect of the total exposure while the camera handles the other. In this instance, you are controlling the shutter speed and the camera is controlling the aperture. This is important, because there will be times when you want to use a particular shutter speed but your lens aperture won't be able to accommodate your request.

For example, you might encounter this problem when shooting in low-light situations. If you are shooting a fast-moving subject that will blur at a shutter speed slower than 1/125 of a second and your lens's largest aperture is f/3.5, you might find your aperture display in your viewfinder or rear LCD panel displaying the word "Lo." This is your warning that there won't be enough light available for the shot—due to the limitations of the lens—so your picture will be underexposed.

Another case where you might run into this situation is when you are shooting moving water. To get that look of silky flowing water, it's usually necessary to use a shutter speed of at least 1/15 of a second. If your waterfall is in full sunlight, you may get a message that reads "Hi" because the lens you are using only stops down to f/22 at its smallest opening. In this instance, your camera is warning you that you will be overexposing your image. There are workarounds for these problems, which we will discuss later in the book, but it is important to know that there can be limitations when using the Shutter Priority mode.

APERTURE PRIORITY MODE

You wouldn't know it from its name, but Aperture Priority mode is one of the most useful and popular shooting modes. Aperture Priority mode is often labeled on your camera as A or Av (which stands for "aperture value" and, like "time value," is another term that you'll never hear a photographer toss around). The mode, however, is one of my personal favorites, and I believe that it will quickly become one of yours as well. Aperture Priority is also deemed a semi-automatic mode because it allows you to once again control one factor of exposure while the camera adjusts for the other.

Why, you may ask, is this one of my favorite modes? It's because the aperture of your lens dictates depth of field. Depth of field, along with composition, is a major factor in how you direct attention to what is important in your image. It is the controlling factor of how much area in your image is sharp. If you want to isolate a subject from the background, such as when shooting a portrait, you can use a large aperture. This will keep the focus on your subject and make both the foreground and background blurry. If your emphasis is keeping the entire scene sharply focused, such as with a landscape scene, try using a small aperture to render the greatest amount of depth of field possible.

WHEN TO USE APERTURE PRIORITY MODE

- When shooting portraits or wildlife (**Figure 3.4**)
- When shooting most landscape photography
- When shooting macro, or close-up, photography (**Figure 3.5**)
- When shooting architectural photography, which often benefits from a large depth of field

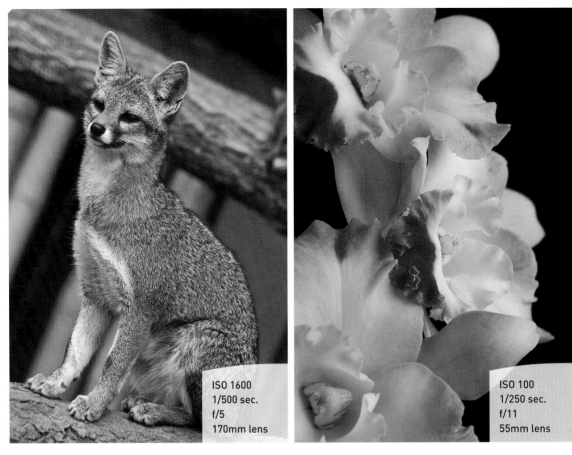

ISO 1600
1/500 sec.
f/5
170mm lens

ISO 100
1/250 sec.
f/11
55mm lens

FIGURE 3.4
To get the narrow depth of field for this shot, I set the camera to Aperture Priority and shot at f/5.

FIGURE 3.5
Shooting close-up shots means that you need a smaller aperture setting to get more sharpness.

So we have established that Aperture Priority mode is highly useful in controlling the depth of field in your image. But it's also pivotal in determining the limits of available light that you can shoot in. Different lenses have different maximum apertures. The larger the maximum aperture, or f-stop, the less light you need to achieve an acceptably sharp image. You will recall that, when in Shutter Priority mode, there is a limit at which you can handhold your camera without introducing movement or hand shake, which causes blurriness in the final picture. If your lens has a larger aperture, then you can let in more light all at once, which means that you can use faster shutter speeds. This is why lenses with large maximum apertures, such as f/1.4, are called "fast" lenses.

On the other hand, bright scenes require the use of a small aperture (such as f/16 or f/22), especially if you want to use a slower shutter speed. That small opening reduces the amount of incoming light, and this reduction of light requires that the shutter stay open longer.

MANUAL MODE

Once upon a time, long before digital cameras and program modes, there was manual mode. Only in those days it wasn't called "manual mode" because there were no other modes. It was just photography. In fact, many photographers cut their teeth on completely manual cameras. Let's face it: if you want to learn what the effects of aperture and shutter speed have on your photography, there is no better way to learn than by setting these adjustments yourself. However, today, with the advancement of camera technology, many new photographers never give this mode a second thought. That's truly a shame, as it is not only an excellent way to learn your photography basics, it's also an essential tool to have in your photographic bag of tricks.

When you have your camera set to Manual (M) mode, the camera meter will give you a reading of the scene you are photographing, but it's your job to actually set both the f-stop (aperture) and the shutter speed to achieve a correct exposure. If you need a faster shutter speed, you will have to make the reciprocal change to your f-stop. Using any other mode—such as Shutter Priority or Aperture Priority—would mean that you just have to worry about one of these changes, but Manual mode requires you to do it all yourself. This can be a little challenging at first, but after a while you will have a complete understanding of how each change affects your exposure, which will, in turn, improve the way that you use the other modes.

WHEN TO USE MANUAL MODE

- When learning how each exposure element interacts with the others
- When your environment is fooling your light meter and you need to maintain a certain exposure setting (**Figure 3.6**)
- When shooting silhouetted subjects, which requires overriding the camera's meter readings
- When working with lights in a studio setting (**Figure 3.7**)

FIGURE 3.6
Manual mode can help you get control over tricky lighting situations like this foggy sunset view of the California coast.

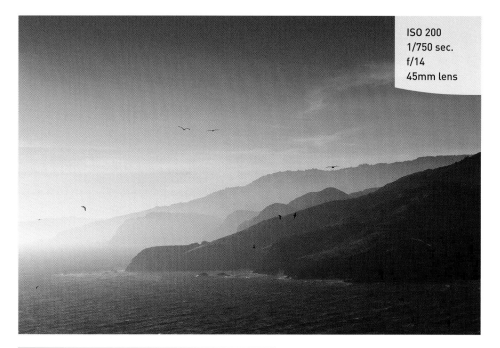

ISO 200
1/750 sec.
f/14
45mm lens

FIGURE 3.7
When working with studio lights I always set my camera to Manual mode and then make changes to my lights, not the camera.

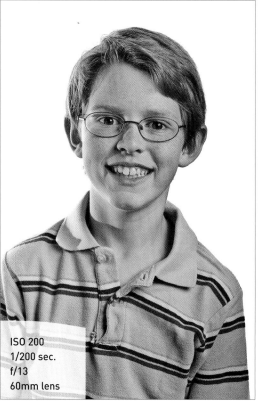

ISO 200
1/200 sec.
f/13
60mm lens

A FEW WORDS ABOUT AUTOMATIC MODES

If you are using a non-professional or semi-professional digital camera, chances are that it has some special automatic modes to help make your shooting decision-free. That's not necessarily a bad thing, especially if you want to just enjoy the moment and grab some casual photos. Most of the auto modes are scenario based, which means that you can just pick the type of shooting environment you are in and let the camera do all the work. Let's take a quick look at some of the more common modes that are found on most cameras.

FULL AUTO MODE

Full Auto mode is all about thought-free photography. There is little to nothing for you to do in this mode except point and shoot. Your biggest concern when using Full Auto mode is focusing. The camera will utilize the automatic focusing modes to achieve the best possible focus for your picture. Naturally, the camera is going to assume that the object that is closest to the camera is the one that you want to have the sharpest focus. Simply press the shutter button down halfway while looking through the viewfinder and you should see one of the focus points light up over the subject. Of course, you know that putting your subject in the middle of the picture is not the best way to compose your shot (right?). So wait for the camera to confirm that the focus has been set, and then, while still holding down the button, recompose your shot. Now just press down the shutter button the rest of the way to take the photo. It's just that easy (**Figure 3.8**). The camera will take care of all your exposure decisions, including when to use flash.

Let's face it: This is the lazy man's mode. But sometimes it's just nice to be lazy and click away without giving thought to anything but preserving a memory. There are times, though, when you will want to start using your camera's advanced features to improve your shots. Note: every camera is a little different, so be sure to read your owner's manual for any special information that you might need to consider when using the Full Auto mode.

FIGURE 3.8
Using Full Auto can be convenient if you are willing to give up total control of the image-making process.

ISO 400
1/1000 sec.
f/8
120mm lens

PORTRAIT MODE

One problem with Full Auto mode is that it has no idea what type of subject you are photographing and, therefore, uses the same settings for each situation. Shooting portraits is a perfect example. Typically, when you are taking a photograph of someone, you want the emphasis of the picture to be on the person, not necessarily on the stuff going on in the background.

This is what Portrait mode is for. When you set your camera to this mode, you are telling the camera to select a larger aperture so that the depth of field is much narrower and will give more blur to objects in the background. This blurry background places the attention on your subject (**Figure 3.9**). Along with aperture selection, most Portrait modes will use a customized picture style. This style is optimized for skin tones and will also be a little softer to improve the look of skin.

ISO 400
1/50 sec.
f/3.5
200mm lens

FIGURE 3.9
Portrait mode will set your camera up to get better people pics by using a large aperture for better background separation.

When using Portrait mode it's usually best to use a lens length that is 50mm or longer. The longer lens will give you a natural view of the subject, as well as aid in keeping the depth of field narrow.

LANDSCAPE MODE

As you might have guessed, Landscape mode has been optimized for shooting landscape images. In most cameras, emphasis is placed on using a Landscape style, with the camera trying to boost the greens and blues in the image (**Figure 3.10**). This makes sense, since the typical landscape would be outdoors where grass, trees, and skies should look more colorful. This style also boosts the sharpness that is applied during processing. The camera also utilizes the lowest ISO settings possible in order to keep digital noise to a minimum. The downfall to this setting is that, once again, your control is quite limited.

MACRO, OR CLOSE-UP, MODE

Although most zoom lenses don't support true "macro" settings, that doesn't mean you can't shoot some great close-up photos. The key here is to use your camera-to-subject distance to fill the frame while still being able to achieve sharp focus. This means that you move yourself as close as possible to your subject while still being able to get a good sharp focus. Oftentimes, your lens will be marked with the minimum focusing distance. For example, on a Canon EF-S 18–55mm zoom it is 0.8 feet. To help get the best focus in the picture, the Macro or Close-Up mode will use the smallest aperture it can while keeping the shutter speed fast enough to get a sharp shot (**Figure 3.11**). It does this by raising the ISO or turning on the built-in flash—or a combination of the two. Unfortunately, there is usually no way to turn off or alter these adjustments, so the possibility exists of getting more digital noise (from a high ISO) or harsh shadows (from the flash) in your picture.

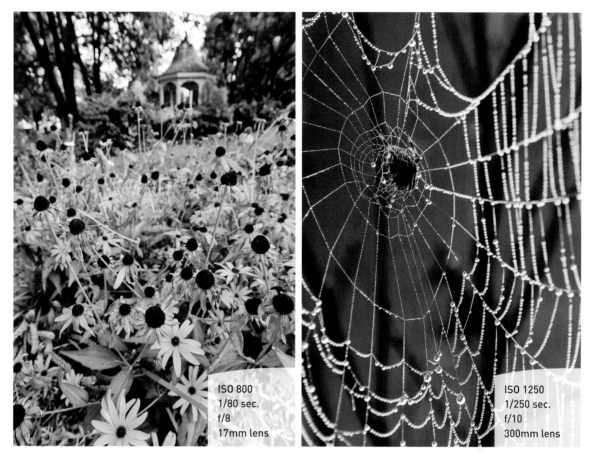

ISO 800
1/80 sec.
f/8
17mm lens

ISO 1250
1/250 sec.
f/10
300mm lens

FIGURE 3.10
This is the kind of scene that would really benefit from the use of the Landscape mode. The small aperture increases the depth of field and the colors are enhanced as well.

FIGURE 3.11
Close-up photos like this dew-covered spider can be enhanced by using the Macro shooting mode.

SPORTS MODE

The name of this mode is Sports, but you can use it for any moving subject that you are photographing. The mode is built on the principles of sports photography: continuous focusing, large apertures, and fast shutter speeds (**Figure 3.12**). To handle these requirements, the camera sets the drive mode to Continuous shooting, the aperture to a large opening, and the ISO to Auto. Overall, these can be sound settings that will capture most moving subjects well.

FIGURE 3.12
Large apertures and fast shutter speeds are requirements for great sport shots, which is one reason you might want to turn to the Sports mode.

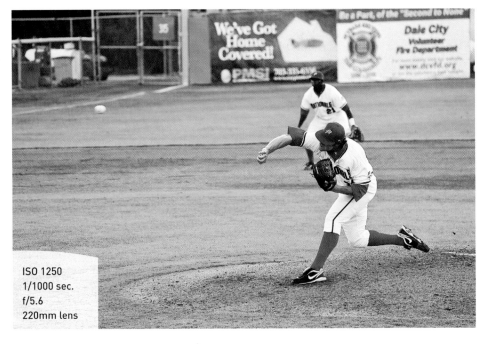

ISO 1250
1/1000 sec.
f/5.6
220mm lens

You can, however, run the risk of too much digital noise in your picture if the camera decides that you need a very high ISO (such as 1600). Also, when using Sports mode, the focus system will usually lock on to a subject and continue to focus on it until you release the shutter button—so composing can be a little more difficult. Depending on the camera you are using, you might be able to change the focus mode to something a little easier but chances are that's not the case.

NIGHT PORTRAIT MODE

You're out on the town at night and you want to take a nice picture of someone, but you want to show some of the interesting scenery in the background as well. You could use Full Auto mode, which would probably turn on the flash and take the photo. The problem is that, while it would give you a decent exposure for your subject, the background would be completely dark. The solution is to use Night Portrait mode. When you set the dial to this mode, you are telling the camera that you want to use a slower-than-normal shutter speed so that the background is getting more time (and, thus, more light) to achieve a proper exposure.

The typical shutter speed for using flash is about 1/60 of a second or faster (but not faster than 1/250 of a second). By leaving the shutter open for a longer duration, the camera allows more of the background to be exposed so that you get a much more balanced scene (**Figure 3.13**). This is also a great mode for taking portraits during sunset. Once again, the camera will typically use an automatic ISO setting, so you will want to keep an eye on it to make sure that setting isn't so high that the noise levels ruin your photo.

ISO 400
1/15 sec.
f/5.6
70mm lens

FIGURE 3.13
Night Portrait mode uses a slower shutter speed, higher ISO, and larger aperture to balance the background lights with the flash exposure.

WHY YOU MAY NEVER WANT TO USE THE AUTOMATIC MODES AGAIN

With so many easy-to-use camera modes, why would anyone ever want to use anything else? Well, the first thing that comes to my mind is control. It is the number one reason for using a digital SLR camera. The ability to control every aspect of your photography will open up creative avenues that just aren't available with the fully automatic modes. Here are a few of the things you might be giving up when using fully automatic modes:

- **ISO.** Most cameras offer no options in the automatic modes to change the ISO setting from the default Auto ISO setting. This will undoubtedly lead to unwanted digital noise in your images when the ISO begins to reach up into the higher settings.

- **Color space.** The default color space for automatic modes in most all cameras is sRGB, and there is usually no way to change it. This is the default color space for posting images on the Internet. If you plan on printing any of your pictures, the preferred yet unavailable setting would be Adobe RGB.

- **White balance.** There is no choice available for white balance. You are simply stuck with the Auto settings. This isn't always a bad thing, but your camera doesn't always get it right.

- **Auto focus.** Depending on the mode you have selected, there will probably be a specific focus mode selected as well. Typically the selected modes are appropriate for the type of subject—but not always. There are situations where one focus mode might be better than another, and fully automatic modes usually won't let you change.

- **Exposure compensation.** As you will see in later chapters, compensating for your camera's metered exposure is essential for creating better photographs. Unfortunately, most auto modes don't allow any changes to exposure so you are stuck with whatever the camera selects.

Chapter 3 Assignments

These assignments will have you shooting in the various modes—both automatic and semi-auto—so that you can experience the advantages and disadvantages of using them in your daily photography. This will be more of a mental challenge than anything else, but you should put a lot of work into these lesson assignments because the information covered in this chapter will define how you work with your camera from this point on. Granted, there may be times when you just want to grab some quick pictures and you'll resort to the automatic scene modes, but to get serious with your photography, you will want to learn the professional modes inside and out.

Checking out Portrait mode

Grab your favorite photogenic person and start shooting in Portrait mode. Try switching between Auto and Portrait mode while photographing the same person in the same setting. You should see a difference in the sharpness of the background as well as the skin tones. If you are using a zoom lens, set it to about 55mm if available.

Capturing the scenery with Landscape and Close-up modes

Take your camera outside for some landscape and macro work. First, find a nice scene and then, with your widest available lens, take some pictures using Landscape mode, then switch back to Auto so that you can compare the settings used for each image, as well as the changes to colors and sharpness. Now, while you are still outside, find something in the foreground—a leaf or a flower—and switch the camera to Close-up mode. See how close you can get and take note of the f-stop that the mode uses. Then switch to Auto and shoot the same subject.

Stopping the action with Sports mode

This assignment requires that you find a subject in motion. That could be the traffic in front of your home or your child at play. This is your opportunity to test out Sports mode. There isn't a lot to worry about here. Just point and shoot. Try shooting a few frames one at a time, then go ahead and hold down the shutter button and shoot a burst of about five or six frames. It will help if your subject is in good available light to start with so that the camera won't be forced to use high ISOs.

Learning to control time with the Shutter Priority mode

Find some moving subjects and then set your camera to S (or Tv) mode. Have someone ride their bike back and forth, or just photograph cars as they go by. Start with a slow shutter speed of around 1/30 of a second and then start shooting with faster and faster shutter speeds. Keep shooting until you can freeze the action. Now find something that isn't moving, like a flower, and start with shutter speed from something fast like 1/500 of a second, and then work your way down to slower shutter speeds. Don't brace the camera on a steady surface. Just try and shoot as slowly as possible, down to about 1/4 of a second. The point is to see how well you can handhold your camera before you start introducing hand shake into the image, making it appear soft and somewhat unfocused.

Controlling depth of field with the Aperture Priority mode

The name of the game with Aperture Priority mode is depth of field. Set up three items at different distances from you. I would use chess pieces or something similar. Now focus on the middle item and set your camera to the largest aperture that your lens allows (remember, large aperture means a small number like f/3.5). Now, while still focusing on the middle subject, start shooting with ever-smaller apertures until you are at the smallest f-stop for your lens. If you have a zoom lens, try doing this exercise with the lens at the widest and then the most telephoto settings. Now move up to subjects that are farther away, like telephone poles, and shoot them in the same way. The idea is to get a feel for how each aperture setting affects your depth of field.

Share your results with the book's Flickr group!

Join the group here: flickr.com/groups/exposure_fromsnapshotstogreatshots

4

ISO 200
1/125 sec.
f/5.6
50mm lens

See the Light

UNDERSTANDING THE PROPERTIES OF LIGHT AND HOW TO USE IT

Understanding light is one of the most important skills in photography, but it's also one of the most overlooked subjects. After all, light touches on every aspect of exposure, from ISO to lens aperture to shutter speed to white balance. It doesn't matter if you are working with natural or artificial light; in order to get great images, you need to have a basic understanding of not only the characteristics of light, but also how to take advantage of them.

PORING OVER THE PICTURE

Sometimes you just get a feeling that it's going to be one of those special shooting days, even before you take your camera out of the bag. That's the way I felt as my buddies, Scott and Dave, and I drove through the darkness of the Utah morning, making our way to the Monument Valley entrance. The sun had not quite risen but there was already an indication that the skies were going to be very favorable for us that morning. Even as the morning progressed, the late summer sun just seemed to hang low in the horizon and provided us with spectacular light for our photos.

I used a portion of the monolith on the left as an anchor for the frame.

The bright morning sun allowed me to use a low ISO for maximum quality.

I achieved depth in the image by composing it such that I have elements in the foreground, middle ground, and background of the scene.

A large vista like this just called out for a wide-angle lens.

ISO 100
1/180 sec.
f/7.1
24mm lens

PORING OVER THE PICTURE

With a couple of plane changes along the way, traveling to Malaysia took quite some time. One of these plane changes took place at the Singapore airport and included a very long layover. Instead of just finding some seat to crash in, I decided to take my camera and explore some of the great sites inside the airport, such as the orchid gardens. I came away with some great flower pics that I had never planned on capturing. It just goes to show that you should always keep your camera near and your options open.

A relatively large aperture provided nice separation of the flowers from the background.

The light levels in the building were very low so a high ISO was needed for good exposures.

Due to mixed light sources,
I created a custom white
balance for shooting in
this area of the airport.

I used the center-weighted
meter setting to place most of
the exposure emphasis on the
flowers in the middle.

ISO 5000
1/400 sec.
f/5.6
85mm lens

TYPES OF LIGHT

Before we start trying to use the light, we should take a look at the various types of light that you will deal with when making images. Knowing the type of light will help you control your white balance, but it will also give you an indication of the quality of the light.

DAYLIGHT

Because the sun passes through the Earth's atmosphere, you will find that daylight can be one of the most varied light sources you ever encounter. It can range in color temperature and intensity based on several factors. First off, there is the time of day that you are taking the photos; the color of light is very different at sunrise than it is at mid-day. There is also a difference in the intensity of the light. Mid-day sun can be very harsh, creating hard-edged shadows (**Figure 4.1**). The shadows that occur after sunrise and before sunset are usually longer and add more definition, especially to a landscape (**Figure 4.2**).

FIGURE 4.1
The mid-day sun can be some of the harshest and most direct light to shoot in, but sometimes it is your only option.

ISO 100
1/180 sec.
f/7.1
24mm lens

ISO 100
1/180 sec.
f/7.1
24mm lens

FIGURE 4.2
Sunrise, with the light coming in low from the horizon, provides some beautiful light across the
landscape.

This can also lead to extreme exposure variances between light and dark areas. This
is known as *contrast*. Having a lot of contrast means that you will often have to
compromise your exposure in some way or another. If you shoot just before sunrise or
just after sunset, you can capture beautiful light without all the really dark shadows
(**Figure 4.3**).

FIGURE 4.3
The long shadows
and warm light of
sunset help add
depth to the scene.

ISO 200
1/60 sec.
f/5.6
55mm lens

One of my favorite times to shoot outdoors is during overcast conditions. Actually, let me clarify. If I am shooting landscape images that will include the sky, overcast is not my favorite, but if I'm shooting a portrait or anything else during the day, it will most likely look better under a little cloud cover. This is because the cloud layer is acting like a large diffuser, which spreads out the sunlight and produces much softer shadows and less contrast in the image (**Figure 4.4**).

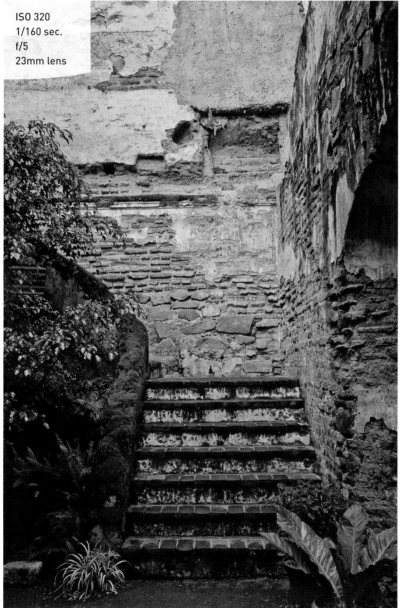

ISO 320
1/160 sec.
f/5
23mm lens

FIGURE 4.4
An overcast sky will help to soften shadows.

FLUORESCENT

With more and more people turning from wasteful incandescent light bulbs to the more energy-efficient fluorescent option, it is more likely than not that you will be shooting under this light source. It used to be that fluorescent bulbs would give off a cool, greenish color cast but now you can find fluorescent bulbs that are balanced for daylight for the home or even for use in a photo studio. As a light source in general, fluorescent bulbs are not that bad to shoot with. They offer a nice bright light that is fairly diffuse, which means lower contrast (**Figure 4.5**). The one thing you will want to do when using them is to either use the Fluorescent white balance setting on your camera or create a custom white balance setting. Creating a custom white balance is probably the best approach, because the color temperature of the bulb can vary greatly depending on whether or not it is daylight-balanced.

FIGURE 4.5
With the proper white balance, you can get some nice, even lighting from a fluorescent light source.

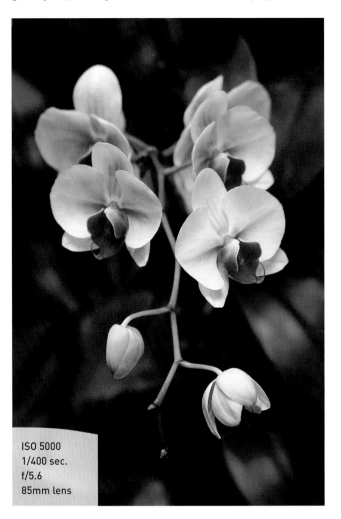

ISO 5000
1/400 sec.
f/5.6
85mm lens

INCANDESCENT

When shooting under incandescent lighting, you will find that the light has an orange-yellow color cast. It can also be a much harsher light source since most of the light is emanating from a small point (the bulb). Of course, shooting with the correct white balance is the easiest way to overcome the color issues. Just be sure to preview your results (**Figure 4.6**).

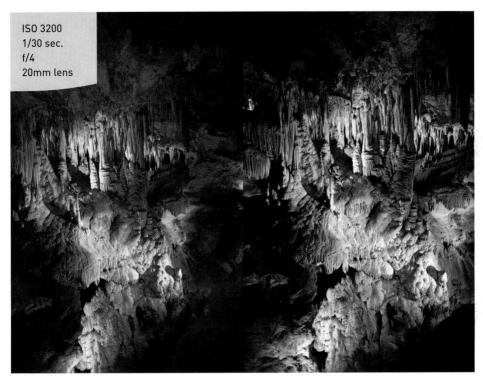

ISO 3200
1/30 sec.
f/4
20mm lens

FIGURE 4.6
Notice the warm orange color cast on the left that comes from the incandescent lighting. By selecting a Tungsten white balance I was able to capture more accurate colors in the rock formations.

FLASH

We will cover flash more extensively in Chapter 8, but I think it's important to mention here. Flash can be a photographer's best friend because it is a reliable, predictable, controllable light source that is very close in color temperature to daylight. This means that it can be used to fill in shadows while shooting in daylight conditions without worrying about mixing different color temperatures. The same can't be said for most of the other artificial light sources (with the exception of daylight-balanced fluorescents).

Flash can also be made to take on different characteristics, which can make the quality of light either very harsh and contrasty, or very soft and flat. This can be done through

the use of diffusion materials or other methods to create a larger apparent light source (such as shooting your flash through a diffuser or a softbox). You can also color the light coming from a flash using gels, which allows you to match another light source's color or create a special effect (**Figure 4.7**).

FIGURE 4.7
A flash fired through a softbox close to the subject provides the main light for this image. Another flash is used to provide "fill light," which lightens the shadows on the left side of his face. Finally, a small flash with a blue gel is used to illuminate the background.

ISO 200
1/250 sec.
f/4.5
85mm lens

QUALITY OF LIGHT

When speaking about the quality of any particular light, we usually talk in terms of "hard light"—which usually is coming from a small, single spot or source—and "soft light," which is more diffuse and seems to come from multiple directions.

HARD LIGHT

Examples of hard light might be the sun, which is a small light source that creates hard light and shadows, or a flash that is pointed directly at your subject without passing through any diffusion material. Hard light is usually very directional and, due to this fact, the shadows that are created by it are very hard-edged. Another characteristic of hard light is that there are very few midtone values separating the highlights from the shadows (**Figure 4.8**).

FIGURE 4.8
Mid-day sun is a perfect example of hard, directional light that creates dark shadows and lots of contrast.

ISO 400
1/500 sec.
f/11
66mm lens

SOFT LIGHT

An overcast day is a perfect example of soft light, where the sun has to penetrate through a cloud layer. The cloud is spreading the light, making it come from multiple angles instead of a small, single point. This is also called diffusion; the light spreads out and creates much softer shadows. (It may actually appear to eliminate shadows altogether.) It also helps to create much more defined midtones because there is a smoother transition from the bright to dark areas (**Figure 4.9**).

FIGURE 4.9
An overcast sky creates a soft, multi-directional light that creates a lot of smooth tones and no hard-edged shadows.

ISO 400
1/2500 sec.
f/4
280mm lens

The smaller a light source is in comparison to the subject, the harder the light will be. That means that a small flash head or even the sun will create dark shadows and lots of contrast. If you want to soften things up a bit, try making the light source larger. You can accomplish this by diffusing the light by passing it through a translucent material, or perhaps by using an umbrella. If you are using a flash on your camera, try bouncing it off a wall or ceiling. Before the light reaches your subject, it will hit that surface and spread out, making it bigger and therefore softer.

For outside solutions, try working in open shade or even overcast conditions. Shade and clouds disperse direct sunlight, making the light fall on your subject from all over, not just from one direction. This is the same as having a larger light source.

DIRECTION OF LIGHT

Light not only has the characteristics of being harder or softer, diffuse or sharp, but it also has a directional quality that you can use to enhance or your subject and, therefore, your images. There are typically three directions that we look at when discussing the direction of light.

FRONT LIGHTING

Front lighting typically comes from a source that is behind the photographer and shining directly onto the subject. One of the characteristics of this type of lighting is that it tends to flatten out your subject. It's kind of like putting your subject on a copy machine where everything is evenly illuminated. It does, however, offer a very well lit and defined subject (**Figure 4.10**).

SIDE LIGHTING

If you really want to define the three-dimensional characteristics of your subject, the best possible light to use as a main light is side lighting. Side lighting will enhance any contour detail by creating shadows and highlights, giving a three-dimensional quality to the scene. This is why a lot of portrait lighting or landscape lighting is done with the light coming from a side direction (**Figure 4.11**).

FIGURE 4.10
When the light is coming from directly in front of the subject, there is less shadow and a flattening of details.

ISO 400
1/2500 sec.
f/4
280mm lens

FIGURE 4.11
The late afternoon sun was crossing in from the right of the frame, creating shadows and highlights that define the contours of the landscape.

ISO 3200
1/500 sec.
f/3.5
24mm lens

BACK LIGHTING

The best light to use for separating your subject from a background is, of course, back light. Unfortunately, back lighting provides little illumination on the front of your subject—which is what your camera is pointing at—but it does an excellent job of separating the subject from the background and giving a three-dimensional feeling to the shot.

Usually, a back lighting technique is used to enhance a silhouette or to provide a little separation in combination with other light sources. Typically, I'll use this kind of light if I'm shooting a person in bright daylight. I might actually put the sun behind them, then use a flash to fill in the shadows on the subject's face. That way, I have my separation using the back light from the sun, and I have an excellent light coming from my camera angle to define the face. Best of all, I don't have bright sunlight shining into my subject's eyes and making him squint. I get the best of all the characteristics of direction and quality of light (**Figure 4.12**).

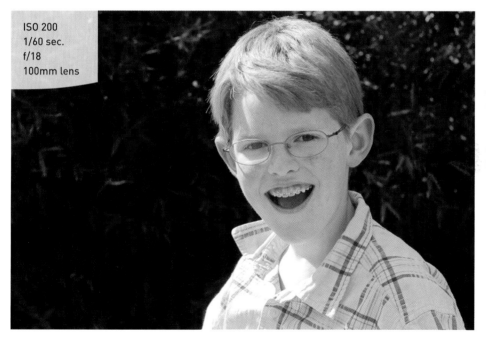

ISO 200
1/60 sec.
f/18
100mm lens

FIGURE 4.12
By positioning myself so that the bright sun is behind my subject, I can get a good rim of light to separate him from the background while using a flash to brighten his face.

Chapter 4 Assignments

Now that you know what light looks like in photographic terms, it's time to start looking for those different qualities of light and discovering how they apply to your photography.

The color of light

Set you camera's white balance to Daylight and try shooting in as many different light sources as possible. Compare the results so that you get a good idea of the qualities of each type of light source.

Hard vs. soft

Find a willing volunteer, have them stand out in the direct sun, and take their picture. Then look for a shady spot and take another. Compare the quality of the light from both photos.

Directional light

As long as you have a volunteer hanging around, have them stand facing the sun and take a shot. Next, have them turn so that the light is coming from the side and take another shot. Finally, have them turn so the sun is at their back. Of course, you will need to rotate your position as well to take advantage of the different directional light.

Share your results with the book's Flickr group!

Join the group here: flickr.com/groups/exposure_fromsnapshotstogreatshots

5

ISO 200
1/1250 sec.
f/5.6
300mm lens

On the Move

THE TRICKS TO SHOOTING SPORTS AND MORE

The past few chapters have been all about shutter speed, f-stop, ISO, and the other elements of exposure. Now let's take a look at how we can apply them to some different situations. In this chapter, we will explore how to get the most from your camera when it comes to taking action and sports photos. There's a lot to learn when it comes to stopping the action or conveying movement, so let's jump in.

PORING OVER THE PICTURE

Usually when I shoot the motocross events at my county fair, I concentrate on the jumping aspects. This past year, though, I thought I would add some different images of the riders aside from their mid-air acrobatics. One technique that I wanted to try out was panning. So as the riders were getting introduced to the crowd and making their first ride across the arena floor, I set up my camera with a slow shutter speed and practiced panning to convey a sense of motion.

Shooting sports under the lights requires high ISO values, even though it looks like there's enough light.

A successful pan shot usually involves several test runs to find just the right shutter speed.

I used a monopod to steady
the camera during panning.
This helps eliminate any
up and down motion and
provides a good pivot-point
for the camera.

Several shots were taken
using the Continuous shooting
mode while following the rider
with the lens.

ISO 2000
1/25 sec.
f/10
125mm lens

PORING OVER THE PICTURE

A couple of years back I had the fortunate experience of shooting the International Gold Cup races from the infield. This gave me a chance to get up close and personal with the racing action as the horses and riders made their way across the course. It also meant that I could get some great close-up images without having to use extremely long telephoto lenses.

The large aperture helped to blur some of the crowd in the background.

ISO 400
1/4000 sec.
f/2.8
200mm lens

I used the Shutter Priority mode to ensure that I had the fastest shutter speed possible.

To keep things in focus, I shot in the Continuous shooting mode using Continuous auto-focus.

I composed the image with the horse to the right of the frame so his motion had a directional flow.

STOP RIGHT THERE!

If you are going to be proficient at capturing moving subjects, then you are going to have to make friends with the shutter speed dial. Shutter speed is the main tool in the photographer's arsenal for capturing great action shots. The ability to freeze a moment in time often makes the difference between a good shot and a great one. To make the most of the relationship between shutter speed and movement, you will need to develop an understanding of how the speed of the shutter affects your image. When you press the shutter release button, your camera goes into action by opening the shutter curtain and then closing it after a predetermined length of time. The longer you leave your shutter open, the more your subject will move across the frame, so common sense dictates that the first thing to consider is just how fast your subject is moving. If you are taking a picture of a mountain, you really don't need to concern yourself with whether or not the mountain is going to move during your exposure. If, however, you are taking a picture of a bird that is soaring in front of a mountain, you will need to consider just how fast that bird is flying and how long your shutter can be open if you don't want it to appear as a mere blur in your final image. Typically, when you are shooting, you will be working in fractions of a second. Just how long those fractions are depends on several factors. Subject movement, while simple in concept, is actually based on three factors. The first is the direction of travel. Is the subject moving across your field of view (left to right) or traveling toward or away from you? The second consideration is the actual speed at which the subject is moving. There is a big difference between a moving sports car and a child on a bicycle. Finally, the distance from you to the subject has a direct bearing on how fast the action seems to be taking place and how quickly it moves across your field of view. Let's take a brief look at each of these factors to see how they might affect your shooting.

DIRECTION OF TRAVEL

Typically, the first thing that people think about when taking an action shot is how fast the subject is moving, but in reality the first consideration should be the direction of travel. Where you are positioned in relation to the subject's direction of travel is critically important in selecting the proper shutter speed. When you open your shutter, the lens gathers light from your subject and records it on the camera sensor. If the subject is moving across your viewfinder, you need a faster shutter speed to keep that lateral movement from being recorded as a streak across your image. Subjects that are moving towards or away from your shooting location do not move across your viewfinder and appear to be more stationary. This allows you to use a slightly slower shutter speed. A subject that is moving in a diagonal direction—both across the frame and toward or away from you—requires a shutter speed in between the two (**Figure 5.1**).

ISO 100
1/320 sec.
f/9
70mm lens

FIGURE 5.1
Action coming toward the camera at an angle can be captured with slower shutter speeds than action moving perpendicular to your position.

SUBJECT SPEED

Once the angle of motion has been determined, you can then assess the speed at which the subject is traveling. The faster your subject moves, the faster your shutter speed needs to be in order to "freeze" that subject (**Figure 5.2**). A person walking across your frame might only require a shutter speed of 1/60 of a second, while a cyclist traveling in the same direction would call for 1/500 of a second. That same cyclist traveling toward you at the same rate of speed, rather than across the frame, might only require a shutter speed of 1/125 of a second. You can start to see how the relationship of speed and direction comes into play in your decision-making process.

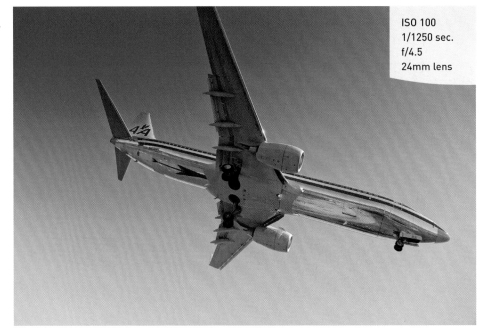

ISO 100
1/1250 sec.
f/4.5
24mm lens

SUBJECT-TO-CAMERA DISTANCE

So now we know both the direction and the speed of your subject. The final factor to address is the distance between you and the action. Picture yourself looking at a highway full of cars from up in a tall building a quarter of a mile from the road. As you stare down at the traffic moving along at 55 miles per hour, the cars and trucks seem to be slowly moving along the roadway. Now picture yourself standing in the median of that same road as the same traffic flies by at the same rate of speed.

Although the traffic is moving at the same speed, the shorter distance between you and the traffic makes the cars look like they are moving much faster. This is because your field of view is much narrower; therefore, the subjects are not going to present themselves within the frame for the same length of time. The concept of distance applies to the length of your lens as well (**Figure 5.3**). If you are using a wide-angle lens, you can probably get away with a slower shutter speed than if you were using a telephoto, which puts you in the heart of the action. It all has to do with your field of view. That telephoto gets you "closer" to the action—and the closer you are, the faster your subject will be moving across your viewfinder.

ISO 100
1/400 sec.
f/5
270mm lens

FIGURE 5.3
Due to the distance from the camera, a slower shutter speed could be used to capture this action.

USING SHUTTER PRIORITY MODE TO STOP MOTION

In Chapter 3, you were introduced to the shooting modes. You'll remember that the mode that gives you ultimate control over shutter speed is Shutter Priority mode (labeled as S or Tv, depending on which camera system you are using). In Shutter Priority mode, you are responsible for selecting the shutter speed while handing over the aperture selection to the camera. The ability to concentrate on just one exposure factor helps you quickly make changes on the fly while staying glued to your viewfinder and your subject.

There are a couple of things to consider when using Shutter Priority mode, both of which have to do with the amount of light that is available when shooting. While you have control over which shutter speed you select in Shutter Priority mode, the range of shutter speeds that is available to you depends largely on how well your subject is lit.

Typically, when shooting fast-paced action, you will be working with very fast shutter speeds. This means that your lens will probably be set to its largest aperture. If the light is not sufficient for the shutter speed selected, you will need to do one of two things: select a lens that offers a larger working aperture, or more likely, raise the ISO of the camera. Working off the assumption that you have only one lens available, let's concentrate on balancing your exposure using the ISO.

ZOOM IN TO BE SURE

When reviewing your shots on the LCD, don't be fooled by the display. The smaller your image is, the sharper it will look. To ensure that you are getting sharp, blur-free images, make sure that you zoom in on your LCD display (**Figure 5.4**).

FIGURE 5.4
Zooming in on your image helps you confirm that the image is really sharp.

Playback

Zoom In

Let's say that you are shooting a baseball game at night, and you want to get some great action shots. You set your camera to Shutter Priority mode and, after testing out some shutter speeds, determine that you need to shoot at 1/500 of a second to freeze the action on the field. When you place the viewfinder to your eye and press the shutter button halfway, you might notice that the f-stop has been replaced by the word "Lo" or some other type of warning in viewfinder. This is your camera's way of telling you that the lens has now reached its maximum aperture and you are going to be underexposed if you shoot your pictures at the currently selected shutter speed. You could slow your shutter speed down until the warning goes away, but then you might get images with too much motion blur.

The alternative is to raise your ISO to a level that is high enough for a proper exposure. The key here is to always use the lowest ISO that you can get away with. That might mean ISO 100 in bright sunny conditions or ISO 6400 for an indoor or night situation (**Figure 5.5**). Just remember that the higher the ISO, the greater the amount of noise in your image. This is the reason that you see professional sports photographers using those mammoth lenses perched atop a monopod: they could use a smaller lens, but to get those very large apertures they need a huge piece of glass on the front of the lens. The larger the glass on the front of the lens, the more light it gathers, and the larger the aperture for shooting. For the working pro, the large aperture translates into low ISO (and thus low noise), fast shutter speeds, and razor-sharp action.

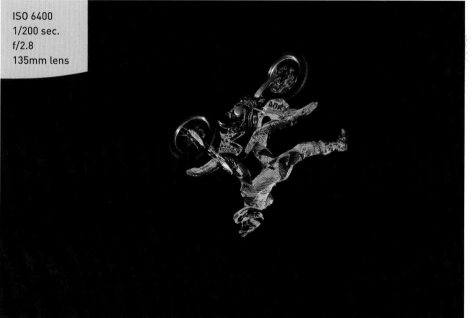

ISO 6400
1/200 sec.
f/2.8
135mm lens

FIGURE 5.5
Sometimes the only way to stop action under the lights is to crank up your ISO.

USING APERTURE PRIORITY MODE TO ISOLATE YOUR SUBJECT

One of the benefits of working in Shutter Priority mode with fast shutter speeds is that, more often than not, you will be shooting with the largest aperture available on your lens. Shooting with a large aperture allows you to use faster shutter speeds, but it also narrows your depth of field.

To isolate your subject in order to focus your viewer's attention on it, a large aperture is required. The larger aperture reduces the foreground and background sharpness: the larger the aperture, the more blurred they will be.

The reason that I bring this up here is that when you are shooting most sporting events, the idea is to isolate your main subject by having it in focus while the rest of the image has some amount of blur. This sharp focus draws your viewer right to the subject. Studies have shown that the eye is drawn to sharp areas before moving on to the blurry areas. Also, depending on what your subject matter is, there can be a tendency to get distracted by a busy background if everything in the photo is equally sharp. Without a narrow depth of field, it might be difficult for the viewer to establish exactly what the main subject is in your picture.

Let's look at how to use depth of field to bring focus to your subject. In the previous section, I told you that you should use Shutter Priority mode for getting those really fast shutter speeds to stop action. Generally speaking, Shutter Priority will be the mode you most often use for shooting sports and other action, but there will be times when you want to ensure that you are getting the narrowest depth of field possible in your image. The way to do this is by using Aperture Priority mode (labeled as A or Av, depending on which camera you own).

So how do you know when you should use Aperture Priority mode as opposed to Shutter Priority mode? It's not a simple answer, but your LCD screen can help you make this determination. The best scenario for using Aperture Priority is a brightly lit scene where maximum apertures will still give you plenty of shutter speed to stop the action.

Let's say that you are shooting a soccer game in the midday sun. If you have determined that you need something between 1/500 and 1/1250 of a second for stopping the action, you could just set your camera to a high shutter speed in Shutter Priority mode and just start shooting. But you also want to be using an aperture of, say, f/4.5 to get that narrow depth of field. Here's the problem: if you set your camera to Shutter Priority mode and select 1/1000 of a second as a nice compromise, you might get that desired f/stop—but you might not. As the meter is trained on your moving subject, the light levels could rise or fall, which might actually change that desired f-stop to something higher like f/5.6 or even f/8. Now the depth of field is extended, and you will no longer get that nice isolation and separation that you wanted.

To rectify this, switch the camera to Aperture Priority mode and select f/4.5 as your aperture. Now, as you begin shooting, the camera holds that aperture and makes exposure adjustments with the shutter speed. As I said before, this works well when you have lots of light—enough light so that you can have a high-enough shutter speed without introducing motion blur.

USING AUTO ISO THE RIGHT WAY

You might recall earlier in the book where I said that Auto ISO is a bad thing and that it should be turned off. Well, that's not always the truth. Sometimes you will need to use the ISO to get a specific result—and by utilizing Auto ISO, you can make life just a little easier. Here's what I mean.

While shooting a sporting event, you determine that the shutter speed you want to work with to freeze motion is 1/1000 of a second. And let's say you want to use your largest aperture to help blur the background. The problem is that it's a partly cloudy day and the sun keeps moving in and out of the clouds, making it difficult to shoot with your desired settings without having to constantly make changes to those settings. Here's the solution: set your camera to the Manual mode and then dial in the appropriate shutter speed and aperture settings. Then set your ISO to Auto. Now, whenever there is a change in the light, the camera will adjust the ISO by small increments to adjust for the changing light. This will allow you to keep your camera set to the desired aperture and shutter speed.

Let's look at **Figure 5.6** to see what I mean. The motocross jumping event didn't begin until sometime around 7:30 in the evening, so as I began to shoot, the light levels started to fall. I knew that I wanted to have my 70-200mm f/2.8 lens opened to its largest aperture setting and my shutter speed needed to be at least 1/200 of a second to stop the action at the apex of the jumps. I could have used a different shooting mode but I would have needed to constantly readjust my ISO as the light levels dropped. Instead, I set the ISO to Auto so that it would always give me just the right sensitivity as the light levels changed. Once the sun was completely down, I just set it on ISO 6400 because I knew that the light level would be constant from that point on.

FIGURE 5.6
By letting the camera choose an appropriate ISO, I can ensure that I have the aperture and shutter speed that is appropriate for my subject.

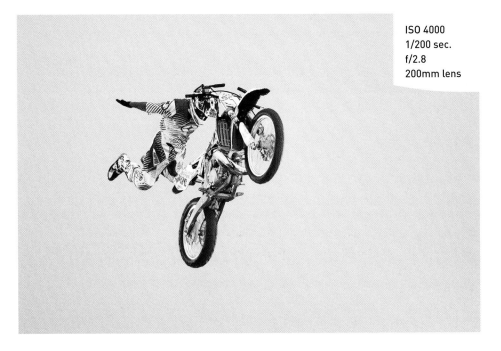

ISO 4000
1/200 sec.
f/2.8
200mm lens

KEEP THEM IN FOCUS WITH CONTINUOUS FOCUS AND FOCUS POINT SELECTION

With the exposure issue handled for the moment, let's move on to an area that is equally important: focusing. Most modern digital SLR cameras have multiple focus modes to choose from. They all have different names but they pretty much do the same thing. In order to get the greatest benefit from each of them, though, it is important to understand how they work and the situations where each mode will give you the best opportunity to grab a great shot. Because we are discussing subject movement, our first choice is going to be the Continuous focus mode. Continuous focus modes generally lock in the focus when the shutter button is halfway depressed and then continue to adjust focus on the subject until you completely depress the shutter button.

Depending on your camera, you might have a couple of options to choose from when using a Continuous focus mode. Canon users might want to use the AI-Servo mode, whereas Nikon users would select AF-C.

The other focusing option to consider is the focus point selection (**Figure 5.7**). While the focus mode addresses *how* the camera focuses, the focus point is about *what* the camera is focusing on. Most cameras will allow you to choose between a single focus point and a more dynamic auto-point system. When using Continuous focusing, the point selection method you choose will be dependent on the type of subject that you are photographing. If it is a single subject that is going to remain in one area of the viewfinder you will probably have great success with the single point selection (**Figure 5.8**), but if you are trying to track movement that is unpredictable and might move around the viewfinder, you should definitely practice using the auto-point feature (**Figure 5.9**).

FIGURE 5.7
The focus points from a Canon T2i.

FIGURE 5.8
A large singular subject like this fighter jet was easy to track using a single focus point and Continuous focus.

ISO 200
1/1000 sec.
f/5.6
300mm lens

FIGURE 5.9
Tracking this horse and rider was made easier by utilizing an auto-point selection paired with Continuous focus.

ISO 1600
1/500 sec.
f/2.8
300mm lens

MANUAL FOCUS FOR ANTICIPATED ACTION

While I utilize the automatic focus modes for the majority of my shooting, there are times when I like to fall back on manual focus. This is usually when I know when and where the action will occur and I want to capture the subject as it crosses a certain plane of focus. This is useful in sports like motocross or auto racing, where the subjects are on a defined track and I know exactly where I want to capture the action. I could try tracking the subject, but sometimes the view can be obscured by a curve. By pre-focusing the camera, all I have to do is wait for the subject to approach my point of focus and then start firing the camera.

Take a look at **Figure 5.10**. The riders in the barrel races were guiding their horses around three barrels and then racing back to the finish line. The lighting in the arena was spotty at best and the horses and riders were passing from bright conditions to almost dark shadows. This made exposures and focusing quite difficult. Instead, I chose a point on the course where I knew the riders would come to as they circled the barrel. I used the single focus point method to focus on the exact spot that I wanted and then switched the lens to manual focus. I also determined the proper exposure and set this in Manual shooting mode. Now all I had to do was wait for horse and rider to enter my target zone and take my shot.

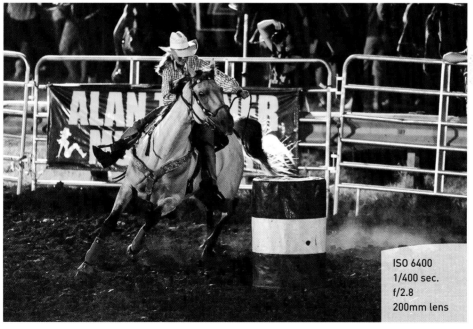

FIGURE 5.10
Pre-focus the camera to a point where you know the subject will be and start shooting right before they get there.

ISO 6400
1/400 sec.
f/2.8
200mm lens

A SENSE OF MOTION

Shooting action isn't always about freezing the action. There are times when you want to convey a sense of motion so that the viewer can get a feel for the movement and flow of an event. Two techniques you can use to achieve this effect are panning and motion blur.

PANNING

Panning has been used for decades to capture the speed of a moving object as it moves across the frame. It doesn't work well for subjects that are moving toward or away from you. Panning is achieved by following your subject across your frame, moving your camera along with the subject, and using a slower-than-normal shutter speed so that the background (and sometimes even a bit of the subject) has a sideways blur but the main portion of your subject is sharp and blur-free. The key to a great panning shot is selecting the right shutter speed: too fast and you won't get the desired blurring of the background; too slow and the subject will have too much blur and will not be recognizable. Practice the technique until you can achieve a smooth motion with your camera that follows along with your subject. The other thing to remember when panning is to follow through even after the shutter has closed. This will keep the motion smooth and give you better images.

In **Figure 5.12**, I used the panning technique to follow this motocross rider as he rode his wheelie in front of me. I set the camera to the Continuous shooting mode, and I used Shutter Priority mode to select a shutter speed of 1/25 of a second while the focus mode was on Continuous-AF. Even though my aperture was f/10, I knew that the panning motion would blur my background.

MOTION BLUR

Another way to let the viewer in on the feel of the action is to simply include some blur in the image. This isn't accidental blur from choosing the wrong shutter speed. This blur is more exaggerated, and it tells a story. In **Figure 5.13**, I was standing next to a bike trail by the Potomac River one day, just watching the riders go by. I could have taken a shot with a nice fast shutter speed and frozen them in their tracks. Instead I chose to slow down the shutter speed and let their motion tell part of the story.

Just as in panning, there is no preordained shutter speed to use for this effect. It is simply a matter of trial and error until you have a look that conveys the action. I try to get some area of the subject or scene that is frozen. The key to this technique is the correct shutter speed combined with keeping the camera still during the

exposure. You are trying to capture the motion of the subject, not the photographer or the camera, so use a good shooting stance or even a tripod.

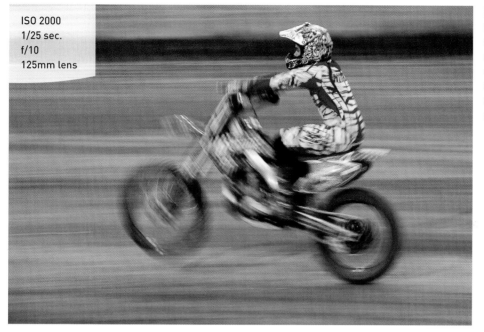

ISO 2000
1/25 sec.
f/10
125mm lens

FIGURE 5.12
Following the subject as it moves across the field of view allows for a slower shutter speed and adds a sense of motion.

ISO 100
1/30 sec.
f/20
70mm lens

FIGURE 5.13
The movement of the riders coupled with the slow shutter speed convey movement as they pass each other on the path.

TIPS FOR SHOOTING ACTION

GIVE THEM SOMEWHERE TO GO

Whether you are shooting something as simple as your child's soccer match or as complex as the aerial acrobatics of a motorcycle jumper, where you place the subject in the frame is equally as important as how well you expose the image. A poorly composed shot can completely ruin a great moment by not holding the viewer's attention.

The one mistake I see many times in action photography is that the photographer doesn't use the frame properly. If you are dealing with a subject that is moving horizontally across your field of view, give the subject somewhere to go by placing them to the side of the frame, with their motion leading toward the middle of the frame (**Figure 5.14**). This offsetting of the subject will introduce a sense of direction and anticipation for the viewer. Unless you are going to completely fill the image with the action, try to avoid placing your subject in the middle of the frame.

FIGURE 5.14
Try to leave space in front of your subject to lead the action in a direction.

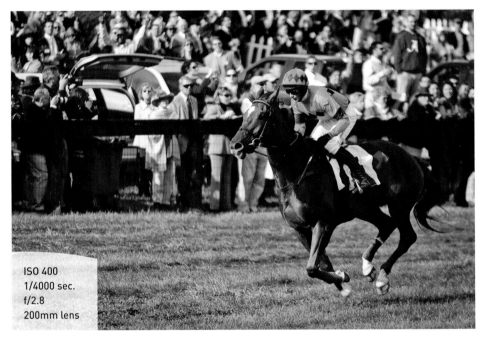

ISO 400
1/4000 sec.
f/2.8
200mm lens

GET IN FRONT OF THE ACTION

Here's another one. When shooting action, show the action coming toward you (**Figure 5.15**). Don't shoot the action going away from you. People want to see faces. Faces convey the action, the drive, the sense of urgency, and the emotion of the moment. So if you are shooting action involving people, always position yourself so that the action is either coming at you or is at least perpendicular to your position.

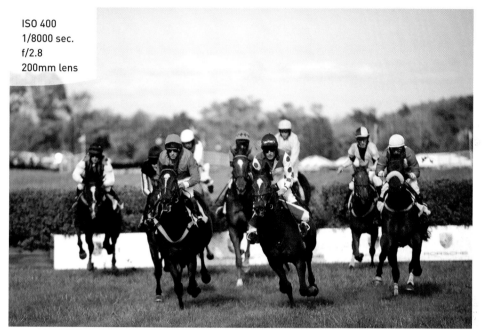

ISO 400
1/8000 sec.
f/2.8
200mm lens

FIGURE 5.15
Try to position yourself so that the action is coming at you face-first.

SHOOT IN MANUAL TO LOCK IN YOUR EXPOSURE

Aperture Priority and Shutter Priority modes are great, but sometimes it pays to just do things yourself. If you find yourself shooting in an environment where the action is moving across backgrounds that will play havoc with your meter readings, you might just do better at setting up your shot in Manual mode.

The image in **Figure 5.16** was one that I got after doing some trial and error in Manual mode.

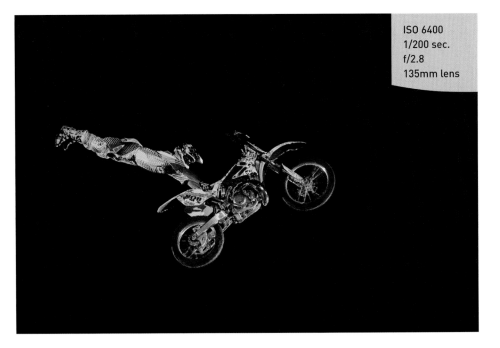

FIGURE 5.16
To keep the dark background from influencing the exposure, I used the Manual shooting mode.

ISO 6400
1/200 sec.
f/2.8
135mm lens

The sun had gone down completely for the evening so the only light left was coming from the big spotlights that were illuminating the outdoor area. I was originally set up in Shutter Priority mode, but the darkness of the sky kept fooling the camera into trying to overexpose the images. I knew that my light source would not be changing for the rest of the night, so all I had to do was nail the right exposure using Manual mode and then concentrate on capturing the action.

Chapter 5 Assignments

The mechanics of motion

For this first assignment, you need to find some action. Explore the relationship between the speed of an object and its direction of travel. Use the same shutter speed to record your subject moving toward you and across your view. Try using the same shutter speed for both to compare the difference made by the direction of travel.

Wide vs. telephoto

Just as with the first assignment, photograph a subject moving in different directions, but this time, use a wide-angle lens and then a telephoto. Check out how the telephoto setting on the zoom lens will require faster shutter speeds than the lens at its wide-angle setting.

Getting a feel for focusing modes

Probably one of the most important aspects of shooting action is learning how to use the focus modes properly so that you always get tack-sharp images. Experiment using the single and Continuous auto focus modes. Then pair them with the different focus point selection modes so that you feel confident that you know how they work and which is the best choice for the type of subject you want to shoot.

Anticipating the spot using manual focus

For this assignment, you will need to find a subject that you know will cross a specific line that you can pre-focus on. A street with moderate traffic works well for this. Focus on a spot on the street that the cars will travel across (don't forget to set your lens for manual focus). To do this right, you need to set the camera the Continuous shooting mode. Now, when a car approaches the spot, start shooting. Try shooting in three- or four-frame bursts.

Following the action

Panning is a great way to show motion. To begin, find a subject that will move across your path at a steady speed and practice following it in your viewfinder from side to side. Now, with the camera in Shutter Priority mode, set your shutter speed to 1/30 of a second and the focus mode to Continuous (and try using an auto focus point selection mode if you have one). Now pan along with the subject and shoot as it moves across your view. Experiment with different shutter speeds and focal lengths. Panning is one of those skills that takes some time to get a feel for, so try it with different types of subjects moving at different speeds.

Feeling the movement

Instead of panning with the motion, use a stationary camera position and adjust the shutter speed until you get a blurred effect that gives the sense of motion while still being able to identify the subject. There is a big difference between a slightly blurred photo that looks like you just picked the wrong shutter speed and one that looks intentional for the purpose of showing motion. Just like panning, it will take some experimentation to find just the right shutter speed to achieve the desired effect.

Share your results with the book's Flickr group!

Join the group here: flickr.com/groups/exposure_fromsnapshotstogreatshots

6

ISO 200
1/80 sec.
f/8
60mm lens

Say Cheese!

SETTINGS AND FEATURES TO MAKE GREAT PORTRAITS

Taking pictures of people is one of the great joys of photography. You will experience a great sense of accomplishment when you capture the spirit and personality of someone in a photograph. At the same time, you have a great responsibility because the person in front of the camera is depending on you to make them look good. You can't always change how someone looks, but you can control the way you photograph that individual. In this chapter, we will explore some camera features and techniques that can help you create great portraits.

PORING OVER THE PICTURE

While exploring the Castillo de San Felipe in Guatemala I found this great doorway that was the perfect background for a photo of my son. It provided the perfect amount of light shade while still being bright enough for a great picture.

Although the doorway was shaded, the sky above was clear and provided soft light on the subject's face.

The arched doorway helped to provide a perfect frame within the frame.

The light bouncing off the walls provided a nice warm glow to the subject's face.

The darker area on the back wall provided a nice background to provide some separation for the subject.

ISO 200
1/40 sec.
f/11
75mm lens

One of the things I love most about traveling is meeting new people. Of course I love architecture and beautiful landscapes but people are what give life to a location, and that was truly the case in the market of Chichicastenango, Guatemala. The market is amazing but for me, it's the people that really bring it to life. I met this cute girl when she came over to skillfully sell her little handmade dolls. We got her to throw in a photo as part of the bargain.

The open sky behind me made for some great catchlights in her eyes.

Holding the camera vertically created a more natural frame for her face.

A large aperture helped blur the background.

The shade of the overhead canopies helped soften the light and reduce harsh shadows.

ISO 400
1/320 sec.
f/4.5
44mm lens

AUTOMATIC PORTRAIT MODE

Many of today's DSLR cameras have automatic shooting modes that are customized for specific subjects. One of them, Portrait mode, is dedicated to shooting portraits. While this is not my preferred camera setting, it is a great jumping-off point for those who are just starting out. The key to using this mode is to understand what is going on with the camera so that when you venture further into portrait photography, you can expand on the settings and get the most from your camera and, more importantly, your subject.

Whether you are photographing an individual or a group, the emphasis should always be on the subject. Portrait mode utilizes a larger aperture setting to keep the depth of field very narrow, which means that the background will appear slightly blurred or out of focus. To take full advantage of this effect, use a medium- to telephoto-length lens (**Figure 6.1**). Also, keep a pretty close distance to your subject. If you shoot from too far away, the narrow depth of field will not be as effective.

FIGURE 6.1
The Portrait shooting mode is fine for casual people shots like this group of school girls in a Malaysian market.

ISO 800
1/1250 sec.
f/4
56mm lens

USING APERTURE PRIORITY MODE

If you took a poll of portrait photographers to see which shooting mode was most often used for portraits, the answer would certainly be Aperture Priority (A or Av) mode. Selecting the right aperture is important for placing the most critically sharp area of the focus on your subject, while simultaneously blurring all of the distracting background clutter (**Figure 6.2**). Not only will a large aperture give the narrowest depth of field, it will also allow you to shoot in lower light levels at lower ISO settings.

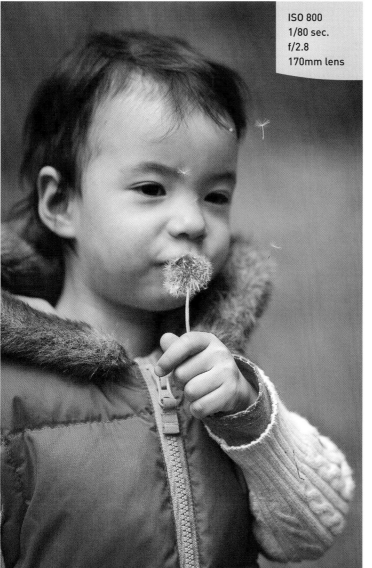

ISO 800
1/80 sec.
f/2.8
170mm lens

FIGURE 6.2
Using a wide aperture, especially with a longer lens, blurs distracting background details.

This isn't to say that you have to use the largest aperture on your lens. A good place to begin is f/5.6. This will give you enough depth of field to keep the entire face in focus, while providing enough blur to eliminate distractions in the background. This isn't a hard-and-fast setting; it's just a good, all-around number to start with. Your aperture might change depending on the focal length of the lens you are using and on the amount of blur that you want for your foreground and background elements.

GO WIDE FOR ENVIRONMENTAL PORTRAITS

There will be times when your subject's environment is of great significance to the story you want to tell. This might mean using a smaller aperture to get more detail in the background or foreground. Once again, by using Aperture Priority mode, you can set your aperture to a higher f-stop, such as f/8 or f/11, and include the important details of the scene that surrounds your subject.

Using a wider-than-normal lens can also assist in getting more depth of field as well as showing the surrounding area. A wide-angle lens requires less stopping down of the aperture (making the aperture smaller) to achieve an acceptable depth of field. This is due to the fact that wide-angle lenses are covering a greater area, so the depth of field appears to cover a greater percentage of the scene.

A wider lens might also be necessary to relay more information about the scenery (**Figure 6.3**). Select a lens length that is wide enough to tell the story but not so wide that you distort the subject. There's little in the world of portraiture quite as unflattering as giving someone a big, distorted nose (unless you are going for that sort of look). When shooting a portrait with a wide-angle lens, keep the subject away from the edge of the frame. This will reduce the distortion, especially in very wide focal lengths. As the lens length increases, distortion will be reduced. I generally don't like to go wider than about 24mm for portraits.

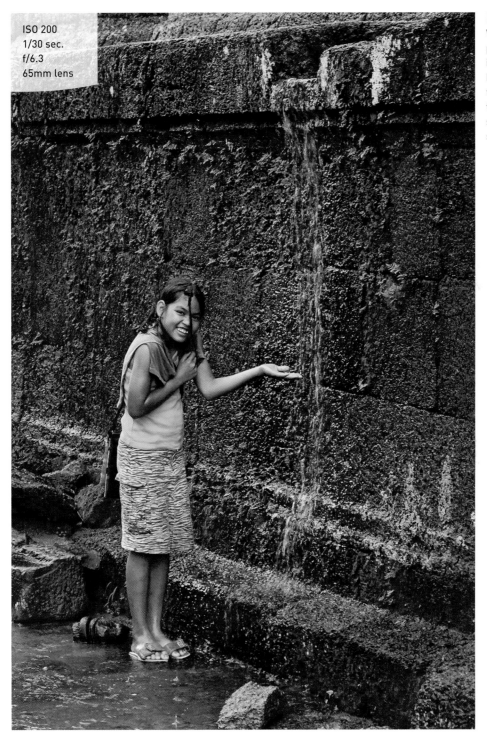

ISO 200
1/30 sec.
f/6.3
65mm lens

As discussed in Chapter 2, there are multiple metering modes in your camera, but the way they work is very similar. A light meter measures the amount of light being reflected off your subject and then renders a suggested exposure value based on the brightness of the subject and the ISO setting of the sensor. To establish this value, the meter averages all of the brightness values to come up with a middle tone, sometimes referred to as 18 percent gray. The exposure value is then rendered based on this middle gray value. This means that a white wall would be underexposed and a black wall would be overexposed in an effort to make each one appear gray. To assist with special lighting situations, most DSLRs have a few metering modes: Matrix (sometimes called Evaluative) (**Figure 6.4**), which uses the entire frame; Spot (**Figure 6.5**), which takes specific readings from small areas (often used with a gray card); and Center-Weighted (**Figure 6.6**), which looks at the entire frame but places most of the exposure emphasis on the center of the frame.

FIGURE 6.4
The Matrix metering mode uses the entire frame.

FIGURE 6.5
The Spot metering mode uses a very small area of the frame.

FIGURE 6.6
The Center-Weighted metering mode looks at the entire frame but emphasizes the center of it.

METERING MODES FOR PORTRAITS

For most situations, the Matrix metering mode is ideal. (For more on how metering works, see Chapter 2, as well as the "Metering Basics" sidebar.) This mode measures light values from all portions of the viewfinder and then establishes a proper exposure for the scene. The only problem that you might encounter when using this metering mode is when you have very light or dark backgrounds in your portrait shots.

In these instances, the meter might be fooled into using the wrong exposure information because it will be trying to lighten or darken the entire scene based on the prominence of dark or light areas (**Figure 6.7**). You can deal with this in one of two ways. You can use the Exposure Compensation feature, which we cover in Chapter 7, to dial in adjustments for over- and underexposure. Or you can change the metering

mode to Center-weighted metering. The Center-weighted metering mode only uses the center area of the viewfinder (about 9 percent) to get its exposure information. This is the best way to achieve proper exposure for most portraits; metering off skin tones, averaged with hair and clothing, will often give a more accurate exposure (**Figure 6.8**). This metering mode is also great to use when the subject is strongly backlit.

ISO 1000
1/80 sec.
f/5.6
40mm lens

ISO 1000
1/40 sec.
f/5.6
40mm lens

FIGURE 6.7
(left) The light background color and clothing fooled the meter into choosing a slightly underexposed setting for the photo.

FIGURE 6.8
(right) When I switched to the Center-weighted metering mode, my camera was able to ignore much of the background and add a little more time to the exposure.

USING THE EXPOSURE LOCK FEATURE

There will often be times when your subject is not in the center of the frame but you still want to use the Center-weighted metering mode. So how can you get an accurate reading if the subject isn't in the center? Try using the Exposure Lock feature to hold the exposure setting while you recompose.

Exposure Lock lets you use the exposure setting from any portion of the scene that you think is appropriate, and then lock that setting in regardless of how the scene looks when you recompose. An example of this would be when you're shooting a photograph of someone and a large amount of blue sky appears in the picture. Normally, the meter might be fooled by all that bright sky and try to reduce the exposure. Using Exposure Lock, you can establish the correct metering by zooming in

on the subject (or even pointing the camera toward the ground), taking the meter reading and locking it in, and then recomposing and taking your photo with the locked-in exposure.

SHOOTING WITH THE EXPOSURE LOCK FEATURE

1. Find the Exposure Lock button (it's probably located on the back of the camera where your right thumb goes) and place your thumb on it.
2. While looking through the viewfinder, place the focus point on your subject and press the shutter release button halfway to get a meter reading, and focus the camera.
3. Press and hold the Exposure Lock button to lock in the meter reading. You should see some sort of indicator in the viewfinder.
4. While holding in the button, recompose your shot and take the photo.

Not every camera works the same way when it comes to Exposure Lock, so take a look at your owner's manual for specific instruction.

FOCUSING: THE EYES HAVE IT

It has been said that the eyes are the windows to the soul, and nothing could be truer when you are taking a photograph of someone (**Figure 6.9**). You could have the perfect composition and exposure, but if the eyes aren't sharp the entire image suffers. While there are many different focusing modes to choose from on your camera, for portrait work you can't beat using a single focus point. Using this focus mode, you will establish a single focus for the lens and then hold it until you take the photograph; the other focusing modes continue focusing until the photograph is taken. The single-point selection lets you place the focusing point right on your subject's eye and set that spot as the critical focus spot. Using the single point focus mode lets you get that focus and recompose all in one motion.

Although most cameras will let you move the single focus point to any number of locations in the frame, I typically use the center point for focus selection. I find it easier to place that point directly on the location where my critical focus should be established and then recompose the shot. Even though the single point can be selected from any of the focus points, it typically takes longer to figure out where that point should be in relation to my subject. By using the center point, I can quickly establish focus and get on with my shooting.

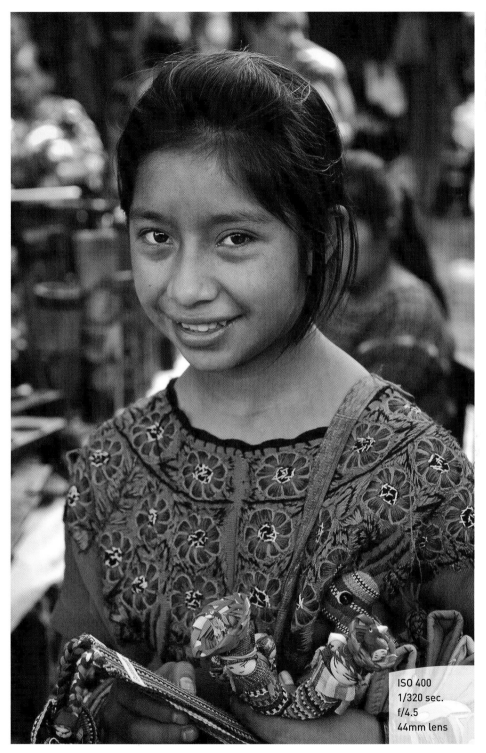

FIGURE 6.9
When photograph-
ing people, you
should almost
always place the
emphasis on
the eyes.

ISO 400
1/320 sec.
f/4.5
44mm lens

CLASSIC BLACK AND WHITE PORTRAITS

There is something timeless about a black and white portrait. It eliminates the distraction of color and puts all the emphasis on the subject. To get great black and whites without having to resort to any image-processing software, try using your camera's Monochrome preset (**Figure 6.10**). You should know that the presets are automatically applied when shooting with the JPEG file format. If you are shooting in RAW, the picture that shows up on your rear LCD display will look black and white, but it will appear as a color image when you open it in your RAW processing software. You can probably use the software to apply the Monochrome look back to the image.

FIGURE 6.10
Getting high-quality black and white portraits is as simple as setting your camera to the Monochrome camera preset.

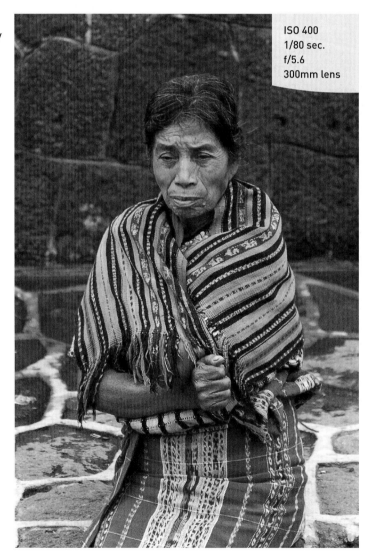

ISO 400
1/80 sec.
f/5.6
300mm lens

The real key to using the Monochrome preset is to customize it for your portrait subject. Most presets can be changed to alter the sharpness and contrast. For women, children, puppies, and anyone else who should look somewhat soft, try a low Sharpness setting. For old cowboys, longshoremen, and anyone else who you want to look really detailed, try one that is much higher. I typically like to leave Contrast at a setting just a little lower than middle. This gives me a nice range of tones throughout the image.

The other adjustment that you should try is to change the preset's color filter effect from None to one of the colored settings. Using the filters will have the effect of either lightening or darkening the skin tones. Red and Yellow filters usually lighten skin, while a Green filter can make skin appear a bit darker. Experiment with the custom settings to see which one works best for your subject (**Figure 6.11**).

FIGURE 6.11
The customizing menu for the Nikon Monochrome picture control.

THE PORTRAIT PRESET FOR BETTER SKIN TONES

As long as we are talking about presets for portraits, there is another one that your camera probably has that is tuned specifically for portrait shooting. Oddly enough, it's called Portrait. To set this preset on your camera, simply follow the directions found in your owner's manual (it's probably the same method used to turn on the Monochrome preset). There are usually individual options for the Portrait preset that, like the Monochrome preset, include sharpness and contrast. You can usually change the saturation (how intense the colors will be) and hue too, which lets you change the skin tones from more reddish to more yellowish. I prefer brighter colors, so I like to boost the Saturation setting and leave everything else at the defaults. You won't be able to use the same adjustments for everyone, especially when it comes to color tone, so do some experimenting to see what works best.

USE FILL FLASH FOR REDUCING SHADOWS

A common problem when taking pictures of people outside, especially during the midday hours, is that the overhead sun can create dark shadows under the eyes and chin. You could have your subject turn his or her face to the sun, but that is usually considered cruel and unusual punishment. So how can you have your subject's back to the sun and still get a decent exposure of the face? Try turning on your flash to fill in the shadows (**Figure 6.12**). This also works well when you are photographing someone with a ball cap on. The bill of the hat tends to create heavy shadows over the eyes, and the fill flash will lighten up those areas while providing a really nice catchlight in the eyes.

CATCHLIGHT

A *catchlight* is that little sparkle that adds life to the eyes. When you are photographing a person with a light source in front of them—be it your flash, the sun, or something else—you will usually get a reflection of that light in the eye. The light is reflected off the surface of the eyes as bright highlights and serves to bring attention to the eyes.

The key to using the flash as a fill is to not use it on full power. If you do, the camera will try to balance the flash with the daylight, and you will get a very flat and featureless face.

ISO 1600
1/60 sec.
f/4
200mm lens

FIGURE 6.12
I used a little fill
flash to lighten
the subject—who
was standing in a
shaded area—and
add a catchlight to
her eyes.

PORTRAITS ON THE MOVE

Not all portraits are shot with the subject sitting in a chair, posed and ready for the picture. Sometimes you might want to get an action shot that says something about the person, similar to an environmental portrait. Children, especially, just like to move. Why fight it? Set up an action portrait instead.

For the photo in **Figure 6.13**, I set my camera to Shutter Priority mode. I knew that there would be a good deal of movement involved, and I wanted to make sure that I had a fairly high shutter speed to freeze the action, so I set it to 1/125 of a second. I used a continuous focus mode, I had the drive mode set to Continuous, and just started firing off shots as he moved within range. There were quite a few throwaway shots, but I was able to get one that captured him in the midst of the ride.

FIGURE 6.13
Although I usually prefer to shoot my people shots in Aperture Priority mode, the key to this shot was using Shutter Priority mode.

ISO 200
1/125 sec.
f/5.6
300mm lens

TIPS FOR SHOOTING BETTER PORTRAITS

Before we get to the assignments for this chapter, I thought it might be a good idea to leave you with a few extra pointers on shooting portraits. There are entire books that cover things like portrait lighting, posing, and so on. But here are a few pointers that will make your people pics look a lot better.

AVOID THE CENTER OF THE FRAME

This falls under the category of composition. Place your subject to the side of the frame (**Figure 6.14**)—it just looks more interesting than plunking them smack dab in the middle (**Figure 6.15**).

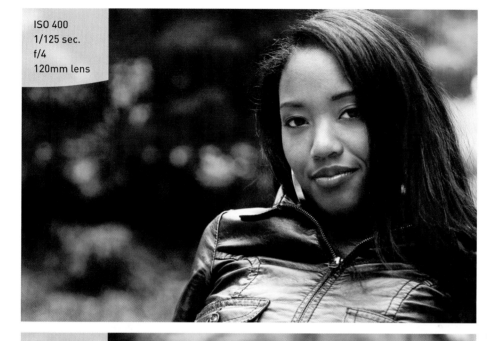

ISO 400
1/125 sec.
f/4
120mm lens

FIGURE 6.14
Try cropping in a bit, and place the subject's face off center to improve the shot.

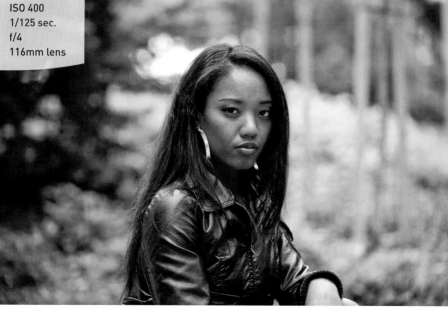

ISO 400
1/125 sec.
f/4
116mm lens

FIGURE 6.15
Having the subject in the middle of the frame with so much empty space on the sides can make for a less-than-interesting portrait.

CHOOSE THE RIGHT LENS

Choosing the correct lens can make a huge impact on your portraits. A wide-angle lens can distort features of your subject, which can lead to an unflattering portrait (**Figure 6.16**). Select a longer focal length if you will be close to your subject (**Figure 6.17**).

FIGURE 6.16
(left) At this close distance, the 18mm lens is distorting the subject's face.

FIGURE 6.17
(right) By zooming out to 70mm, I am able to remove the distortion for a much better photo.

ISO 1000
1/80 sec.
f/5.6
18mm lens

ISO 1000
1/80 sec.
f/7.1
70mm lens

DON'T CUT THEM OFF AT THE KNEES

There is an old rule about photographing people: never crop the picture at a joint. This means no cropping at the ankles, knees, or waist. If you need to crop at the legs, the proper place to crop is mid-shin or mid-thigh (**Figure 6.18**).

USE THE FRAME

Have you ever noticed that most people are taller than they are wide? Turn your camera vertically for a more pleasing composition (**Figure 6.19**).

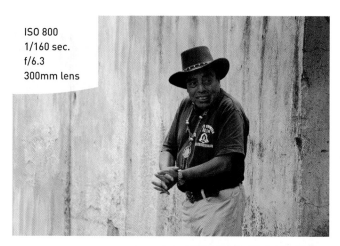

ISO 800
1/160 sec.
f/6.3
300mm lens

FIGURE 6.18
A good crop for people
is when it intersects at
mid-thigh or mid-shin.

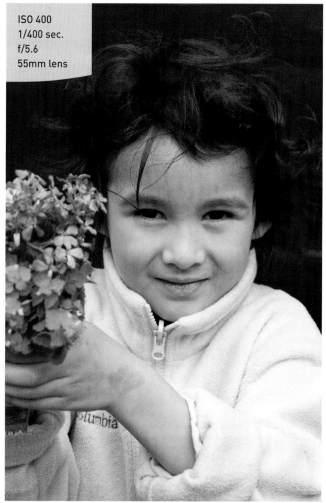

ISO 400
1/400 sec.
f/5.6
55mm lens

FIGURE 6.19
Get in the habit of turning
your camera to a vertical
position when shooting
portraits. This is also
referred to as portrait
orientation.

SUNBLOCK FOR PORTRAITS

The midday sun can be harsh and can do unflattering things to people's faces (**Figure 6.20**). If you can, find a shady spot out of the direct sunlight. You will get softer shadows, smoother skin tones, and better detail (**Figure 6.21**). This holds true for overcast skies as well. Just be sure to adjust your white balance accordingly.

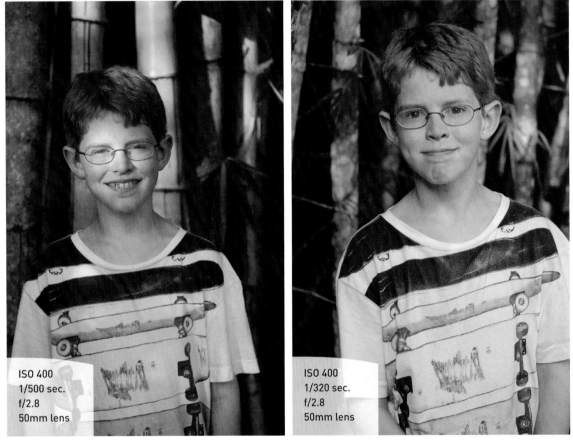

ISO 400
1/500 sec.
f/2.8
50mm lens

ISO 400
1/320 sec.
f/2.8
50mm lens

FIGURE 6.20
The dappled sunlight does unflattering things to this subject's face.

FIGURE 6.21
By moving him over just a couple of feet, I was able to get him out of the direct light and into a much more flattering situation.

GIVE THEM A HEALTHY GLOW

Nearly everyone looks better with a warm, healthy glow. Some of the best light of the day happens just a little before sundown, so shoot at that time if you can (**Figure 6.22**).

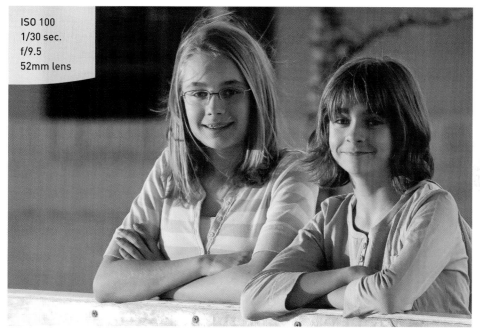

ISO 100
1/30 sec.
f/9.5
52mm lens

FIGURE 6.22
You just can't beat the glow of the late afternoon sun for adding warmth to your portraits.

KEEP AN EYE ON YOUR BACKGROUND

Sometimes it's so easy to get caught up in taking a great shot that you forget about the smaller details. Try to keep an eye on what is going on behind your subject so they don't end up with things popping out of their heads (**Figures 6.23** and **6.24**).

FRAME THE SCENE

Using elements in the scene to create a frame around your subject is a great way to draw the viewer in. You don't have to use a window frame to do this. Just look for elements in the foreground that could be used to force the viewer's eye toward your subject (**Figure 6.25**).

ISO 400
1/1250 sec.
f/5.6
185mm lens

FIGURE 6.23
A downspout in the background is going right into the subject's head.

ISO 400
1/1250 sec.
f/5.6
185mm lens

FIGURE 6.24
By moving the camera position a little to the left, I was able to remove the distracting pipe from the photo.

ISO 200
1/40 sec.
f/11
75mm lens

FIGURE 6.25
I'll often look for elements of the surrounding background to use as compositional elements in my portraits. This arched doorway made a great frame for my subject.

GET DOWN ON THEIR LEVEL

If you want better pictures of children, don't shoot from an adult's eye level. Getting the camera down to the child's level will make your images look more personal (**Figure 6.26**).

DON'T BE AFRAID TO GET CLOSE

When you are taking someone's picture, don't be afraid of getting close and filling the frame (**Figure 6.27**). This doesn't mean you have to shoot from a foot away; try zooming in to capture the details.

ISO 640
1/4000 sec.
f/2.8
85mm lens

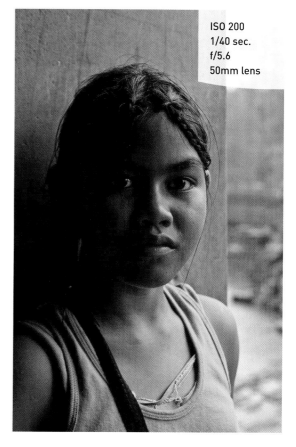

ISO 200
1/40 sec.
f/5.6
50mm lens

FIGURE 6.26
Sometimes taking photographs of children means taking a knee to get the camera down on their level, but the end result is a much better image.

FIGURE 6.27
Filling the frame with the subject's face can lead to a much more intimate portrait.

TRY A LONG LENS FOR CANDID SHOTS

Putting a camera in someone's face can elicit some unnatural results. People just feel a need to pose, or they get nervous and stiff. If you really want to capture some nice portraits with a more candid feel, try shooting with a long lens (**Figure 6.28**). The distance will remove you and your camera from the equation, and people will tend to react more normally with you around. If you are looking to be a street photographer, a long lens will be one of your best tools.

FIGURE 6.28
Try using a long lens to capture more candid portraits.

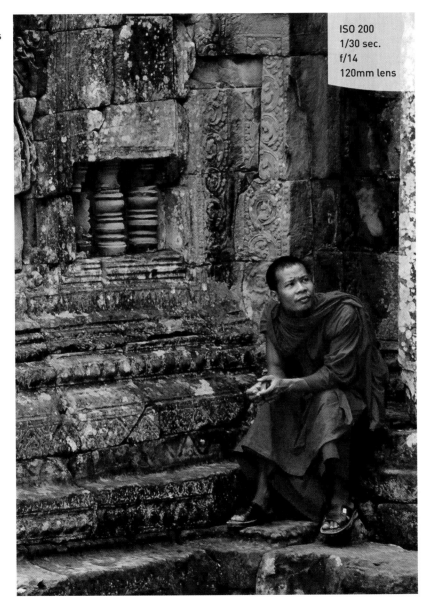

ISO 200
1/30 sec.
f/14
120mm lens

Chapter 6 Assignments

Depth of field in portraits

Let's start with something simple. Grab your favorite person and start experimenting with using different aperture settings. Shoot wide open (the widest your lens goes, such as f/3.5 or f/5.6) and then really stopped down (like f/22). Look at the difference in the depth of field and how it plays an important role in placing the attention on your subject. (Make sure you don't have your subject standing against the background. Give some distance so that there is a good blurring effect of the background at the wide f-stop setting.)

Discovering the qualities of natural light

Pick a nice sunny day and try shooting some portraits in the midday sun. If your subject is willing, have them turn so the sun is in their face. If they are still speaking to you after blinding them, have them turn their back to the sun. Try this with and without the fill flash so you can see the difference. Finally, move them into a completely shaded spot and take a few more.

Picking the right metering method

Find a very dark or light background and place your subject in front of it. Now take a couple of shots, giving a lot of space around your subject for the background to show. Now switch metering modes and use the Exposure Lock feature to get a more accurate reading of your subject. Notice the differences in exposure between the metering methods.

Camera presets for portraits

Have some fun playing with the different presets. Try the one for Portrait as compared to the Standard. Then try out Monochrome and play with the different color filter options to see how they affect skin tones.

Use different focal lengths

If you have a wide-angle zoom lens like the 18–55mm that is often sold as a bundle with many DSLRs, try out the effect of the focal length on people's faces. Have someone pose for you and then shoot with the lens set to its widest setting and move close to fill the frame. Now zoom in to the longest lens length and move back until you have the person about the same size in the frame. Compare the effects of different focal lengths and see what your most flattering setting will be.

Share your results with the book's Flickr group!

Join the group here: flickr.com/groups/exposure_fromsnapshotstogreatshots

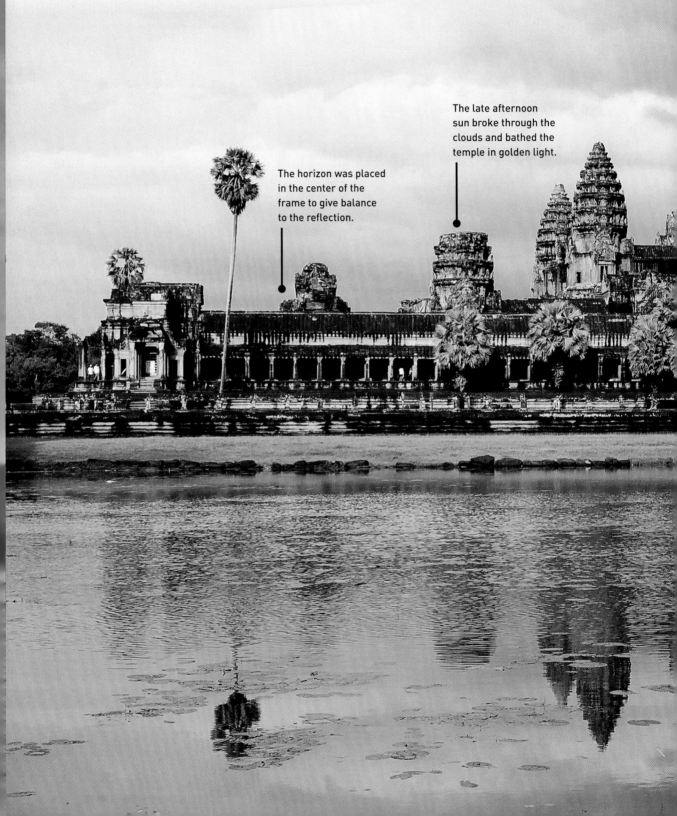

PORING OVER THE PICTURE

The horizon was placed in the center of the frame to give balance to the reflection.

The late afternoon sun broke through the clouds and bathed the temple in golden light.

This photograph was actually several years in the making. It all started when I saw an article in *Smithsonian* magazine about the amazing temples of Angkor in Cambodia. The crown jewel of all the temples was Angkor Wat, the largest religious temple in the world. Something about the place really inspired me, so several years later I packed my bags and flew halfway around the world to see it for myself. This shot is the one I wanted most, but it almost didn't happen due to rainy weather for most of my visit. But then, on the last day, the sun broke through the clouds at sunset and I was able to get my iconic shot.

I chose the tree closest to the water as my focus point.

The wide-angle lens and small aperture ensured that everything in the image was in focus.

ISO 200
1/50 sec.
f/18
29mm lens

PORING OVER THE PICTURE

High Dynamic Range (HDR) photography is fairly new to the industry, but it has captured the collective imaginations of millions and continues to grow in popularity every day. There are those who love it and those who hate it, but sometimes it truly is the only way to capture all of the visual information in a scene. Thus was the case with this temple in Guatemala. The dense jungle brush meant that trees would be several stops darker than the temple and even more so for the sky. By using HDR, I was able to capture all the tones in the scene and get a great image in the process.

This is the kind of scene that HDR was made for, with lots of shadows and highlights.

The overexposed frame brought out all of the detail in the trees and other heavily shaded areas.

The shutter speed was changed during the different exposures to make sure that the depth of field remained constant.

The underexposed frame made sure there was plenty of detail in the bright sky.

ISO 800
f/4.5
24mm lens

SHARP AND IN FOCUS: USING TRIPODS

Throughout the previous chapters we have concentrated on using the camera to create great images. We will continue that trend through this chapter, but there is one additional piece of equipment that is crucial in the world of landscape shooting: the tripod. There are a couple of reasons why tripods are so critical to your landscape work, the first being the time of day that you will be working. For reasons that will be explained later, the best light for most landscape work happens early in the morning and just before sunset. While this is the best time to shoot, it's also kind of dark. That means you'll be working with slow shutter speeds. Slow shutter speeds mean camera shake. Camera shake equals bad photos.

The second reason is also related to the amount of light that you're gathering with your camera. When taking landscape photos, you will usually want to be working with very small apertures as they give you lots of depth of field. This also means that, once again, you will be working with slower-than-normal shutter speeds.

Slow shutter + hand holding the camera = camera shake = bad photos.

I think you get the idea. The one tool in your arsenal to truly defeat the camera shake issue and ensure tack-sharp photos is a good tripod (**Figure 7.1**).

FIGURE 7.1
A sturdy tripod is the key to sharp landscape photos. (Photo: Scott Kelby)

ISO 100
1/2 sec.
f/8
12mm lens

So what should you look for in a tripod? Well, first make sure it is sturdy enough to support your camera and any lens that you might want to use. Next, check the height of the tripod. Bending over all day to look through the viewfinder of a camera on a short tripod can wreak havoc on your back. Finally, think about getting a tripod that utilizes a quick-release head. This usually employs a plate that screws into the bottom of the camera and then quickly snaps into place on the tripod. This will be especially handy if you are going to move between shooting by hand and using the tripod. You'll find more information about tripods in Chapter 11.

TRIPOD STABILITY

Most tripods have a center column that allows the photographer to extend the height of the camera above the point where the tripod legs join together. This might seem like a great idea, but the reality is that the further you raise that column, the less stable your tripod becomes. Think of a tall building that sways in the wind near the top floors. To get the most solid base for your camera, always try to use it with the center column at its lowest point so that your camera is right at the apex of the tripod legs.

VR/IS LENSES AND TRIPODS DON'T MIX

If you are using Vibration Reduction (VR) or Image Stabilization (IS) lenses on your camera, you need to remember to turn this feature off when you use a tripod. This is because the VR/IS feature can, while trying to minimize camera movement, actually create movement when the camera is already stable. Make sure you know how to turn off your lens-stabilizing feature prior to using the camera on a tripod (**Figure 7.2**).

FIGURE 7.2
The Vibration Reduction (VR) On/Off switch on a Nikon lens.

SELECTING THE PROPER ISO

When shooting most landscape scenes, the ISO is the one factor that should only be increased as a last resort. While it is easy to select a higher ISO to get a smaller aperture, the noise that it can introduce into your images can be quite harmful. The noise is not only visible as large grainy artifacts; it can also be multi-colored, which further degrades the image quality and color balance.

Take a look at **Figures 7.3** and **7.4**, which shows a photograph taken with an ISO of 1600. The purpose was to shorten the shutter speed and still use a small aperture setting of f/22. The problem is that the noise level is so high that, in addition to being distracting, it is obscuring fine details in the canyon wall.

FIGURE 7.3
(left) A high ISO setting created a lot of digital noise in the shadows.

FIGURE 7.4
(right) When the image is enlarged, the noise is even more apparent.

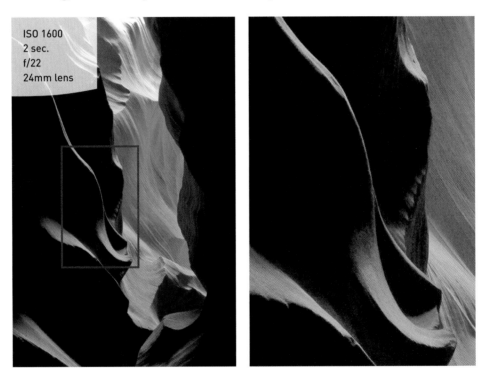

ISO 1600
2 sec.
f/22
24mm lens

Now check out another image that was taken in the same canyon light but with a much lower ISO setting (**Figures 7.5** and **7.6**). As you can see, the noise levels are much lower, which means that my blacks look black, and the fine details are beautifully captured.

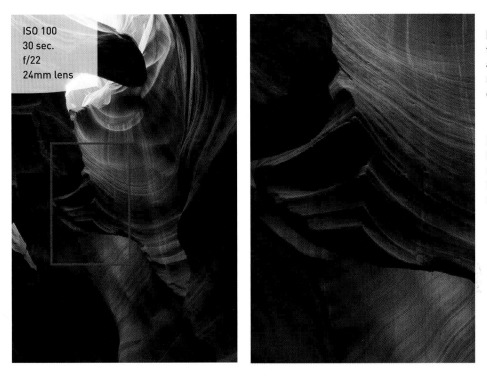

ISO 100
30 sec.
f/22
24mm lens

FIGURE 7.5
[left] By lowering the ISO to 100, I was able to avoid the noise and capture a clean image.

FIGURE 7.6
[right] Zooming in shows that the noise levels for this image are almost nonexistent.

When shooting landscapes, set your ISO to the lowest possible setting at all times. Between the use of Vibration Reduction (VR) or Image Stabilization (IS) lenses (if you are shooting handheld) and a good tripod, there should be few circumstances where you would need to shoot landscapes with anything above an ISO of 400.

As you start shooting with shutter speeds that exceed one second, the level of image noise can increase. Your camera probably has a feature called Noise Reduction that you can turn on to combat noise from long exposures and high ISOs. Once the noise reduction feature is turned on, your camera will be aware of the settings and work towards minimizing unwanted noise in your images.

SELECTING A WHITE BALANCE

This probably seems like a no-brainer. If it's sunny, select Daylight. If it's overcast, choose the Shade or Cloudy setting. Those choices wouldn't be wrong for those circumstances, but why limit yourself? Sometimes you can actually change the mood of the photo by selecting a white balance that doesn't quite fit the light for the scene that you are shooting.

Figure 7.7 is an example of a correct white balance. It was late afternoon and the sun was starting to move low in the sky, giving everything that warm afternoon glow. The white balance for this image was set to Daylight.

FIGURE 7.7
Using the "proper"
white balance
yields predictable
results.

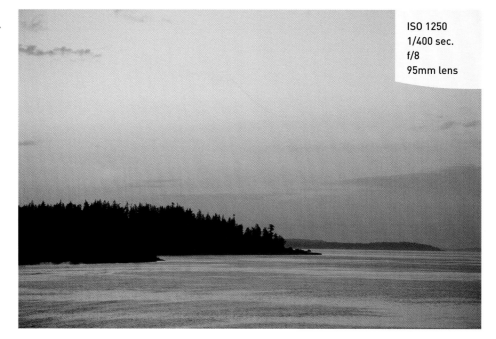

ISO 1250
1/400 sec.
f/8
95mm lens

But what if I want to make the scene look like it was shot in the early morning hours? Simple, I just change the white balance to Fluorescent, which is a much cooler setting (**Figure 7.8**).

So how do you know what a good white balance selection is? Simple, just take a shot and review it on your LCD screen. Keep changing the white balance setting and reviewing the images until you have one that you like. Of course if you are shooting in the RAW format you can set the white balance in your post-processing software.

Some cameras with Live View can actually preview the effect of changing the white balance without ever capturing an image. Simply turn on the Live View feature and then change the white balance setting while viewing the rear LCD. (If your camera does not have a dedicated White Balance button, you can usually program a Function button to act as one. Check out your owner's manual to assign button functions.)

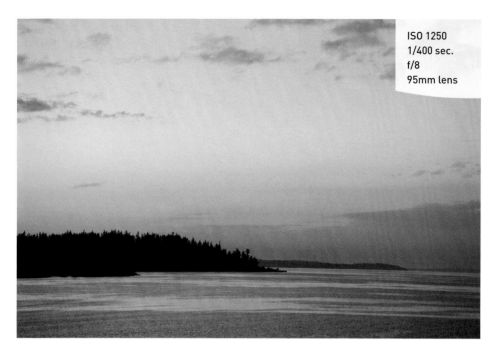

ISO 1250
1/400 sec.
f/8
95mm lens

FIGURE 7.8
Changing the white balance to Fluorescent gives the impression that the picture was taken at a different time of day than it really was.

USING THE LANDSCAPE PICTURE ENHANCEMENT

When shooting landscapes, I always look for great color and contrast. This is one of the reasons that so many landscape shots are taken in the early morning or during sunset. The light is much more vibrant and colorful at these times of day and adds a sense of drama to an image. There are also much longer and deeper shadows due to the angle of the light. These shadows are what give depth to your image.

You can help boost the vibrancy and contrast, especially in the less-than-golden hours of the day, by using a built-in preset referred to as a Landscape style (**Figure 7.9**). By using this camera preset, you can set up your landscape shooting so that you capture images with increased sharpness and a boost in blues and greens. This preset will add some pop to your landscapes without the need for additional processing in any software.

FIGURE 7.9
The image on
the left is using a
standard camera
profile but the one
on the right has
been enhanced
with the use of a
Landscape camera
preset.

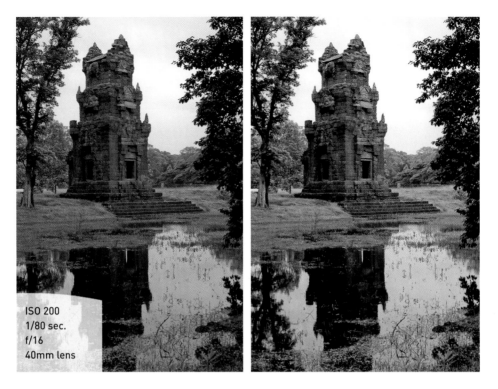

ISO 200
1/80 sec.
f/16
40mm lens

TAMING BRIGHT SKIES WITH EXPOSURE COMPENSATION

Balancing exposure in scenes that have a wide contrast in tonal ranges can be extremely challenging. The one thing you should try to avoid is overexposing your skies to the point of blowing out your highlights (unless, of course, that is the look you are going for). It's one thing to have white clouds, but it's a completely different and bad thing to have no detail at all in those clouds. This usually happens when the camera is trying to gain exposure in the darker areas of the image (**Figure 7.10**). The one way to tell if you have blown out your highlights is to turn on the Highlight Alert, or "blinkies," feature on your camera. When you take a shot where the highlights are exposed beyond the point of having any detail, that area will blink in your LCD display. It is up to you to determine if that particular area is important enough to regain detail by altering your exposure. If the answer is yes, then the easiest way to go about it is to use some exposure compensation.

With this feature, you can force your camera to choose an exposure that ranges, in 1/3-stop increments, from as many as five stops over to five stops under the metered exposure (**Figure 7.11**), depending on the camera.

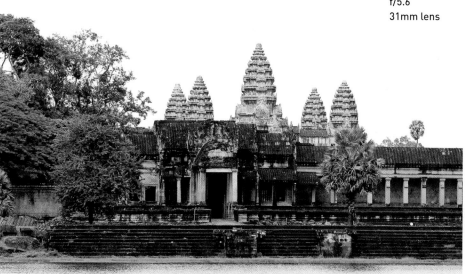

ISO 400
1/640 sec.
f/5.6
31mm lens

FIGURE 7.10
The meter was
basing the exposure
on the darker areas
at the bottom of the
frame, causing the
image to be a little
overexposed.

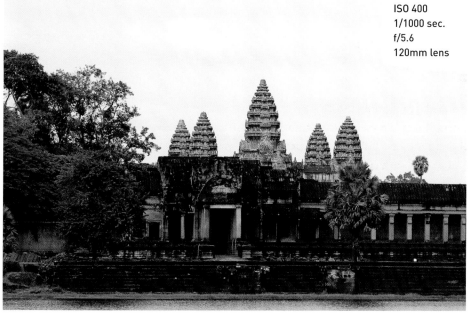

ISO 400
1/1000 sec.
f/5.6
120mm lens

FIGURE 7.11
A compensation
of –2/3 stops of
underexposure
brought some
color back into the
sky and made the
building slightly
darker, which is the
look I was after.

It should be noted that any exposure compensation will typically remain in place even after turning the camera off and then on again. Don't forget to reset it once you have successfully captured your image. Also, exposure compensation usually only works in the Program, Shutter Priority, and Aperture Priority modes. Changing between these three modes should maintain the compensation you set while switching from one to the other. If your camera has automatic modes, the compensation will set itself to zero.

SHOOTING BEAUTIFUL BLACK AND WHITE LANDSCAPES

There's nothing as timeless as a beautiful black and white landscape photo. For many, it is the purest form of photography. The genre conjures up thoughts of Ansel Adams out in Yosemite Valley, capturing stunning monoliths with his 8x10 view camera. Well, just because you are shooting with a digital camera doesn't mean you can't create your own stunning photos using the power of the Monochrome camera preset. Not only can you shoot in black and white, you can usually customize the camera to apply built-in filters to lighten or darken different elements within your scene, as well as add contrast and definition (**Figure 7.12**).

You can see that Monochrome setting can be fairly flat and lacking in contrast. By adding a color filter adjustment, you can achieve some very impressive black and white images. Note: not all cameras have a Monochrome preset with color filter variations. You should check your owner's manual to be certain. Nikon owners should look for the Picture Controls while Canon shooters should check out the Picture Styles section.

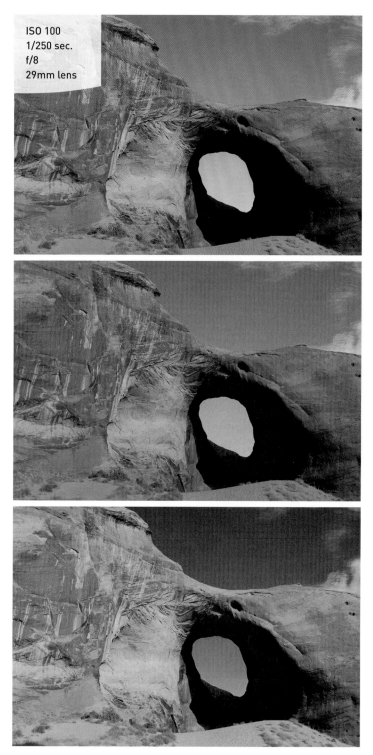

ISO 100
1/250 sec.
f/8
29mm lens

FIGURE 7.12
The image on the left
is the original color
file. The middle shot
utilizes a straight
Monochrome camera
preset. The image on
the bottom is using
the Monochrome
setting with a yellow
enhancement.

POST-PROCESSING FOR BLACK AND WHITE

I really enjoy shooting black and white in the camera so I can see my results right at the time of capture. Of course, most people creating black and white images will do so in their post-processing software. There are so many options and ways to do this that it could fill an entire book. There are a couple of software plug-ins, though, that give you exceptional results based on actual black and white films. The best thing is that they also work with a large number of programs including Adobe Photoshop Lightroom, Adobe Photoshop, and Adobe Photoshop Elements. My favorites are Silver Efex Pro from Nik Software (www.niksoftware.com) (**Figure 7.13**) and Exposure 3 from Alien Skin Software (www.alienskin.com). Both of these programs are Mac and PC compatible and Silver Efex is also compatible with Apple's Aperture 3 software.

FIGURE 7.13
This image was made from a color file that was processed in Adobe Photoshop Lightroom with the Nik Silver Efex Pro plug-in. The effect is similar to the look of a traditional Tri-X film image.

ISO 400
1/30 sec.
f/6.3
52mm lens

THE GOLDEN LIGHT

If you ask any professional landscape photographer what their favorite time of day to shoot is, chances are they will tell you it's the hours surrounding daybreak and sunset (**Figures 7.14** and **7.15**). The reason for this is that the light is coming from a very low angle to the landscape, which creates shadows and gives depth and character. There is also a quality to the light that seems cleaner and is more colorful than the light you get when shooting at midday. One thing that can dramatically improve any morning or evening shot is the presence of clouds. The sun will fill the underside of the clouds with a palette of colors and add drama to your image.

ISO 100
1/160 sec.
f/7.1
35mm lens

FIGURE 7.14
The right subject can come alive with color during the few minutes after sunrise.

ISO 200
1/50 sec.
f/18
29mm lens

FIGURE 7.15
The late afternoon sun was painting a warm glow on the Angkor Wat temple, aided by the darker clouds in the background.

These two terms are used to describe the overall colorcast of an image. Reds and yellows are said to be *warm*, which is usually the look that you get from the late afternoon sun. Blue is usually the predominant color when talking about a *cool* cast.

WHERE TO FOCUS

Large landscape scenes are great fun to photograph, but they can present a problem: where exactly do you focus when you want everything to be sharp? Since our goal is to create a great landscape photo, we will need to concentrate on how to best create an image that is tack sharp, with a depth of field that renders great focus throughout the scene.

I have already stressed the importance of a good tripod when shooting landscapes. The tripod lets you concentrate on the aperture portion of the exposure without worrying how long your shutter will be open. This is because the tripod provides the stability to handle any shutter speed you might need when shooting at small apertures. I find that for *most* of my landscape work I set my camera to Aperture Priority mode and the ISO to 100 (for a clean, noise-free image).

However, shooting with the smallest aperture on your lens doesn't necessarily mean that you will get the proper sharpness throughout your image. The real key is knowing where in the scene to focus your lens to maximize the depth of field for your chosen aperture. To do this, you must utilize something called the "hyper focal distance" of your lens.

Hyper focal distance, also referred to as HFD, is the point of focus that gives you the greatest acceptable sharpness from a point near your camera all the way out to infinity. If you combine good HFD practice in combination with a small aperture, you will get images that are sharp to infinity.

There are a couple of ways to do this, and the one that is probably the easiest, as you might guess, is the one that is most widely used by working pros. When you have your shot all set up and composed, focus on an object that is about one-third of the distance into your frame (**Figure 7.16**). It is usually pretty close to the proper distance and will render favorable results. When you have the focus set, take a photograph and then zoom in on the preview on your LCD to check the sharpness of your image.

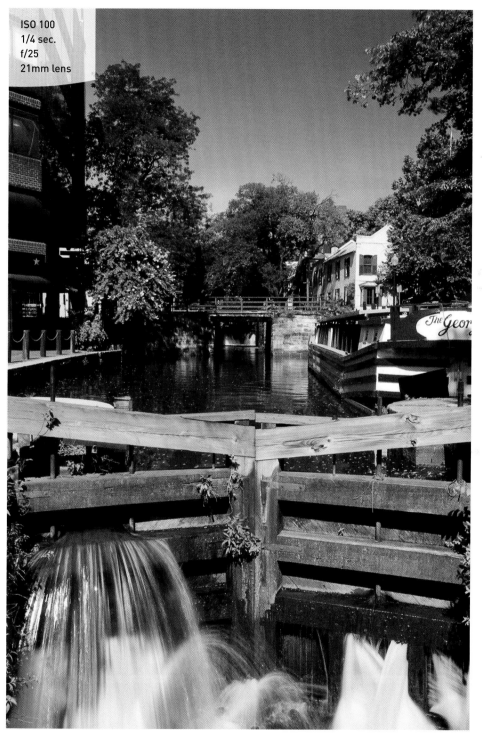

ISO 100
1/4 sec.
f/25
21mm lens

FIGURE 7.16
To get maximum focus from near to far, the focus was set one-third of the way into the scene, on the boat to the right. I then recomposed before taking the picture. Using this point of focus with an aperture of f/25 gave me a sharply focused image all the way back to the distant trees.

One thing to remember is that as your lens gets wider in focal length, your HFD will be closer to the camera position. This is because the wider the lens, the greater depth of field you can achieve. This is yet another reason why a good wide angle lens is indispensable to the landscape shooter.

EASIER FOCUSING

There's no denying that the automatic focus features on today's DLSR cameras are great, but sometimes it just pays to turn them off and focus manually. This is especially true if you are shooting on a tripod: once you have your shot composed in the viewfinder and you are ready to focus, chances are that the area you want to focus on is not going to be in the area of one of the focus points. Often this is the case when you have a foreground element that is fairly low in the frame. You could use a single focus point set low in your viewfinder and then pan the camera down until it rests on your subject. But then you would have to press the shutter button halfway to focus the camera and then try to recompose and lock down the tripod. It's no easy task.

But you can have the best of both worlds by having the camera focus for you, then switching to manual focus to comfortably recompose your shot (**Figure 7.17**).

FIGURE 7.17
Using the HFD (Hyper Focal Distance) rule, I focused about 1/3 of the way into the field of flowers, then switched the lens to manual focus before recomposing for the final shot.

ISO 400
1/25 sec.
f/22
22mm lens

GETTING FOCUSED WHILE USING A TRIPOD

1. Set up your shot and find the area that you want to focus on.

2. Pan your tripod head so that your active focus point is on that spot.

3. Press the shutter button halfway to focus the camera and then remove your finger from the button.

4. Switch the camera to manual focus by sliding the switch on the lens barrel (or wherever your manual focus switch may be) from A to M.

5. Recompose the composition on the tripod and then take the shot.

The camera will fire without trying to refocus the lens. This works especially well for wide-angle lenses, which can be difficult to focus in manual mode.

MAKING WATER FLUID

There's little that is quite as satisfying for the landscape shooter as capturing a silky waterfall shot. Creating the smooth-flowing effect is as simple as adjusting your shutter speed to allow the water to be in motion while the shutter is open. The key is to have your camera on a stable platform (such as a tripod) so that you can use a shutter speed that's long enough to work (**Figure 7.18**). To achieve a great effect, use a shutter speed that is at least 1/15 of a second or longer.

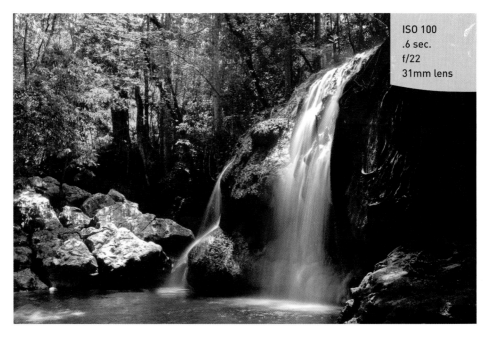

FIGURE 7.18
A tripod was a necessity for capturing this shot. There's just no way to hand-hold the camera for over half a second and still get a sharp image.

ISO 100
.6 sec.
f/22
31mm lens

SETTING UP FOR A WATERFALL SHOT

1. Attach the camera to your tripod, then compose and focus your shot.

2. Make sure the ISO is set to 100.

3. Using Aperture Priority mode, set your aperture to the smallest opening (such as f/22 or f/36).

4. Press the shutter button halfway so the camera takes a meter reading.

5. Check to see if the shutter speed is 1/15 or slower.

6. Take a photo and then check the image on the LCD.

You can also use Shutter Priority mode for this effect by dialing in the desired shutter speed and having the camera set the aperture for you. I prefer to use Aperture Priority to ensure that I have the greatest depth of field possible.

If the water is blinking on the LCD, indicating a loss of detail in the highlights, then use the Exposure Compensation feature (as discussed earlier in this chapter) to bring details back into the waterfall.

There is a possibility that you will not be able to have a shutter speed that is long enough to capture a smooth, silky effect, especially if you are shooting in bright daylight conditions. To overcome this obstacle, you need a filter for your lens—either a polarizing filter or a neutral density filter. The polarizing filter redirects wavelengths

of light to create more vibrant colors, reduce reflections, and darken blue skies, as well as lengthening exposure times by about two stops due to the darkness of the filter (this amount can vary depending on the brand of filter used). It is a handy filter for landscape work. The neutral density (ND) filter is typically just a dark piece of glass that serves to darken the scene by one, two, or three stops (**Figure 7.19**). This allows you to use slower shutter speeds during bright conditions. Think of it as sunglasses for your camera lens. You will find more discussion on filters in Chapter 11.

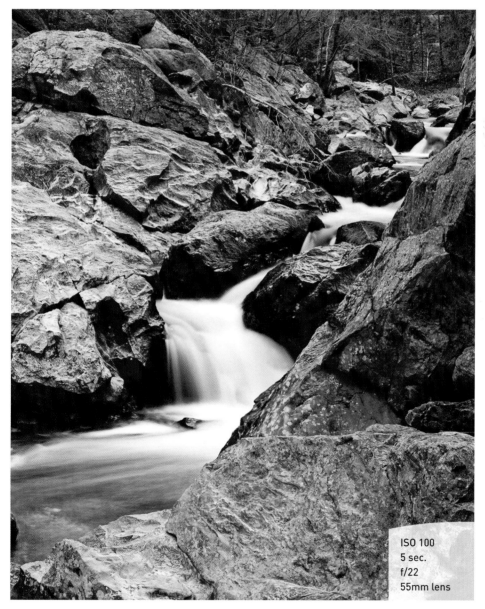

FIGURE 7.19
I used a neutral density filter to add two stops of exposure, thus allowing for a longer exposure time.

ISO 100
5 sec.
f/22
55mm lens

DIRECTING THE VIEWER: A WORD ABOUT COMPOSITION

As a photographer, it's your job to lead the viewer through your image. You accomplish this by utilizing the principles of composition, which is the arrangement of elements in the scene that draw the viewer's eyes through your image and holds their attention. As the director of this viewing, you need to understand how people see, and then use that information to focus their attention on the most important elements in your image.

There is a general order at which we look at elements in a photograph. The first is brightness. The eye wants to travel to the brightest object within a scene. So if you have a bright sky, it's probably the first place the eye will travel to. The second order of attention is sharpness. Sharp, detailed elements will get more attention than soft, blurry areas. Finally, the eye will move to vivid colors while leaving the dull, flat colors for last. It is important to know these essentials in order to grab—and keep—the viewer's attention and then direct them through the frame.

In **Figure 7.20**, the eye is drawn to the bright white cloud in the middle of the frame. From there, it is pulled toward the sharpness and color of the large boulder that is anchoring the lower-left portion of the image. The eye moves around the curved section of stone at the bottom of the frame, where it is then lifted back up to the sky and clouds, right back to the beginning. The elements within the image all help to keep the eye moving but never leave the frame.

RULE OF THIRDS

There are, in fact, quite a few philosophies concerning composition. The easiest one to begin with is known as the "rule of thirds." Using this principle, you simply divide your viewfinder into thirds by imagining two horizontal and two vertical lines that divide the frame equally.

The key to using this method of composition is to have your main subject located at or near one of the intersecting points (**Figure 7.21**).

ISO 100
1/40 sec.
f/11
24mm lens

FIGURE 7.20
The composition of the
elements pulls the viewer's
eyes around the image, leading
from one element to the next in
a circular pattern.

ISO 400
1/125 sec.
f/11
120mm lens

FIGURE 7.21
Placing the small
hoodoo in the
lower-left portion
of the image
creates a much
more interesting
composition than
having it dead
center in the frame.

By placing your subject near these intersecting lines, you are giving the viewer space to move within the frame. The one thing you don't want to do is place your subject smack dab in the middle of the frame. This is sometimes referred to as "bull's eye" composition, and it requires the right subject matter for it to work. It's not always wrong, but it will usually be less appealing and may not hold the viewer's attention.

Speaking of the middle of the frame; the other general rule of thirds deals with horizon lines. Generally speaking, you should position the horizon one third of the way up or down in the frame (**Figure 7.22**). Splitting the frame in half by placing your horizon in the middle of the picture is akin to placing the subject in the middle of the frame; it doesn't lend a sense of importance to either the sky or the ground.

ISO 100
1/80 sec.
f/13
32mm lens

FIGURE 7.22
Following the standard rule of thirds, I place my horizon line in the bottom third of the frame.

The exception to this rule is when you are photographing reflecting objects. This is one circumstance where it's generally okay to balance your image by placing the horizon directly in the middle of the image (**Figure 7.23**).

ISO 200
1/125 sec.
f/14
24mm lens

FIGURE 7.23
If you are photographing a subject with a reflection you can usually compose the image with the horizon line in the center of the image.

CREATING DEPTH

Because a photograph is a flat, two-dimensional space, you need to create a sense of depth by using the elements in the scene to create a three-dimensional feel. This is accomplished by including different and distinct spaces for the eye to travel: a foreground, middle ground, and background. By using these three spaces, you draw the viewer in and render depth to your image.

The hilly scene in northern California, shown in **Figure 7.24**, illustrates this well. The tree strongly defines the foreground area. The shadowy hills help separate the tree from the middle ground, and the sky gives a great blue background that contrasts with the warm tones of the late afternoon sun.

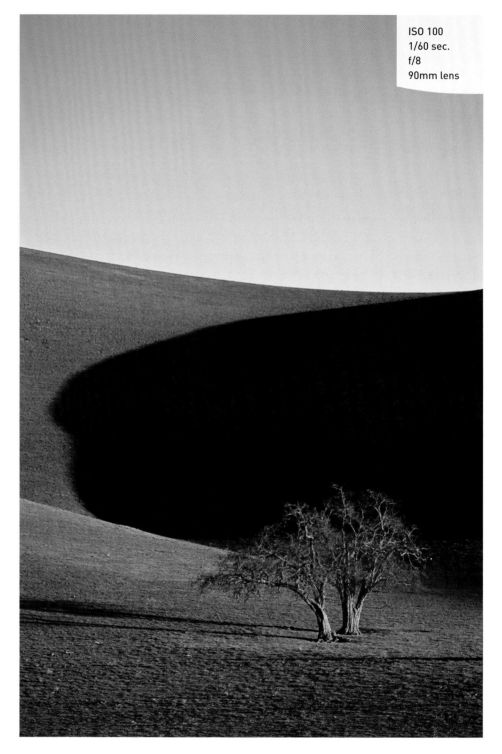

ISO 100
1/60 sec.
f/8
90mm lens

ADVANCED TECHNIQUES TO EXPLORE

This section comes with a warning attached. All of the techniques and topics up to this point have been centered on your camera. The following two sections, covering panoramas and high dynamic range (HDR) images, require you to use image-processing software to complete the photograph. They are, however, important enough that you should know how to correctly shoot for success, should you choose to explore these two popular techniques.

SHOOTING PANORAMAS

If you have ever visited the Grand Canyon, you know just how large and wide open it truly is—so much so that it would be difficult to capture its splendor in just one frame. The same can be said for a mountain range, or a cityscape, or any extremely wide vista. There are two methods that you can use to capture the feeling of this type of scene.

THE "FAKE" PANORAMA

The first method is to shoot with your lens set to its widest focal length, and then crop out the top and bottom portion of the frame in your imaging software. Panoramic images are generally two or three times wider than a normal image.

CREATING A FAKE PANORAMA

1. To create the look of the panorama, find your widest lens focal length.

2. Using the guidelines discussed earlier in the chapter, compose and focus your scene, and select the smallest aperture possible.

3. Shoot your image using whichever technique and shooting mode you desire. That's all there is to it from a photography standpoint.

4. Then, open the image in your favorite image-processing software and crop the extraneous foreground and sky from the image, leaving you with a wide panorama of the scene.

Figure 7.25 shows an example using a photo taken in Monument Valley, Arizona.

FIGURE 7.25
This is a nice image but it lacks visual impact.

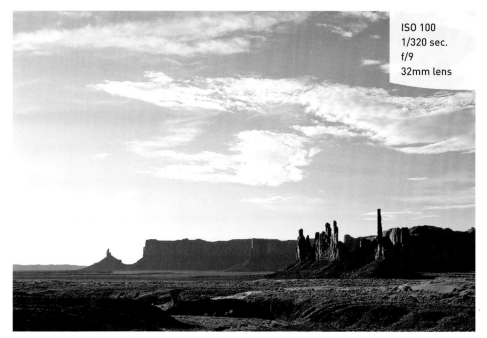

ISO 100
1/320 sec.
f/9
32mm lens

As you can see, the image was shot with a wide perspective, using a 32mm lens. While it is not a bad photo, it lacks visual impact. This isn't a problem, though, because it was shot for the express purpose of creating a "fake" panorama. Now look at the same image, cropped for panoramic view (**Figure 7.26**). As you can see, it makes a huge difference in the image and gives much higher visual impact by reducing the uninteresting sky; it draws your eyes across the length of the horizon.

FIGURE 7.26
Cropping gives the feeling of a sweeping vista and makes the shot visually appealing.

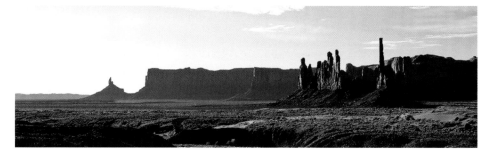

THE MULTIPLE-IMAGE PANORAMA

The reason the previous method is sometimes referred to as a "fake" panorama is because it is made with a standard-size frame and then cropped down to a narrow perspective. To shoot a true panorama, you need to use either a special panorama camera that shoots a very wide frame, or use the following method, which requires combining multiple frames.

The multiple-image pano has gained in popularity in the past few years; this is principally due to advances in image-processing software. Many software options are available now that will take multiple images, align them, and then "stitch" them into a single panoramic image. The real key to shooting a multiple-image pano is to overlap your shots by about 30 percent from one frame to the next (**Figures 7.27 and 7.28**). It is possible to handhold the camera while capturing your images, but the best method for capturing great panoramic images is to use a tripod.

Now that you have your series of overlapping images, you can import them into your image-processing software to stitch them together and create a single panoramic image.

SORTING YOUR SHOTS FOR THE MULTI-IMAGE PANORAMA

If you shoot more than one series of shots for your panoramas, it can sometimes be difficult to know when one series of images ends and the other begins. Here is a quick tip for separating your images.

Set up your camera using the steps listed here. Now, before you take your first good exposure in the series, hold up one finger in front of the camera and take a shot. Now move your hand away and begin taking your overlapping images. When you have taken your last shot, hold two fingers in front of the camera and take another shot.

Now when you go to review your images, use the series of shots that falls between the frames with one and two fingers in them. Then just repeat the process for your next panorama series.

FIGURE 7.27
Here you see the makings of a panorama, with five shots overlapping by about 30 percent from frame to frame.

ISO 100
1/100 sec.
f/5
50mm lens

FIGURE 7.28
I used Adobe Photoshop to combine all of the exposures into one large panoramic image.

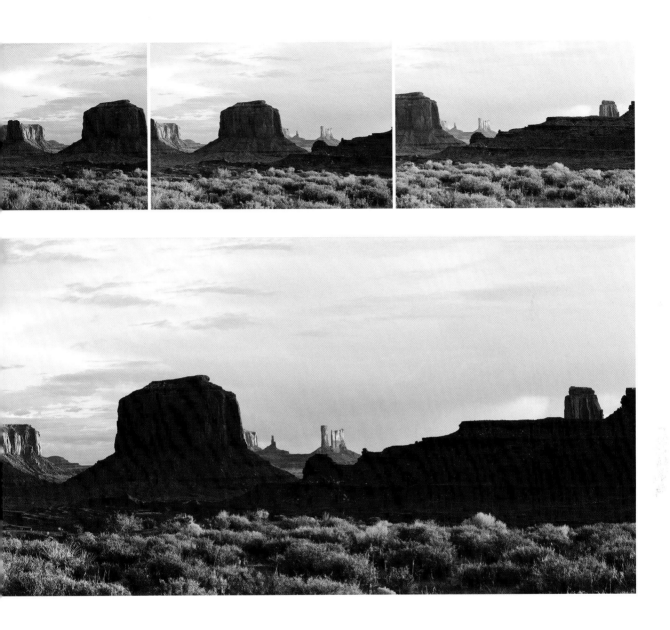

1. Mount your camera on your tripod and make sure it is level.

2. Choose a focal length for your lens that is somewhere between 35mm and 50mm.

3. In Aperture Priority mode, use a small aperture, if possible, for the greatest depth of field. Take a meter reading of a bright part of the scene, and make note of it.

4. Now change your camera to Manual mode (M), and dial in the aperture and shutter speed that you obtained in the previous step.

5. Set your lens to manual focus, and then focus your lens for the area of interest using the HFD method of finding a point one-third of the way into the scene. (If you use the autofocus, you risk getting different points of focus from image to image, which will make the image stitching more difficult for the software.)

6. While carefully panning your camera, shoot your images to cover the entire area of the scene from one end to the other, leaving a 30-percent overlap from one frame to the next.

7. The final step would involve using your favorite imaging software to take all of the photographs and then combine them into a single panoramic image.

SHOOTING HIGH DYNAMIC RANGE (HDR) IMAGES

One of the more recent trends in digital photography is the use of high dynamic range (HDR) imaging to capture the full range of tonal values in your final image. Typically, when you photograph a scene that has a wide range of tones from shadows to highlights, you have to make a decision regarding which tonal values you are going to emphasize and then adjust your exposure accordingly. This is because your camera has a limited dynamic range, at least as compared to the human eye. HDR photography allows you to capture multiple exposures for the highlights, shadows, and midtones, and then combine them into a single image using software (**Figures 7.29–7.32**). A number of software applications allow you to combine the images and then perform a process called "tonemapping," whereby the complete range of exposures is represented in a single image. I will not be covering the software applications, but I will explore the process of shooting a scene to help you render properly captured images for the HDR process. Note that using a tripod is *absolutely necessary* for this technique, since you need to have perfect alignment of each image when they are combined.

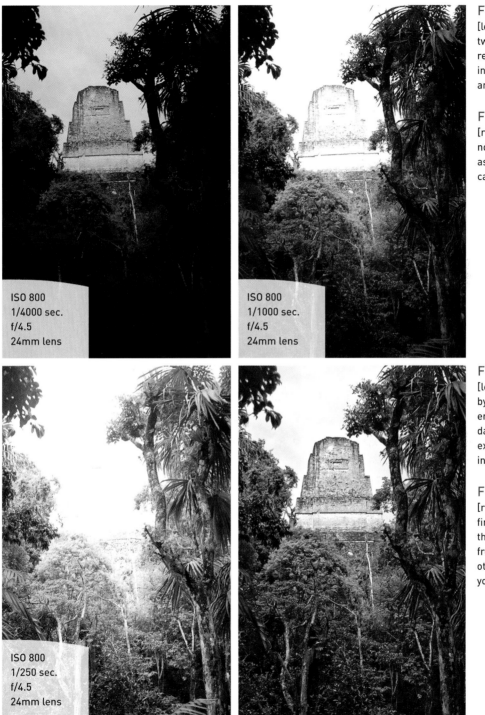

ISO 800
1/4000 sec.
f/4.5
24mm lens

ISO 800
1/1000 sec.
f/4.5
24mm lens

ISO 800
1/250 sec.
f/4.5
24mm lens

FIGURE 7.29
[left] Underexposing two stops will render more detail in the highlight areas of the clouds.

FIGURE 7.30
[right] This is the normal exposure as dictated by the camera meter.

FIGURE 7.31
[left] Overexposing by two stops ensures that the darker areas are exposed for detail in the shadows.

FIGURE 7.32
[right] This is the final HDR image that was rendered from the three other exposures you see here.

SETTING UP FOR SHOOTING AN HDR IMAGE

1. Set your ISO to 100 to ensure clean, noise-free images.

2. Set your shooting mode to Aperture Priority. During the shooting process, you will be taking three shots of the same scene, creating an overexposed image, an underexposed image, and a normal exposure. Since the camera is going to be adjusting the exposure, you want it to make changes to the shutter speed, not the aperture, so that your depth of field is consistent.

3. Set your camera file format to RAW. This is extremely important because the RAW format contains a much larger range of exposure values than a JPEG file and the HDR software needs this information.

4. Focus the camera using the manual focus method discussed earlier in the chapter, compose your shot, and secure the tripod.

5. Press the shutter button halfway to activate the meter and the set your exposure.

6. Use the Exposure Compensation on your camera to get your first exposure of –2 stops. Take one photo.

7. Now use the Exposure Compensation again and set the exposure to normal and take a picture.

8. Finally, repeat the last step and use Exposure Compensation to get your two stops of overexposure and take a shot.

This is just one way to actually capture the necessary images. Some cameras have auto-bracketing features built in that allow you to set the amount of over- and underexposure. Then the camera will calculate the exposure changes as you take three images.

Some folks prefer to use the Manual shooting mode. Then once they have computed a normal exposure using the camera meter they simply dial in the necessary shutter speed changes for over- and underexposure. There really is no wrong or right way as long as you get the exposures you need.

Once you have the images, you need a software program, such as Photoshop CS5, Photomatix Pro, HDR PhotoStudio 2, or any of the dozen other programs that can process your exposure-bracketed images into a single HDR file. You can find more information on HDR photography and creating HDR images in the Tutorials section at www.photowalkpro.com.

BRACKETING YOUR EXPOSURES

In HDR, bracketing is the process of capturing a series of exposures at different stop intervals. You can bracket your exposures even if you aren't going to be using HDR. Sometimes this is helpful when you have a tricky lighting situation and you want to ensure that you have just the right exposure to capture the look you're after. In HDR, you bracket to the plus and minus side of a "normal" exposure, but you can also bracket all of your exposures to the over or under side of normal. It all depends on what you are after. If you aren't sure whether you are getting enough shadow detail, you can bracket a little toward the overexposed side. The same is true for highlights. You can bracket in increments as small as a third of a stop. This means that you can capture several images with very subtle exposure variances and then decide later which one is best. If you want to bracket just to one side of a normal exposure, set your exposure compensation to +1 or –1, whichever way you need, and then use the bracketing method discussed above to bracket your exposures.

Chapter 7 Assignments

We've covered a lot of ground in this chapter, so it's definitely time to put this knowledge to work in order to get familiar with these new camera settings and techniques.

Comparing depth of field: Wide-angle vs. telephoto

Speaking of depth of field, you should also practice using the hyper focal distance of your lens to maximize the depth of field. You can do this by picking a focal length to work with on your lens.

If you have a zoom lens, try using the longest length. Compose your image and find an object to focus on. Set your aperture to f/22 and take a photo.

Now do the same thing with the zoom lens at its widest focal length. Use the same aperture and focus point.

Review the images and compare the depth of field when using wide angle as opposed to a telephoto lens. Try this again with a large aperture as well.

Applying hyper focal distance to your landscapes

Pick a scene that once again has objects that are near the camera position and something that is clearly defined in the background. Try using a wide to medium wide focal length for this (18–35mm). Use a small aperture and focus on the object in the foreground; then recompose and take a shot.

Without moving the camera position, use the object in the background as your point of focus and take another shot.

Finally, find a point that is one-third of the way into the frame from near to far and use that as the focus point.

Compare all of the images to see which method delivered the greatest range of depth of field from near to infinity.

Placing your horizons

Finally, find a location with a defined horizon and, using the rule-of-thirds grid overlay, shoot the horizon along the top third of the frame, in the middle of the frame, and along the bottom third of the frame.

Share your results with the book's Flickr group!

Join the group here: flickr.com/groups/exposure_fromsnapshotstogreatshots

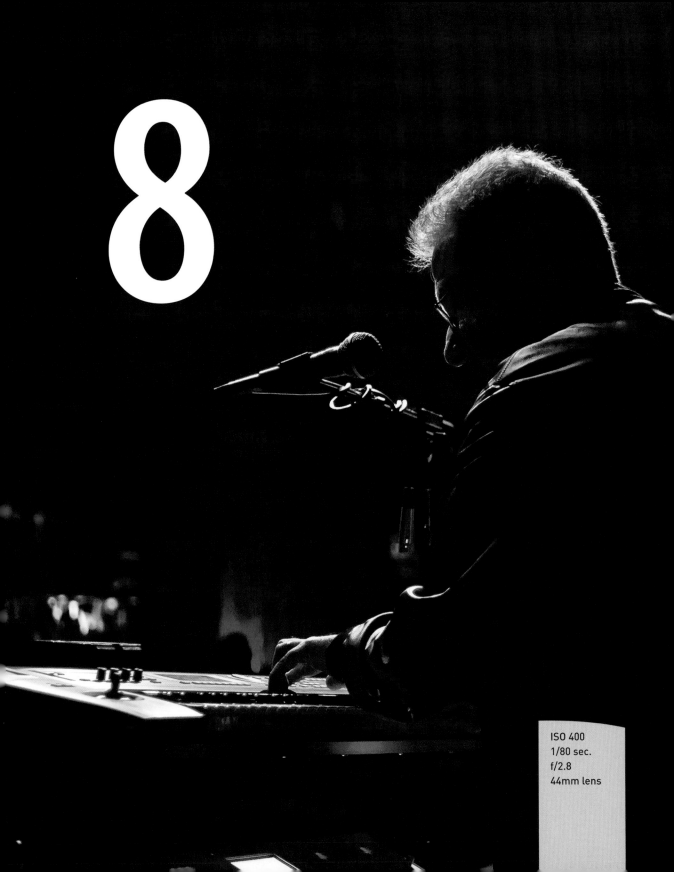

8

ISO 400
1/80 sec.
f/2.8
44mm lens

Mood Lighting

SHOOTING WHEN THE LIGHTS GET LOW

There is no reason to put your camera away when the sun goes down.
Your DSLR has features that let you work with available light as well as the
built-in flash. In this chapter, we will explore ways to push your camera's
technology to the limit in order to capture great photos in difficult lighting
situations. We will also explore the use of flash and how best to utilize the
pop-up flash features to improve your photography. But let's first look at
working with low-level available light.

The first couple of shots with the flash on were way too much for the flowers so I used flash compensation to reduce the power by 2 stops.

As my day of shooting the sunflowers in Maryland was closing to an end, I came across one last field that I just couldn't pass up. The flowers were huge, the sky looked great, and I still had a charge on my battery and space on my memory card. The only problem was that the sun was going down behind the flowers. Who knew that they grew facing East? I didn't let that stop me, though. Not as long as I had a flash built into my camera.

Since there was bright sky and clouds behind the flowers, I decided to stick with the Matrix meter to read the entire frame.

To darken the skies a bit, I dialed in –2/3 of a stop of underexposure.

The background is out of focus despite the small aperture because I was shooting from close range with a fairly long focal length.

ISO 200
1/60 sec.
f/22
70mm lens

RAISING THE ISO: THE SIMPLE SOLUTION

Let's begin with the obvious way to keep shooting when the lights get low: raising the ISO (**Figure 8.1**). By now you know should know how to change the ISO on your camera. In typical shooting situations, you should keep the ISO in the 100–800 range. This will keep your pictures nice and clean by keeping the digital noise to a minimum. But as the available light gets low, you might find yourself working in the higher ranges of the ISO scale, which could lead to more noise in your image.

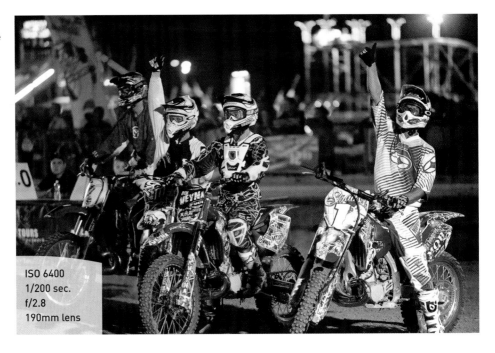

ISO 6400
1/200 sec.
f/2.8
190mm lens

You could use the flash, but typically it will have a limited range (15–20 feet) that might not work for you. Also, you could be in a situation where flash is prohibited, or at least frowned upon, like at a wedding or in a museum.

And what about a tripod in combination with a long shutter speed? That is also an option, and we'll cover it a little further into the chapter. The problem with using a tripod and a slow shutter speed in low-light photography, though, is that it performs best when subjects aren't moving. Besides, try to set up a tripod in a museum and see how quickly you grab the attention of the security guards.

So if the only choice to get the shot is to raise the ISO to 800 or higher, make sure that you turn on the your Noise Reduction feature. If you don't know how to turn it on you should check out your owner's manual.

To see the effect of Noise Reduction, you need to zoom in and take a closer look (**Figures 8.2** and **8.3**).

ISO 6400
1/200 sec.
f/5.6
55mm lens

FIGURE 8.2
Here is an enlargement of a flower shot at a high ISO without any Noise Reduction.

ISO 6400
1/200 sec.
f/5.6
55mm lens

FIGURE 8.3
Here is the same flower photographed with Noise Reduction turned to On. While it doesn't get rid of all the noise, it certainly reduces the effect and improves the look of the image.

Turning on the Noise Reduction feature slightly increases the processing time for your images, so if you are shooting in the Continuous drive mode you might see a little reduction in the speed of your frames per second.

USING VERY HIGH ISOs

Is ISO 3200 just not enough for you? Well, many of today's new DSLR cameras can push the upper ends of the ISO scale to crazy sensitivities. I'm talking about ISOs of 6400, 12800, even 25600. With ISOs like that, you can almost shoot in the dark.

USING THE HIGHER ISO SETTINGS

Some cameras have a normal ISO range and then an expanded ISO range to get an extra one or two stops of ISO. Here's a word of warning about the expanded ISO settings: although it is great to have these high ISO settings available during low-light

shooting, it should always be your last resort. Even with the Noise Reduction turned on, the amount of visible noise will be very high. That being said, you might find yourself at a nighttime sporting event under the lights, which would require a really high ISO to improve your shutter speeds to capture the action (**Figure 8.4**).

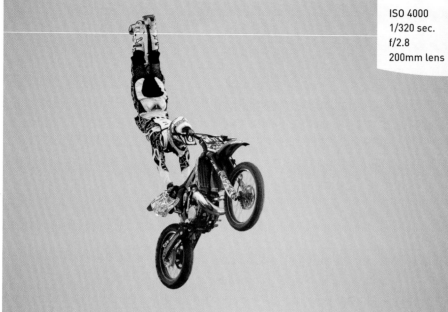

ISO 4000
1/320 sec.
f/2.8
200mm lens

FIGURE 8.4
The only way to get a fast-enough shutter speed during this night motocross event was to raise the ISO to 4000.

STABILIZING THE SITUATION

If you purchased your camera with a Vibration Reduction (VR) or Image Stabilization (IS) lens, you already own a great tool to squeeze two stops of exposure out of your camera when shooting without a tripod. Typically, the average person can handhold their camera down to about 1/60 of a second before blurriness results due to hand shake. As the length of the lens is increased (or zoomed), the ability to handhold at slow shutter speeds (1/60 and slower) and still get sharp images is further reduced.

The lenses contain small gyro sensors and servo-actuated optical elements, which correct for camera shake and stabilize the image. They function so well that it is possible to improve your handheld photography by two or three stops, meaning that if you are pretty solid at a shutter speed of 1/60, the VR/IS feature lets you shoot at 1/15, and possibly even 1/8 of a second (**Figures 8.5** and **8.6**). When shooting in low-light situations, make sure you set the VR or IS switch on the side of your lens to the On position.

FIGURE 8.5
This image was handheld with the Nikon VR turned off.

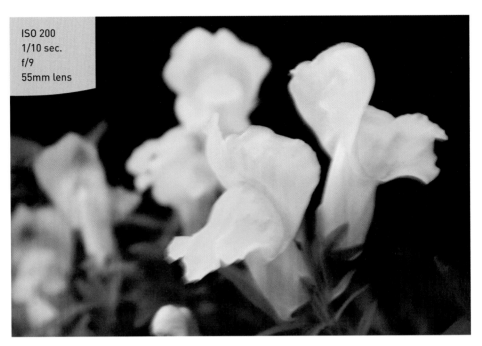

ISO 200
1/10 sec.
f/9
55mm lens

FIGURE 8.6
Here is the same subject shot with the same camera settings but this time I turned the VR on.

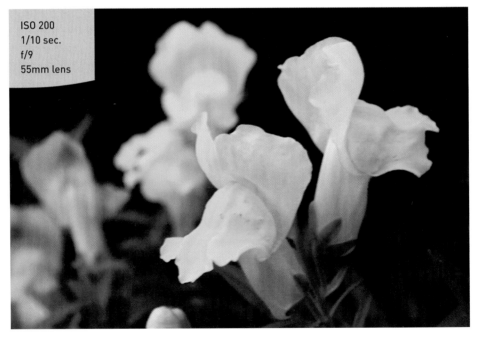

ISO 200
1/10 sec.
f/9
55mm lens

Whether you are shooting with a tripod or even resting your camera on a wall, you can increase the sharpness of your pictures by taking your hands out of the equation. Whenever you use your finger to depress the shutter release button, you are increasing the chance that there will be a little bit of shake in your image. To eliminate this possibility, try setting your camera up to use the self-timer. Many cameras have two self-timer modes: 2 and 10 seconds. I generally use the two-second mode to cut down on time between exposures.

FOCUSING IN LOW LIGHT

Auto focus systems are amazing but occasionally the light levels might be too low for the camera to achieve an accurate focus. There are a few things that you can do to overcome this obstacle.

First, you should know that the camera utilizes contrast in the viewfinder to establish a point of focus. This is why your camera will not be able to focus when you point it at a white wall or a cloudless sky. It simply can't find any contrast in the scene to work with. Knowing this, you might be able to use a single focus point to find an area of contrast that is of the same distance as your subject. You can then hold that focus by holding down the shutter button halfway and recomposing your image.

Then there are those times when there just isn't anything there for you to focus on. A perfect example of this would be a fireworks display. If you point your lens to the night sky in any automatic focus mode, it will just keep searching for—and not finding—a focus point. On these occasions, you can simply turn off the autofocus feature and manually focus the lens (**Figure 8.7**).

Don't forget to put it back in auto focus mode at the end of your shoot.

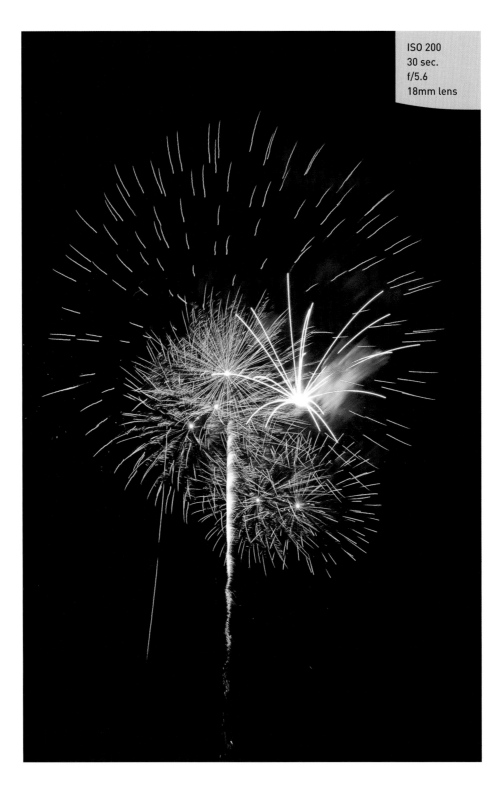

FIGURE 8.7
Focusing on the night sky is best done in manual focus mode.

ISO 200
30 sec.
f/5.6
18mm lens

AF ASSIST

Another way to ensure good focus is to use your camera's auto focus assist. Most auto focus assist modes use a small, bright beam of light or an infrared beam from the front of the camera to shine some light on the scene, which assists the autofocus system in locating more detail. This feature is automatically activated when using the flash. Also, auto focus assist will usually be disabled when shooting in continuous or manual focus mode, as well as when the feature is turned off in the camera menu.

Some cameras need to be set to the center focus point for the auto focus assist to work, so check your manual for specific instructions.

SHOOTING LONG EXPOSURES

We have covered some of the techniques for shooting in low light, so let's go through the process of capturing a night or low-light scene for maximum image quality (**Figure 8.8**). The first thing to consider is that in order to shoot in low light with a low ISO, you will need to use shutter speeds that are longer than you could possibly handhold (longer than 1/15 of a second). This will require the use of a tripod or stable surface for you to place your camera on. For maximum quality, the ISO should be low—somewhere below 400. The noise reduction should be turned on to minimize the effects of exposing for longer durations.

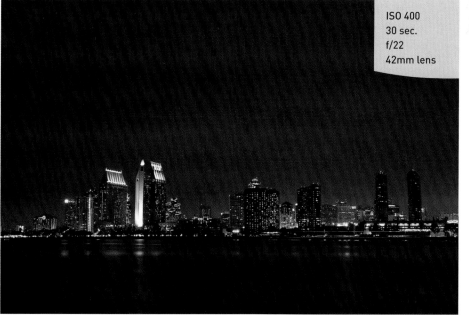

ISO 400
30 sec.
f/22
42mm lens

FIGURE 8.8
A long exposure and a tripod were necessary to catch the lights of the San Diego skyline at night.

Once you have the noise reduction turned on, set your camera to Aperture Priority (A or Av) mode. This way, you can concentrate on the aperture that you believe is most appropriate and let the camera determine the best shutter speed. If it is too dark for the autofocus to function properly, try manually focusing. Finally, consider using a remote switch to activate the shutter. If you don't have one, check out the sidebar on page 187 on using the self-timer. Once you shoot the image, you may notice some lag time before it is displayed on the rear LCD. This is due to the noise reduction process, which can take anywhere from a fraction of a second up to 30 seconds, depending on the length of the exposure. Typically the noise reduction process will take the same amount of time as the exposure itself.

FLASH SYNC

The basic idea behind the term *flash synchronization (flash sync* for short) is that when you take a photograph using the flash, the camera needs to ensure that the shutter is fully open at the time that the flash goes off. This is not an issue if you are using a long shutter speed such as 1/15 of a second, but it does become more critical for fast shutter speeds. To ensure that the flash and shutter are synchronized so that the flash is going off while the shutter is open, most cameras implement a top sync speed of 1/200 or 1/250 of a second. This means that when you are using the flash, you will not be able to have your shutter speed be any faster than 1/200 or 1/250. If you did use a faster shutter speed, the shutter would actually start closing before the flash fired, which would cause a black area to appear in the frame where the light from the flash was blocked by the shutter.

USING THE BUILT-IN FLASH

There are going to be times when you have to turn to your camera's built-in flash to get the shot. Typically, the pop-up flash is not extremely powerful, but with the camera's metering system it does a pretty good job of lighting up the night…or just filling in the shadows.

If you are working with an automatic shooting mode, the flash should automatically activate when needed. If, however, you are working in one of the advanced shooting modes like Aperture Priority or Shutter Priority mode, you will have to turn the flash on for yourself (**Figure 8.9**).

FIGURE 8.9
The pop-up flash on a Nikon D3100 in its ready position.

FLASH RANGE

Because the pop-up flash is fairly small, it does not have enough power to illuminate a large space (**Figure 8.10**). The effective distance varies depending on the ISO setting. At ISO 200, the range is about 13 feet. This range can be extended to as far as 27 feet when the camera is set to an ISO of 1600. For the best image quality, your ISO setting should not go above 800. Anything higher will begin to introduce excessive noise into your photos. Check out your manual for more information on the effective flash range for differing ISO and aperture settings.

ISO 200
1/60 sec.
f/22
70mm lens

FIGURE 8.10
The pop-up flash was used as a fill flash to illuminate the front of the sunflowers. This is very handy when you are shooting with the sun coming in from behind your subjects.

SHUTTER SPEEDS

The standard flash synchronization speed for your camera is somewhere between 1/60 and 1/200 of a second. When you are working with the built-in flash in the automatic and scene modes, the camera will typically use a shutter speed of 1/60 of a second. The exception to this is when you use a Night Portrait mode, which will fire the flash with a slower shutter speed so that some of the ambient light in the scene has time to record in the image.

The real key to using the flash to get great pictures is to control the shutter speed. The goal is to balance the light from the flash with the existing light so that everything in the picture has an even illumination.

METERING MODES

The built-in flash uses a technology called TTL (Through The Lens) metering to determine the appropriate amount of flash power to output for a good exposure. When you depress the shutter button, the camera quickly adjusts focus while gathering information from the entire scene to measure the amount of ambient light. As you press the shutter button down completely, the flash uses that exposure information and fires a predetermined amount of light at your subject during the exposure.

The default setting for most built-in flashes is TTL (this terminology might be slightly different for your camera system but the concept is still the same). The meter can also be set to Manual mode. In Manual flash mode, you can determine how much power you want coming out of the flash ranging from full power all the way down to about 1/32 power. Each setting from full power on down will cut the power by half. This is the equivalent of reducing flash exposure by one stop with each power reduction.

COMPENSATING FOR THE FLASH EXPOSURE

The TTL system will usually do an excellent job of balancing the flash and ambient light for your exposure, but it does have the limitation of not knowing what effect you want in your image. You may want more or less flash in a particular shot. You can achieve this by using the Flash Exposure Compensation feature.

Just as with exposure compensation, flash compensation allows you to dial in a change in the flash output in increments of 1/3 of a stop. You will probably use this most often to tone down the effects of your flash, especially when you are using the flash as a subtle fill light (**Figures 8.11** and **8.12**).

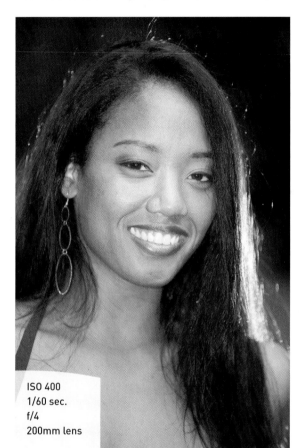

ISO 400
1/60 sec.
f/4
200mm lens

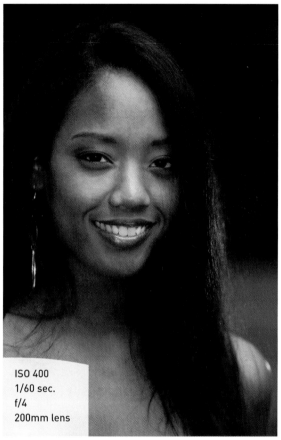

ISO 400
1/60 sec.
f/4
200mm lens

FIGURE 8.11
This shot was taken with the pop-up flash set to normal power. As you can see, it was trying too hard to illuminate my subject.

FIGURE 8.12
This image was made with the same settings. The difference is that the flash compensation was set to −1.3 stops.

REDUCING RED-EYE

We've all seen the result of using on-camera flashes when shooting people: the dreaded red-eye! This demonic effect is the result of the light from the flash entering the pupil and then reflecting back as an eerie red glow. The closer the flash is to the lens, the greater the chance that you will get red-eye. This is especially true when it is dark and the subject's pupils are fully dilated. There are two ways to combat this problem. The first is to get the flash away from the lens. That's not really an option, though, if you are using the pop-up flash. Therefore, you will need to turn to the Red-Eye Reduction feature.

This is a simple feature that shines a light from the camera at the subject, causing their pupils to shrink, thus eliminating or reducing the effects of red-eye (**Figure 8.13**). The feature is set to Off by default, so be sure to turn it on if you'd like to use it.

FIGURE 8.13
The picture on the left did not utilize Red-Eye Reduction, thus the glowing red eyes. Notice that the pupils on the image on the right, without red-eye, are smaller as a result of using the Red-Eye Reduction lamp.

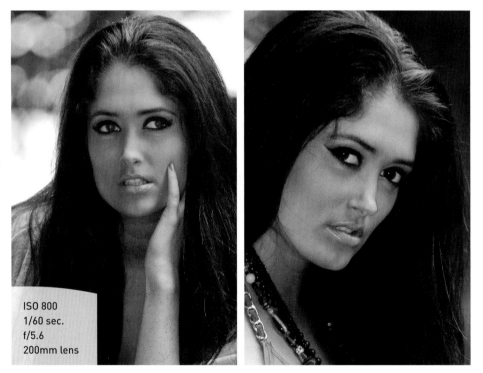

ISO 800
1/60 sec.
f/5.6
200mm lens

When red-eye reduction is activated, the camera will not fire the instant that you press the shutter release button. Instead, the red-eye reduction lamp will illuminate for a second or two and then fire the flash for the exposure. This is important to remember as people have a tendency to move around, so you will need to instruct them to hold still for a moment while the lamp works its magic.

Some cameras use a completely different system to reduce red-eye. Instead of a bright lamp, the camera will fire a series of pre-flashes that will reduce the size of the pupil, thereby reducing the amount of red-eye.

Truth be told, I rarely shoot with red-eye reduction turned on because of the time it takes before being able to take a picture. If I am after candid shots and have to use the flash, I will take my chances on red-eye and try to fix the problem in my image processing software. Some cameras now even support red-eye correction right in the camera as part of a built-in retouching feature.

TURN ON THE LIGHTS!

When shooting indoors, another way to reduce red-eye, or just shorten the length of time that the reduction lamp needs to be shining into your subject's eyes, is to turn on a lot of lights. The brighter the ambient light levels, the smaller the subject's pupils will be. This will reduce the time necessary for the red-eye reduction lamp to shine. It will also allow you to take more candid pictures because your subjects won't be required to stare at the red-eye lamp while waiting for their pupils to reduce.

REAR CURTAIN SYNC

There are two flash synchronization modes when shooting with flash. There's front curtain and rear curtain (some manufacturers call this 1st and 2nd curtain). You may be asking, "What in the world does synchronization do, and what's with these 'curtains'?" Good question.

When your camera fires, there are two curtains that open and close to make up the shutter. The first, or front, curtain moves out of the way, exposing the camera sensor to the light. At the end of the exposure, the second, or rear, curtain moves in front of the sensor, ending that picture cycle. In flash photography, timing is extremely important because the flash fires in milliseconds and the shutter is usually opening in tenths or hundredths of a second. To make sure these two functions happen in order, the camera usually fires the flash just as the first curtain moves out of the way (see the sidebar earlier in the chapter about flash sync).

In Rear Curtain Sync (also called 2nd Curtain Sync by some manufacturers) mode, the flash will not fire until just before the second shutter curtain ends the exposure. So, why have this mode at all? Well, there might be times when you want to have a longer exposure to balance out the light from the background to go with the subject

needing the flash. Imagine taking a photograph of a friend standing in Times Square at night with all the traffic moving about and the bright lights of the streets overhead. If the flash fires at the beginning of the exposure, and then the objects around the subject move, those objects will often blur or even obscure the subject a bit. If the camera is set to Rear Curtain Sync all of the movement is recorded using the existing light first, and then the subject is "frozen" by the flash at the end by the exposure.

There is no right or wrong to it. It's just a decision on what type of effect it is that you would like to create. Many times, Rear Curtain Sync is used for artistic purposes or to record movement in the scene without it overlapping the flash-exposed subject (**Figure 8.14**). To make sure that the main subject is always getting the final pop of the flash, I leave my camera set to Rear Curtain Sync most of the time.

Figure 8.15 shows an example of a fairly long exposure to record the light trails from the passing traffic, with a burst of flash at the end that gives a ghostly appearance to the subject.

If you do intend to use a long exposure with first curtain synchronization, you need to have your subject remain fairly still so that any movement that occurs after the flash goes off will be minimized in the image (**Figure 8.16**).

FIGURE 8.14
Using Rear Curtain Sync is most evident during long flash exposures.

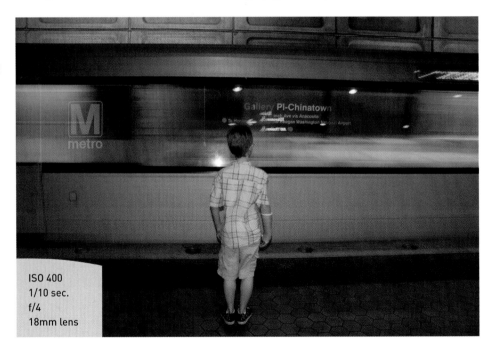

ISO 400
1/10 sec.
f/4
18mm lens

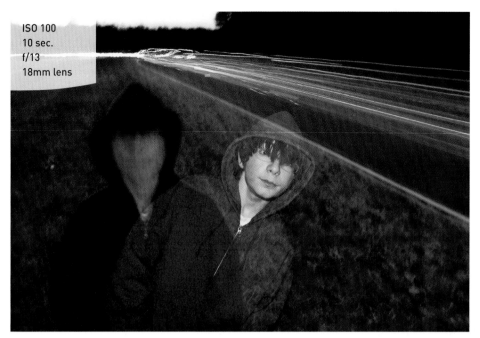

ISO 100
10 sec.
f/13
18mm lens

FIGURE 8.15
This effect is possible because the flash fired at the end of the exposure using Rear Curtain Sync.

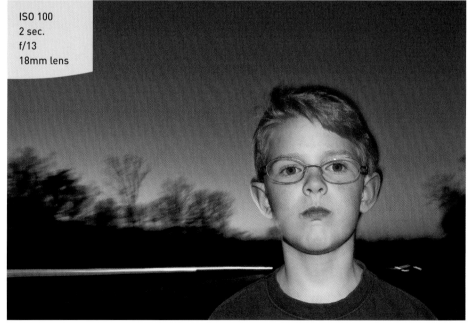

ISO 100
2 sec.
f/13
18mm lens

FIGURE 8.16
Front Curtain Sync is the default setting for flash photography and can be used for longer exposures as long as the subject remains still.

FLASH AND GLASS

If you find yourself in a situation where you want to use your flash to shoot through a window or display case, try placing your lens right against the glass so that the reflection of the flash won't be visible in your image (**Figures 8.17** and **8.18**). This is extremely useful in museums and aquariums.

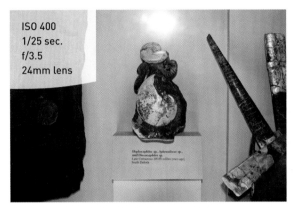

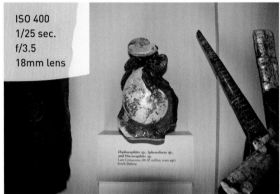

FIGURE 8.17
The bright spot at the top of the frame is a result of the flash reflecting off the display case.

FIGURE 8.18
To eliminate the reflection, place the lens against the glass or as close to it as possible. This might also require zooming the lens out a little.

A FEW WORDS ABOUT EXTERNAL FLASH

We have discussed several ways to get control over the built-in pop-up flash. The reality is that, as flashes go, it will only render fairly average results. For people photography, it is probably one of the most unflattering light sources that you could ever use. This isn't because the flash isn't good—it's actually very sophisticated for its size. The problem is that light should come from any direction besides the camera to best flatter a human subject. When the light emanates from directly above the lens, it gives the effect of becoming a photocopier. Imagine putting your face down on a scanner: the result would be a flatly lit, featureless photo.

To really make your flash photography come alive with possibilities, you should consider buying an external flash such like a Nikon SB600 Speedlight, a Canon 430EX II, or even a third-party shoe-mounted flash from Metz or Sunpak. Some of the advantages to these flash units are the swiveling flash head to redirect the light, more power, and communication with the camera and the TTL system to deliver balanced flash exposures. A shoe-mounted flash does represent a more substantial investment but if you want more flexibility with your flash photography, it will pay huge dividends.

OFF-CAMERA FLASH

Another advantage of having a separate flash unit is the flexibility to move the flash from the camera to a position that is off camera. The reason for this is that the further the light gets from the camera, the more pleasing and natural the light will look (**Figure 8.19**). Some camera flash systems—like those from Canon and Nikon—support wireless, untethered flash operations, depending on which flash head you are using. You can also use a flash cord that attaches to the camera's hotshoe and sends the TTL signal to the flash (**Figure 8.20**). This is a little more restrictive than a wireless system but still very useful and not nearly as costly.

ISO 200
1/250 sec.
f/11
70mm lens

FIGURE 8.19
I used two wireless off-camera flashes fired through umbrellas to create this portrait.

FIGURE 8.20
Remote cords like this Nikon SC-28 allow you to get your flash away from the camera's hot shoe.

Chapter 8 Assignments

Now that we have looked at the possibilities of shooting after dark, it's time to put it all to the test. These assignments cover the full range of shooting possibilities, both with flash and without. Let's get started.

How steady are your hands?

It's important to know just what your limits are in terms of handholding your camera and still getting sharp pictures. This will change depending on the focal length of the lens you are working with. Wider angle lenses are more forgiving than telephoto lenses, so check this out for your longest and shortest lenses. Using the 18–55mm zoom as an example, set your lens to 55mm and then, with the camera set to ISO 200 and the mode set to Shutter Priority, turn off the VR or IS and start taking pictures with lower and lower shutter speeds. Review each image on the LCD at a zoomed-in magnification to take note of when you start seeing visible camera shake in your images. It will probably be around 1/60 of a second for a 55mm lens.

Now do the same for the wide-angle setting on the lens. My limit is about 1/30 of a second. These shutter speeds are with the Vibration Reduction (or Image Stabilization) feature turned off. If you have a VR or IS lens, try it with and without the VR/IS feature enabled to see just how slow you can set your shutter while getting sharp results.

Pushing your ISO to the extreme

Find a place to shoot where the ambient light level is low. This could be at night or indoors in a darkened room. Using the mode of your choice, start increasing the ISO from 100 until you get to your highest ISO setting. Make sure you evaluate the level of noise in your image, especially in the shadow areas. Only you can decide how much noise is acceptable in your pictures. I can tell you from personal experience that I never like to stray above that ISO 800 mark.

Getting rid of the noise

Turn on the Noise Reduction and repeat the previous assignment. Find your acceptable limits with the noise reduction turned on. Also pay attention to how much detail is lost in your shadows with this function enabled.

Long exposures in the dark

If you don't have a tripod, find a stable place to set your camera outside and try some long exposures. Set your camera to Aperture Priority mode and then use the self-timer to activate the camera (this will keep you from shaking the camera while pressing the shutter button).

Shoot in an area that has some level of ambient light, be it a streetlight or traffic lights, or even a full moon. The idea is to get some late-night low-light exposures.

Testing the limits of the pop-up flash

Wait for the lights to get low and then press that pop-up flash button to start using the built-in flash. Try using the different shooting modes to see how they affect your exposures. Use the Flash Exposure Compensation feature to take a series of pictures so that you become familiar with how much latitude you will get from this feature.

Getting the red out

Find a friend with some patience and a tolerance for bright lights. Have them sit in a darkened room or outside at night and then take their picture with the flash. Now turn on the Red-Eye Reduction feature to see if you get better results. Don't forget to have them sit still while the red-eye lamp or pre-flash does its thing.

Getting creative with Rear/2nd Curtain Sync

Now it's time for a little creative fun. Set your camera up for Rear (or 2nd) Curtain Sync and start shooting. Moving targets are best. Experiment with Shutter and Aperture Priority modes to lower the shutter speeds and exaggerate the effect. Try using a low ISO so the camera is forced to use longer shutter speeds. Be creative and have some fun!

Share your results with the book's Flickr group!

Join the group here: flickr.com/groups/exposure_fromsnapshotstogreatshots

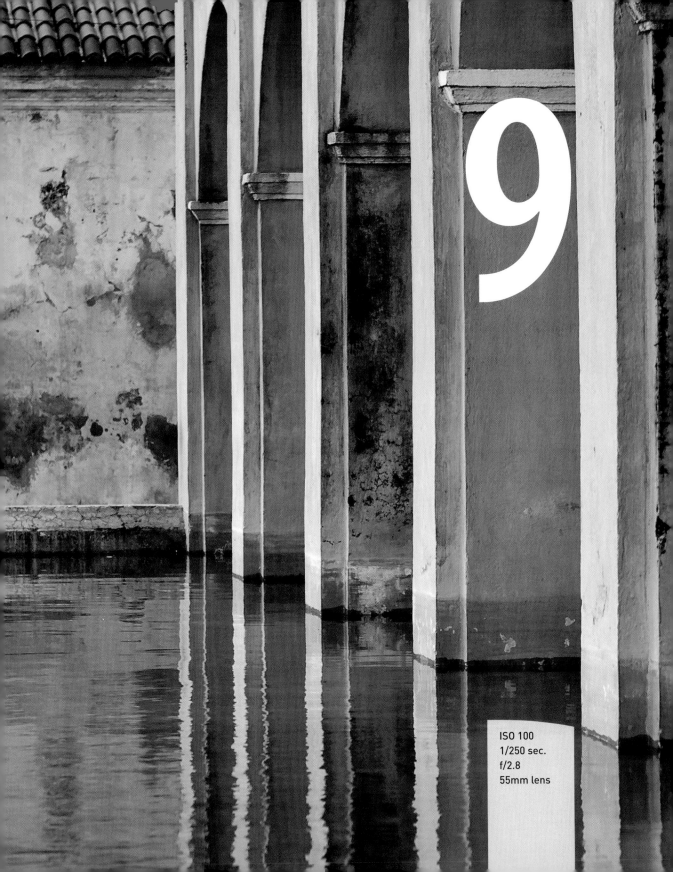

9

ISO 100
1/250 sec.
f/2.8
55mm lens

Creative Compositions

IMPROVE YOUR PICTURES WITH SOUND COMPOSITIONAL ELEMENTS

Creating a great photograph takes more than just the right settings on your camera. To take your photography to the next level, you need to gain an understanding of how the elements within the frame come together to create a compositionally pleasing image. Composition is the culmination of light, shape, and, to borrow a word from the iconic photographer Jay Maisel, gesture. Composition is a way for you to pull your viewers into your image and guide them through the scene. Let's examine a few methods you can use to add interest to your photos by utilizing some common compositional elements.

I'm a big fan of architecture photography. I love capturing the spirit of a great building and making the vision of the architect merge with my own reality of how I see their design. Did they intend for me to see what I see or did they have something else in mind? This particular façade belongs to one of the most beautiful churches I have ever seen: La Merced Church in Antigua, Guatemala. I was equally blessed to have some wonderful light that day as the yellows and whites seemed to be especially vivid and added to the compositional possibilities.

ISO 100
1/320 sec.
f/10
220mm lens

There is a convergence of horizontal, vertical, and diagonal lines that keeps the eyes moving around the image.

The use of a telephoto lens visually compresses the distance between the columns, making them seem closer than they are.

Although the colors were very bright, care was taken not to overexpose the whites and lose any detail.

The wooden drain spouts create a leading line towards the white dome.

It was extremely bright that afternoon so there was no problem getting a small aperture and a low ISO while hand-holding the camera.

There are three leading lines coming in from the left that all converge at the arch.

There are so many different ways to photograph a subject. It all comes down to your vision and how you want to express it in your image. On this day in St. Louis, I had circled the arch from every conceivable angle, trying to find just the right shot. I kept coming back to this spot by the pond so I guess it was just the right location for me.

The warm light on the trees from the late afternoon sun balances perfectly against the cool blue of the sky.

ISO 100
1/100 sec.
f/18
48mm lens

The point of focus was placed on the duck by the water's edge, about a third of the way into the scene.

Or perhaps you are photographing a reflection in a puddle or lake. With a narrow depth of field, you could only get the reflected object or the puddle in focus. By making the aperture smaller, you will be able to maintain acceptable sharpness in both areas (**Figure 9.4**).

FIGURE 9.4
Getting a distant subject in focus in a reflection, along with the reflective surface, requires a small aperture.

ISO 640
1/160 sec.
f/9
70mm lens

PHOTOGRAPHING REFLECTIONS

A mirror is a two-dimensional surface, so why do I have to focus at a different distance for the image in the mirror? This was one of those questions that drove me crazy when I began to learn about photography. The answer is pretty simple, and it has to do with light. When you focus your lens, you are focusing the light being reflected off a surface onto your camera sensor. So if you wanted to focus on the mirror itself, it would be at one distance, but if you wanted to focus on the subject being reflected, you would have to take into account the distance that the object is from the mirror and then to you. Remember that the light from the subject has to travel all the way to the mirror and then to your lens. This is why a smaller aperture can be required when shooting reflected subjects. Sit in your car and take a few shots of objects in the side view mirrors to see what I mean.

ANGLES

Having strong angular lines in your image can add to the composition, especially when they are juxtaposed to each other (**Figure 9.5**). This can create a tension that is different from the standard horizontal and vertical lines that we are so accustomed to seeing in photos.

ISO 100
1/320 sec.
f/10
220mm lens

FIGURE 9.5
The strong angular lines of the building create a dynamic composition.

There are times when you can accentuate the angles in your images by tilting the camera, thus adding an unfamiliar angle to the subject, which draws the viewer's attention (**Figure 9.6**).

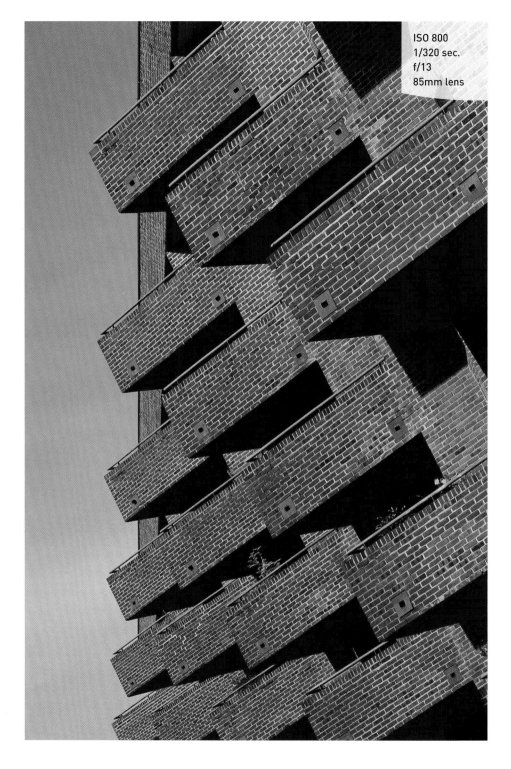

FIGURE 9.6
By tilting the camera, I was able to create an unfamiliar view of the balconies, which can create more visual interest.

ISO 800
1/320 sec.
f/13
85mm lens

POINT OF VIEW

Sometimes the easiest way to influence your photographs is to simply change your perspective. Instead of always shooting from a standing position, try moving your camera to a place where you normally would not see your subject. Try getting down on your knees or even lying on the ground. This low angle can completely change how you view your subject, creating a new interest in common subjects (**Figure 9.7**).

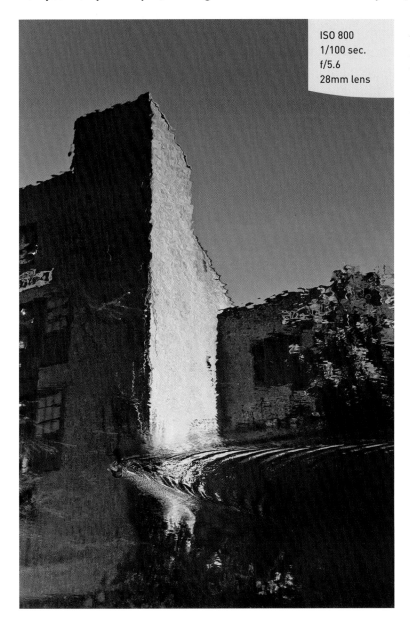

ISO 800
1/100 sec.
f/5.6
28mm lens

FIGURE 9.7
You might not notice at first glance that this was shot to display upside down, giving a unique look to the scene.

PATTERNS

Rhythm and balance can be added to your images by finding the patterns in everyday life and concentrating on the elements that rely on geometric influences. Try to find the balance and patterns that often go unnoticed (**Figure 9.8**).

FIGURE 9.8
I moved in close to emphasize the patterns made by the stack of incense sticks.

ISO 3200
1/30 sec.
f/4
85mm lens

COLOR

Color works well as a tool for composition when you have very saturated colors to work with. Some of the best colors are those within the primary palette. Reds, greens, and blues, along with their complementary colors (cyan, magenta, and yellow), can all be used to create visual tension (**Figure 9.9**). This tension between bright colors will add visual excitement, drama, and complexity to your images when combined with other compositional elements (**Figure 9.10**).

**ISO 100
1/1000 sec.
f/1.4
50mm lens**

**ISO 1600
1/500 sec.
f/10
155mm lens**

FIGURE 9.10
The vibrant colors combined with the rippling of the water gives the image an impressionistic feel.

You can also use a color as a theme for your photography. One of the shots that I am known for is something that I call "The Blue Sky Shot." If I am out shooting when the skies are blue, I can almost guarantee that I will try to use the sky as part of a background for some element of my image (**Figure 9.11**). The blue sky can act as a color contrast to the subject, giving a pleasing tension, visual interest, and isolation to my subject.

FIGURE 9.11
The deep blue sky is balanced by the gold dome.

ISO 200
1/1000 sec.
f/5.6
120mm lens

CONTRAST

We just saw that you can use color as a strong compositional tool. One of the most effective uses of color is to combine two contrasting colors that make the eye move back and forth across the image (**Figure 9.12**). There is no exact combination that will work best, but consider using dark and light colors, like red and yellow or blue and yellow, to provide the strongest contrasts.

ISO 200
1/400 sec.
f/5.6
100mm lens

FIGURE 9.12
Contrasting colors complement each other and add balance to the scene.

You can also introduce contrast through different geometric shapes that battle (in a good way) for the attention of the viewer. You can combine circles and triangles, ovals and rectangles, curvy and straight, hard and soft, dark and light, and so many more (**Figure 9.13**). You aren't limited to just one contrasting element either. Combining more than one element of contrast will add even more interest. Look for these contrasting combinations whenever you are out shooting, and then use them to shake up your compositions.

FIGURE 9.13
This image is full of contrasting elements. The round shape of the bulbs contrasts with the straight, angular rows of lights. There is also a lot of color contrast going on, as well.

ISO 800
1/400 sec.
f/2.8
200mm lens

LEADING LINES

One way to pull a viewer into your image is to incorporate leading lines. These are elements that come from the edge of the frame and then lead into the image toward the main subject (**Figure 9.14**). This can be the result of vanishing perspective lines, an element such as a river, or some other feature used to move from the outer edge in to the heart of the image.

SPLITTING THE FRAME

Generally speaking, splitting the frame right down the middle is not necessarily your best option. While it may seem more balanced, it can actually be pretty boring.

Generally speaking, you should utilize the rule of thirds when deciding how to divide your frame (**Figure 9.15**).

ISO 400
1/100 sec.
f/9
55mm lens

FIGURE 9.14
The curb and rooflines lead the eye across the frame towards the horse and carriage.

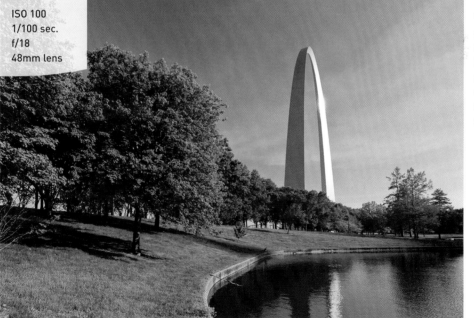

ISO 100
1/100 sec.
f/18
48mm lens

FIGURE 9.15
The frame is divided equally in thirds with the tree line at the bottom and the arch rising up vertically on the right-hand third of the image.

With horizons, a low horizon will give a sense of stability to the image. Typically, this is done when the sky is more appealing than the landscape below. When the emphasis is to be placed on the landscape, the horizon line should be moved upward in the frame, leaving the bottom two thirds to the subject below (**Figure 9.16**).

FIGURE 9.16
The star of this show is the field of colorful sunflowers, which is why the horizon was placed in the top third of the frame.

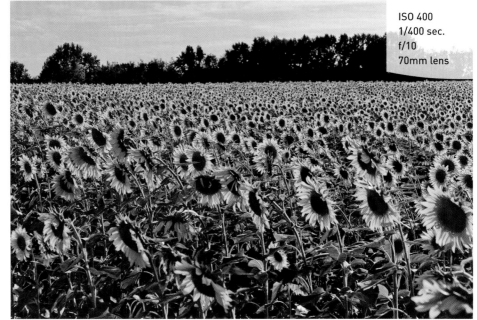

ISO 400
1/400 sec.
f/10
70mm lens

FRAMES WITHIN FRAMES

The outer edge of your photograph acts as a frame to hold all of the visual elements of the photograph. One way to add emphasis to your subject is through the use of internal frames (**Figures 9.17** and **9.18**). Depending on how the frame is used, it can create the illusion of a third dimension to your image, giving it a feeling of depth.

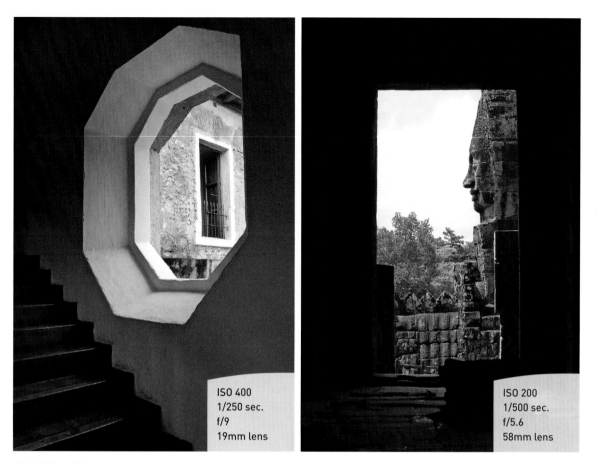

ISO 400
1/250 sec.
f/9
19mm lens

ISO 200
1/500 sec.
f/5.6
58mm lens

FIGURE 9.17
The outside window is perfectly framed by the larger window over the stairs, creating the perfect frame within a frame.

FIGURE 9.18
The temple doorway created a great frame for the large face lurking outside.

This chapter has just begun to scratch the surface of composition. There are so many different things to consider that it could literally fill a book. In fact, it already has. When you are ready to dive deeper into the creative process of image composition, check out the book from Laurie Excell, John Batdorff, David Brommer, Rick Rickman, and Steve Simon called *Composition: From Snapshots to Great Shots*.

Chapter 9 Assignments

Apply the shooting techniques and tools that you have learned in the previous chapters to these assignments, and you'll improve your ability to incorporate good composition into your photos. Make sure you experiment with all the different elements of composition and see how you can combine them to add interest to your images.

Learning to see lines and patterns

Take your camera for a walk around your neighborhood and look for patterns and angles. Don't worry so much about getting great shots as much as developing an eye for details.

The ABCs of composition

Here's a great exercise that was given to me by my friend Vincent Versace: shoot the alphabet. This will be a little more difficult but with practice you will start to see beyond the obvious. Don't just find letters in street signs and the like. Instead, find objects that aren't really letters but have the shape of the letters.

Finding the square peg and the round hole

Circles, squares, and triangles. Spend a few sessions concentrating on shooting simple geometric shapes.

Using the aperture to focus attention

Depth of field plays an important role in defining your images and establishing depth and dimension. Practice shooting wide open, using your largest aperture for the narrowest depth of field. Then find a scene that would benefit from extended depth of field, using very small apertures to give sharpness throughout the scene.

Leading them into a frame

Look for scenes where you can use elements as leading lines and then look for framing elements that you can use to isolate your subject and add both depth and dimension to your images.

Share your results with the book's Flickr group!

Join the group here: flickr.com/groups/exposure_fromsnapshotstogreatshots

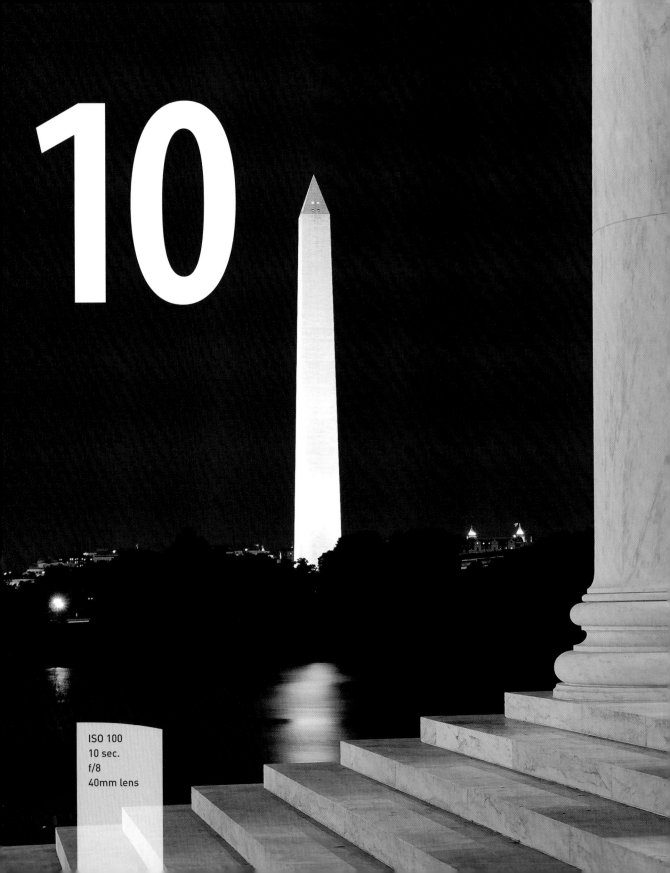

10

ISO 100
10 sec.
f/8
40mm lens

Advanced Techniques

IMPRESS YOUR FAMILY AND FRIENDS

We've covered a lot of ground in the previous chapters, especially on the general photographic concepts that apply to most, if not all, shooting situations. There are, however, some specific tools and techniques that will give you an added advantage in obtaining a great shot.

PORING OVER THE PICTURE

If you have already read the other chapters then you are aware of the golden hours and why they produce great photos. So what if you don't have the opportunity to shoot at sunrise or sunset? What if the only time you have is during the harsh hours of mid-day? Simple, you just make the best of it and try to use what you have to your advantage. That's what I did for this image taken at about one in the afternoon. The sun was very bright and almost directly overhead, so I decided to make it part of my composition.

Due to the use of a small aperture, the ISO had to be raised to 400 to get a fast enough shutter speed for handholding the camera.

The shot was composed so that just a small portion of the sun was peeking over the roofline.

Due to the bright influence of the sun on the light meter, the shot was overexposed by 1½ stops.

To get the starburst effect, I selected an f-stop of 22.

ISO 400
1/25 sec.
f/22
17mm lens

A long focal length lens helps to get close to the subject while still being a fair distance away.

The overcast sky forced me to raise the ISO in order to use the camera settings that I needed; a fast shutter speed and a large aperture.

I really love the experience of shooting in a zoo. It gives me a chance to photograph animals that I would probably never get to see otherwise. The challenge for me, though, is to get my shot without making it evident that I was in a zoo. It requires some patience, along with some special shooting techniques to pull it off well.

The use of a large aperture blurs the background and foreground elements to draw attention to the lion.

Moving the lens close to the wire mesh fence is crucial in making it disappear.

ISO 1600
1/800 sec.
f/5.6
300mm lens

SPOT METER FOR MORE EXPOSURE CONTROL

Generally speaking, Matrix metering mode provides accurate metering information for the majority of your photography. It does an excellent job of evaluating the scene and then relaying the proper exposure information to you. The only problem with this mode is that, like any metering mode on the camera, it doesn't know what it is looking at. There will be specific circumstances where you want to get an accurate reading from just a portion of a scene and discount all of the remaining area in the viewfinder. To give you greater control of the metering operation, you can switch the camera to Spot metering mode. This allows you to take a meter reading from a very small circle (usually about 1 to 10 degrees) while ignoring the rest of the viewfinder area. You need to check in your camera manual to see how your Spot meter function works, but usually the meter will be using the center focus point to gather exposure information.

So when would you need to use this? Think of a person standing in front of a very light wall. In Matrix metering mode, the camera would see the entire scene and try to adjust the exposure information so that the background is exposed to render a darker wall in your image. This means that the scene would actually be underexposed and your subject would then appear too dark (**Figure 10.1**). To correct this, you can place the camera in Spot metering mode and take a meter reading right off of—and *only* off of—your subject, ignoring the white wall altogether. (As discussed in Chapter 6, you could also use Center-weighted metering mode to take a reading off of a larger portion of your subject.) The Spot metering will read the light levels from a very small circle, placing all of the exposure information right on your point of interest (**Figure 10.2**).

Other situations that would benefit from Spot metering include:

- Snow or beach environments where the overall brightness level of the scene could fool the meter
- Strongly backlit subjects that are leaving the subject underexposed
- Cases where the overall feel of a photo is too light or too dark

Some camera models allow you to use whatever the current focus point is so that you can move the Spot metering to somewhere in the frame other than the middle.

When using Spot metering mode, remember that the meter believes it is looking at a middle gray value, so you might need to incorporate some exposure compensation of your own to the reading that you are getting from your subject. This will come from experience as you use the meter.

ISO 400
1/320 sec.
f/8
45mm lens

ISO 400
1/80 sec.
f/8
45mm lens

FIGURE 10.1
[left] A white wall can throw off your exposure by one or two stops. Using the Spot meter can help you zero in on great exposures.

FIGURE 10.2
[right] By switching to Spot metering I was able to get a more accurate exposure for the darker window frame.

METERING FOR SUNRISE OR SUNSET

Capturing a beautiful sunrise or sunset is all about the sky. If there is too much foreground in the viewfinder, the camera's meter will deliver an exposure setting that is accurate for the darker foreground areas but leaves the sky looking overexposed, undersaturated, and generally just not very interesting (**Figure 10.3**). To gain more emphasis on the colorful sky, point your camera at the brightest part of it and take your meter reading there. Use the Exposure Lock feature to meter for the brightest part of the sky and then recompose. The result will be an exposure setting that underexposes the foreground but provides a darker, more dramatic sky (**Figure 10.4**).

AVOIDING LENS FLARE

Lens flare is one of the problems you will encounter when shooting in the bright sun. Lens flare will show itself as bright circles on the image (**Figure 10.6**). Often you will see multiple circles in a line leading from a very bright light source such as the sun. The flare is a result of the sun bouncing off the multiple pieces of optical glass in the lens and then being reflected back onto the sensor. You can avoid the problem using one of these methods:

- Try to shoot with the sun coming from over your shoulder, not in front of you or in your scene.

- Use a lens shade to block the unwanted light from striking the lens. You don't have to have the sun in your viewfinder for lens flare to be an issue. All it has to do is strike the front glass of the lens to make it happen.

- If you don't have a lens shade, just try using your hand or some other element to block the light.

FIGURE 10.6
Although the sun is not visible in the frame, there is still visible lens flare being created in the image.

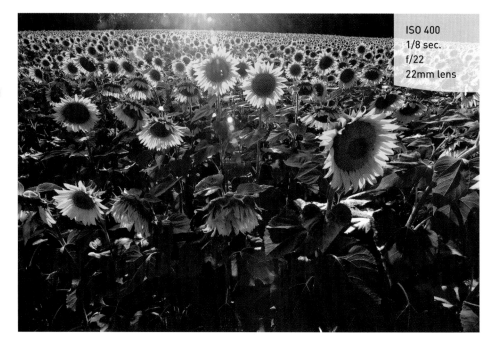

ISO 400
1/8 sec.
f/22
22mm lens

USING THE SUN CREATIVELY

Have you ever seen photographs where the sun is peeking through a small hole and it creates a very cool starburst effect (**Figure 10.7**)? There is actually a little trick to pulling it off and it's fairly easy once you know how. The real key is to be shooting at f/22 (or whatever your smallest aperture is). Then you need to have just a small bit of the sunlight in your frame, either peeking over an edge, or through a small hole. The other thing you need to do is make sure that you are properly exposing for the rest of your scene, not the bright bit of sunlight that you are allowing in. With a little practice, you can really make some very cool shots.

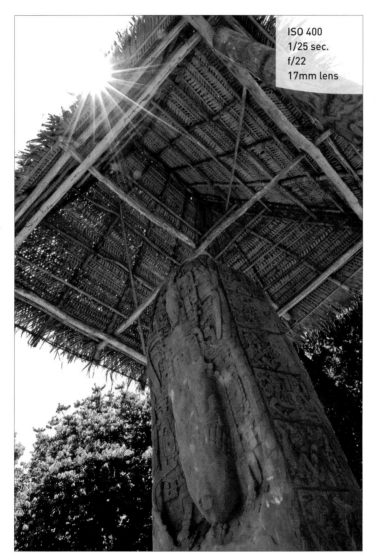

ISO 400
1/25 sec.
f/22
17mm lens

FIGURE 10.7
By letting the sun peek into my shot and using f/22, I was able to capture this cool starburst.

MACRO PHOTOGRAPHY

Put simply, macro photography is close-up photography. Depending on the lens or lenses that you got with your camera, you may have the perfect tool for macro work. Some lenses are made to shoot in a macro mode, but you don't have to feel left out if you don't have one of those. Check the spec sheet that came with your lens to see what the minimum focusing distance is for your lens.

If you have a zoom, you should work with the lens at its longest focal length. Also, work with a tripod because handholding will make focusing difficult. The easiest way to make sure that your focus is precisely where you want it to be is to use Manual focus mode.

Since I am recommending a tripod for your macro work, I will also recommend using Aperture Priority mode so that you can achieve differing levels of depth of field. Long lenses at close range can make for some very shallow depth of field, so you will need to work with apertures that are probably much smaller than you might normally use. If you are shooting outside, try shading the subject from direct sunlight by using some sort of diffusion material, such as a white sheet or a diffusion panel. By diffusing the light, you will see much greater detail because you will have a lower contrast ratio (softer shadows), and detail is often what macro photography is all about (**Figure 10.8**).

FIGURE 10.8
This hungry guy was captured using a long focal length combined with a close-up filter.

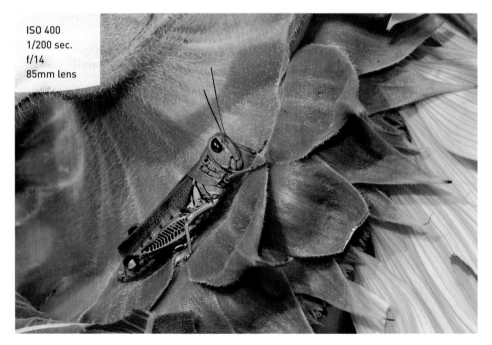

ISO 400
1/200 sec.
f/14
85mm lens

CUSTOMIZE YOUR WHITE BALANCE

Previous chapters have addressed the issue of setting your white balance, but what if you are in a situation that doesn't really fall neatly into one of the existing categories like Daylight or Tungsten? You might want to consider creating a custom white balance. This is especially helpful if you are working in a mixed lighting scenario where you have more than one kind of light source that is shining on your subject. A perfect example might be inside with fluorescent lighting fixtures overhead and daylight coming in through a window. To ensure that you are getting the best possible results in a situation like this, you can perform a quick white balance customization by using the Preset Manual option. Don't worry, though; it's easier than you might think. Typically, the only thing you will need is a white piece of paper (**Figure 10.9**).

You camera manual will guide you through the process of creating the custom or preset white balance. There are also devices available whose sole purpose is creating a custom balance. Typically, they look like a white filter that screws or snaps on to your lens. Much like photographing a white piece of paper, they allow your camera to analyze the color temperature of the light and then create a customized white balance setting. Most of them come with directions based on the type of camera you are using. Check out www.expoimaging.com for more info.

FIGURE 10.9
Many cameras will allow you to create a custom white balance by photographing a white piece of paper.

SHOOT IN BURSTS FOR STEADIER IMAGES

If you ever watch a pro taking photos, you might wonder why they shoot so many photos of a non-action subject. It seems like the camera is always set to continuous burst mode, but why? The answer is that they are looking to capture the sharpest image possible. By shooting 3- or 4-shot bursts, they are giving themselves a chance to let the camera settle in their hands while firing, helping to get a more stable shot. The mere act of pressing the shutter release button can infuse a little camera shake, but when you hold it down, you are more likely to get a better image on the second or third frame. It's not a huge difference, but it can save a slightly burry shot, especially if you are using a slightly longer shutter speed.

SHOOTING THROUGH OBSTRUCTIONS

One of my favorite places to shoot is the zoo. I am fortunate enough to have a great zoo that is not too far from home so I try to get there at least once or twice a year. One of the things I try to do is to capture images of the animals in such a way that they don't look like they are in a zoo. This can be difficult if there are things like wire mesh between you and the subject. There is a way, though, to get rid of the obstructions, or at least blur them to the point that you can't tell they are there.

There are two things to do to make this little trick work. The first thing is to put your camera in Aperture Priority mode and set the aperture to the largest opening. The second thing you will need to do is to move as close as possible to the fence or whatever the obstruction is. If you look at **Figure 10.10** you will see that the small aperture setting of f/18 has extended the depth of field to the point where the wire mesh is visible and creates a bit of a distraction.

FIGURE 10.10
The small aperture is extending the depth of field to the point that the wire mesh is visible in the image.

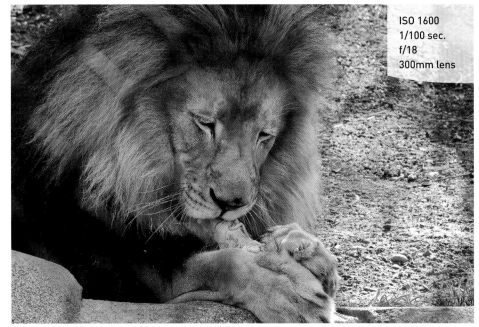

ISO 1600
1/100 sec.
f/18
300mm lens

By doing nothing more than changing the aperture to f/5.6 (the maximum opening for the particular lens I was using), the mesh fence becomes so out of focus that you can't even tell that it is there (**Figure 10.11**).

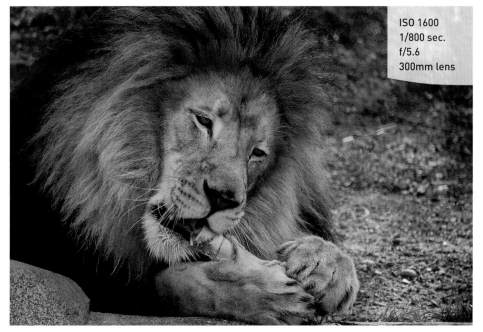

ISO 1600
1/800 sec.
f/5.6
300mm lens

FIGURE 10.11
Using a large aperture combined with a long lens that is close to the fence can make the obstruction disappear.

ZOOM DURING EXPOSURE

Zoom lenses are great for giving you a lot of different shooting angles without having to change lenses. There's also another benefit to using them that you just don't have with a prime lens: zooming for effect. That's right, you can actually zoom your lens during an exposure to create some very cool special effects. The key is that you need to be using a long enough exposure for the zoom to really make an impact (**Figure 10.12**). Also, it takes some practice and a little trial and error until you achieve just the look you want.

Another way to use this is with your flash. Try setting the flash to a rear or 2nd curtain sync mode, and then use a long shutter speed. When you press the shutter release, start zooming the lens as smoothly and quickly as possible. The flash will go off at the end of your exposure, leaving you with some really interesting results.

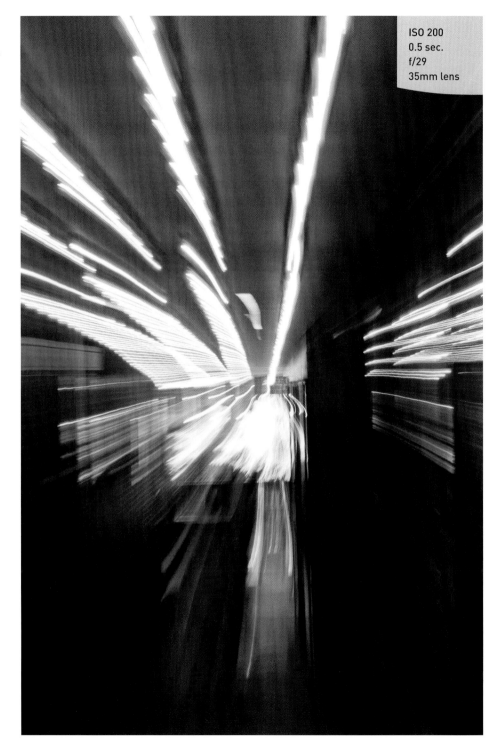

FIGURE 10.12
Zooming during exposure turned a boring scene into something much more interesting.

ISO 200
0.5 sec.
f/29
35mm lens

Chapter 10 Assignments

Many of the techniques covered in this chapter are specific to certain shooting situations that may not come about very often. This is even more reason to practice them so that when the situation does present itself you will be ready.

Adding some drama to the end of the day

Most sunset photos don't reflect what the photographer saw because they didn't meter correctly for them. The next time you see a colorful sunset, pull out your camera and take a meter reading from the sky and then one without and see what a difference it makes.

Making your exposure spot on

Using the Spot meter mode can give accurate results but only when pointed at something that has a middle tone. Try adding something gray to the scene and taking a reading off it. Now switch back to your regular metering mode and see if the exposure isn't slightly different.

Using the Bulb setting to capture the moment

This is definitely one of those settings that you won't use often, but it's pretty handy when you need it. If you have the opportunity to shoot a fireworks display or a distant storm, try setting the camera to Bulb and then play with some long exposures to capture just the moments that you want.

Moving in for a close-up

Macro photography is best practiced on stationary subjects, which is why I like flowers. If you have a zoom lens, check the minimum focusing distance and then try to get right to that spot to squeeze the most from your subject. Try using a diffuse light source as well to minimize shadows.

Share your results with the book's Flickr group!

Join the group here: flickr.com/groups/exposure_fromsnapshotstogreatshots

11

ISO 400
1/320 sec.
f/2.8
55mm lens

Pimp My Ride

UPGRADES AND ACCESSORIES TO EXPAND YOUR CAMERA'S CREATIVE POTENTIAL

If you bought your camera with a lens, then you basically have everything you need to begin shooting. I took great care to ensure that almost all of the techniques covered in the book are not beyond your basic camera setup. That being said, there are some accessories that are essential for certain types of photography. Other accessories aren't necessarily essential, but they will improve the look of your images.

Let's take a look at some items that I believe are must-have accessories for your photography.

FILTERS

You should have several filters in your camera bag. Each one serves a unique purpose. Some say that digital imaging programs such as Adobe Photoshop can duplicate the effects that the filters offer. This may be true, but I would rather screw on a filter than spend countless hours trying to replicate an effect on my computer. Here's another benefit to using a filter: lens protection.

SKYLIGHT

Probably the cheapest—yet one of the best—investments you can make for your camera is a skylight filter. This filter is used more for its protective effects than for any visual boost. At one point in time, the skylight, UV, and haze filters were used to filter out UV light in order to add sharpness to distant subjects, correct a minute bluish color cast, and reduce the effects of haze in a film image. A digital camera offers the benefit of having filters that are built into the camera in front of the image sensor to eliminate the effects of haze and infrared light. Therefore, most of the visual benefits of using a skylight filter are not evident. So why, if there is no real visual difference, should you use a skylight filter? Because what they do offer is protection for your valuable lens for a relatively low price.

For example, a Canon EF-S 18–200mm IS lens will cost you about $600. A 72mm HOYA Skylight 1B filter costs around $40. As someone who often either forgets or loses lens caps, it's reassuring to me that a $40 filter protects the precious glass on the front of my lens without degrading the quality of my image. If it does get scratched, I just unscrew it and buy another. That beats the heck out of $600 or thereabouts to replace or repair a scratched front lens element.

POLARIZING

This one ranks right up there at the top of the list of must-own photography accessories. You won't find a self-respecting landscape photographer who doesn't have at least one polarizer in his camera bag (**Figure 11.1**).

Light travels in straight lines, but the problem is that all those lines are moving in different directions. When they enter the camera

FIGURE 11.1
A B+W circular warming polarizing filter.

lens, they are scattering about, creating color casts and other effects. The polarizer controls how light waves are allowed to enter the camera, only letting certain ones pass through. So what does that mean for you? Polarizing filters will make blue skies appear darker, vegetation color will be more accurate, colors will look more saturated, haze will be reduced, and images can look sharper (**Figures 11.2** and **11.3**). Not bad for a little piece of glass.

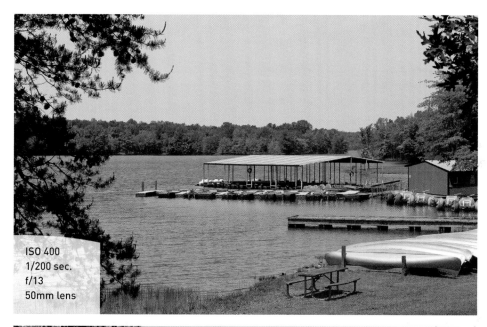

ISO 400
1/200 sec.
f/13
50mm lens

FIGURE 11.2
Without using the polarizing filter, the scene looks a little low on contrast and has a blue color cast from the sky.

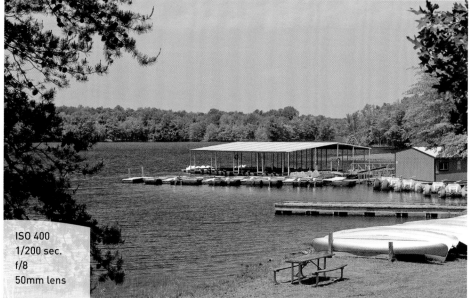

ISO 400
1/200 sec.
f/8
50mm lens

FIGURE 11.3
After adding a polarizer, the colors are much more accurate and the color cast is now gone.

Most polarizers are circular and allow you to rotate the polarizing element to control the amount of polarization that you need. As the filter is rotated, different light waves will be allowed to pass through, such as a reflection on a lake. Turn the filter a little and the light waves from the reflection are blocked, making the reflection disappear. Another benefit of the filter is that it is fairly dark, so when used in bright lighting conditions, it can act as a neutral density filter (you'll learn more in the next section), allowing you to use larger apertures or slower shutter speeds. The average polarizing filter requires an increase in exposure of about one and a half stops. This won't be an issue for you since you will be using the camera meter, which is already looking through the filter to calculate exposure settings. You should consider it, though, if your intention is to shoot with a fast shutter speed or use a small aperture for increased depth of field.

NEUTRAL DENSITY (ND)

Sometimes there is just too much light falling on your scene to use the camera settings that you want. Most often this is the case when you want to use a slow shutter speed, but your lens is already stopped down to its smallest aperture, leaving you with a shutter speed that's faster than you want.

A classic example of this is shooting a waterfall in bright sunlight. To get the silky look to the water, the shutter speed needs to be about 1/15 of a second or slower. The problem is that a proper exposure for bright sunlight is f/16 at 1/100 of a second with the camera set to ISO 100 (this comes from the Sunny 16 rule). If your lens has a minimum aperture of f/22, the slowest shutter speed you would be able to use is 1/50.

The way around this problem is to use a neutral density (ND) filter to make the outside world appear to be a little darker. Think of it as sunglasses for your camera. ND filters come in different strengths, which are labeled as .3, .6, and .9. They represent a one-stop difference in exposure per each .3 increment. If you need to turn daylight into dark, a .9 ND filter will give you an extra three stops of exposure (**Figure 11.4**). This means that, in my earlier example, you could get an exposure of f/16 at about 1/10 of a second. This would be an ideal exposure for getting a silky smooth waterfall (**Figure 11.5**).

To see more B+W filters, check out www. schneideroptics.com.

FIGURE 11.4
A B+W 77mm 0.9 ND filter.

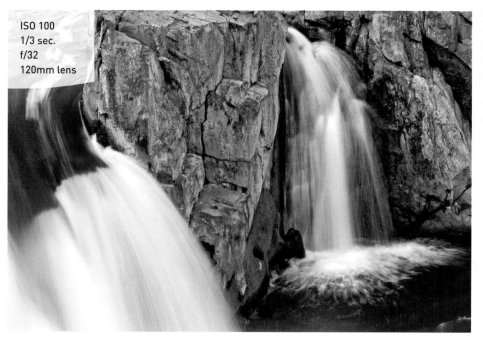

ISO 100
1/3 sec.
f/32
120mm lens

FIGURE 11.5
Using a .9 ND filter
allowed me to
use a long shutter
speed in broad
daylight to capture
this silky smooth
waterfall image.

GRADUATED ND

Another favorite of the landscape photographer, the graduated ND has the benefit
of the standard ND filter but graduates to a clear portion (**Figure 11.6**). This allows
you to darken just the upper or lower portion of your scene while leaving the other
part unaffected. This filter is most commonly used to darken skies that are too bright
without affecting the foreground area. If a regular ND is used, the entire area will
get darker, so there is no visual change in the image as far as the brightness ratio
between the sky and the ground is concerned.

You can purchase the graduated ND as a screw-on filter, but most photographers
prefer to use the larger 4x6" version, which allows them to control exactly where the
filter transitions from dark to transparent. There are many different options when
looking for graduated ND filters, such as the density factor (number of stops), as well
as how gradual the transition is from dark to clear.

FIGURE 11.6
Graduated filters
come in different
strengths and
transitions, from
soft (right) to hard
(left).

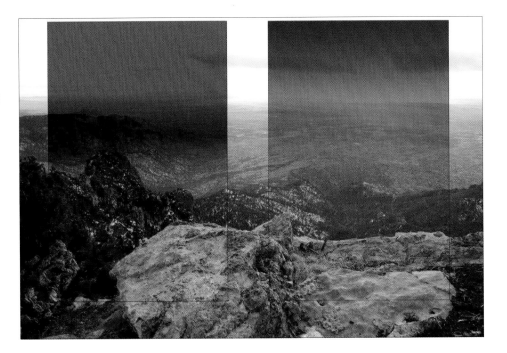

TRIPODS

If you only buy one accessory for your photography, do yourself a favor and make it a tripod (**Figures 11.7** and **11.8**). In general, any tripod is going to be better than no tripod at all. A tripod makes your photos sharper and lets you shoot in any lighting condition. There are more choices in tripods than there are in DSLRs. So how do you go about choosing the right one for you? The main considerations are weight, height, and head.

The weight of your tripod will probably determine whether or not you will actually carry it along with you farther than the parking lot. Many different types of materials are used in tripods today. The lightest is carbon fiber, which is probably the most expensive as well. More than likely, you should consider an aluminum tripod that is sturdy and has a weight rating that is suitable for your camera as well as your lenses.

Make sure that the tripod extends to a height that is tall enough to allow you to shoot from a comfortable standing position. Nothing ruins a good shoot like a sore back. Taller tripods need to be sturdier to maintain a rigid base for your camera. You will also want to consider how low the tripod can go. If you want to do macro work of low-level subjects such as flowers, you will need to lower the tripod fairly close to the ground. Many new tripods have leg supports that allow you to spread the legs very wide and get the camera low to the ground.

FIGURE 11.7
The Giottos MTL 22/32 tripod.

FIGURE 11.8
The Manfrotto 785SHB Modo tripod.

The other determining factor when purchasing a tripod will be the type of head that it employs to secure the camera to the legs. There are two basic types of tripod heads: ball and pan. Ball heads use a simple ball joint that allows you to freely position the camera in any upright position and then clamp it down securely (**Figure 11.9**). This type of head is flexible and quick to use, but it can sometimes be difficult to switch between portrait and landscape orientations. They also tend to be slightly more expensive as well.

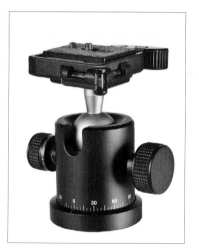

FIGURE 11.9
The Giottos MH 1000-652 ball head.

Pan heads employ a swivel and usually two hinged joints that allow the camera to pan left and right, move up and down, and adjust the position along the horizontal axis (**Figure 11.10**). Handles are typically employed to allow movement of the camera and lock down the position. The pan head is by and large the most popular tripod head style on the market. If you have a DSLR that also shoots video, you might want to consider the pan head style since it will deliver more functionality for your videography, specifically panning from side to side.

If you really want to make your tripod shooting move faster, consider buying a tripod that utilizes a quick-release head (**Figure 11.11**). There are many styles of quick-release brackets; most use a small plate that screws into the bottom of the camera and then quickly locks into and releases from the tripod head. This locking plate function will let you move quickly from a hand-holding situation to a tripod with minimal effort.

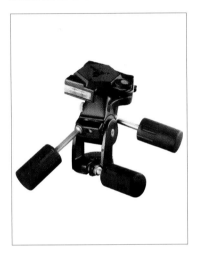

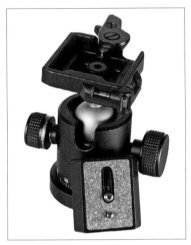

FIGURE 11.10
The Bogen 3047 pan/tilt tripod head.

FIGURE 11.11
The quick release plate used on the Giottos ball head.

The other thing to consider when purchasing a tripod is the leg locking system. Whether it is a lever-lock, locking rings, or some other system, make sure that you test it thoroughly to see how easy it is to lock and unlock the leg positions. Also check to see how smoothly the legs retract and extend. Avoid legs that stick because they will probably only get stickier over time.

You can find more information on Giottos tripods and accessories at www.giottos.com. Manfrotto tripod products can be found at www.manfrotto.com.

CABLE RELEASE

When shooting long exposures, you can use the self-timer to activate the camera or you can get yourself a cable release (**Figure 11.12**). The cable release, which is an electronic release, attaches to the camera via a remote port and lets you trip the shutter. It is also the preferred tool of choice when shooting with the camera set to Bulb (see Chapter 10). The idea of the release is that it allows shutter activation without having to place your hands on the camera. This is the best way to ensure that your images

FIGURE 11.12
A remote cord like this Nikon MC-DC2 lets you activate the shutter without touching the camera.

will not be influenced by self-induced camera shake. If you want to purchase a wireless remote, make sure that it will work from behind the camera as well as in front. Most wireless remotes use an infrared system and need to "see" the sensor on the front of the camera to work. This is great for taking self-portraits but not so good when you want to work from behind the camera.

MACRO PHOTOGRAPHY ACCESSORIES

EXTENSION TUBES

Extension tubes are like spacers between your lens and your camera. The tubes are typically hollow, and their sole purpose is to move the rear of the lens farther away from the camera body (**Figure 11.13**).

A lens can only get so close to a subject and still be able to achieve a sharp focus. This is because as the subject gets closer, the focal point for the lens moves back to a point where it is behind the image sensor. Using an extension tube lets you move that focal point forward by placing the rear of the lens a little farther away from the camera sensor, thus letting you get the lens closer to the subject and enlarging it in your picture.

FIGURE 11.13
Extension tubes like these from Kenko allow you to get macro shots from a variety of different lenses.

The tubes come in varying sizes, which are typically measured in millimeters. The more common sizes are 12mm, 20mm, and 36mm. The longer the tube, the greater the magnification factor (up to 1:1). The tubes are best used with lenses that are 35mm in focal length and longer. A wide-angle lens will have such a short focusing distance that you will be right on top of your subject. Many camera manufacturers, like Canon and Nikon, make extension tubes, or you can buy them from third-party manufacturers. Prices vary, but you will pay more for tubes that utilize optics in their design. You can also purchase sets of tubes with varying lengths that can be used individually or stacked together for greater magnification.

CLOSE-UP FILTERS

Another great way to jump into macro work is by purchasing a close-up filter (**Figures 11.14** and **11.15**). Close-up filters also come in varying magnifications but tend to be a little more expensive than extension tubes. This is because they are usually made of high-quality glass that works in concert with the lens. The filters and lenses can have some advantages over tubes, too. Because they screw onto the front of your lens, they don't interfere with any of the communication functions between the lens and camera body. They also result in less loss of light, so exposures can be slightly shorter than when you're using extension tubes. They do, however, work similarly to tubes in that they allow you to shorten the minimum focus distance of your lens so that you can move closer to your subject, thereby increasing the size of the subject on your sensor. Close-up lenses usually come in magnification factors like +1, +2, +3, +4, and +5. They can also be stacked, strongest to weakest, to increase the magnification factor.

FIGURE 11.14
The Canon 500D close-up filter can be used on any make or model of lens but must be purchased by lens filter diameter.

The other difference is that they are usually screw-threaded onto your lens, which means that you have to purchase a specific thread diameter. So if your favorite lens has a 68mm filter thread, this is the size you would use for the close-up filter. The big downside is that if you want to use different lenses that have different thread sizes, you will have to buy multiple filters. This is why I prefer to work with a zoom lens so that I can have a range of focal lengths to use with just one filter. Also, just as with most glass filters, the larger the diameter, the higher the price.

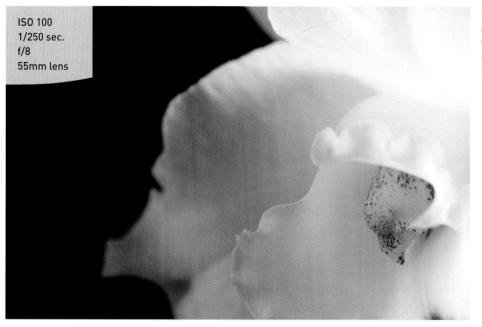

ISO 100
1/250 sec.
f/8
55mm lens

FIGURE 11.15
A close-up filter was used to help capture this orchid image.

HOT-SHOE FLASHES

Earlier in the book I covered the built-in flash and what you can accomplish with it. Now that we have covered that, let me say that you really, really need to get yourself a hot-shoe mounted flash if you want to take better flash images (**Figure 11.16**). For one thing, the external flash is going to be much more powerful than the pop-up version. Also, there is much more flexibility built into the external flashes than you could ever hope to get from the built-in version.

Most manufacturers make at least one—if not two or three—different hot-shoe flashes for their cameras. They can be a little pricey, but the flexibility of being able to move the flash head and redirect the light is well worth the price. Another benefit to this style of flash is the added power. Most hot-shoe flashes have at least twice the power of a built-in flash, and they also throw a wider swath of light, meaning you can illuminate a larger area.

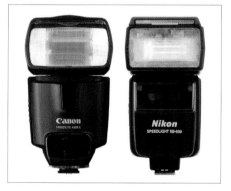

FIGURE 11.16
A Canon 430EX (left) or a Nikon SB-600 (right) flash unit will add power and flexibility to your flash photography.

The third benefit is their mobility. You can add a remote flash cord and move your flash completely away from the top of the camera while maintaining all the functionality. This will let you expand your lighting possibilities to areas that a pop-up flash could never hope to achieve.

DIFFUSERS

While I am covering flashes, let's discuss a tool that lets you improve the light you are using in your portrait photography. A diffusion panel is a piece of semitransparent material, usually white, that you place between your light source and your subject (**Figure 11.17**). The fabric does as the name implies: it diffuses the light, spreading it out into a soft, low-contrast light source that makes any subject look better. You could make your own or buy one of the many commercially available versions. I prefer the 5-in-1 Reflector Kit made by Westcott. It not only has a very nice diffusion panel, but it also has reflective covers that slip over the diffusion panel so that you can bounce some fill light into your scene. Best of all, the entire system is collapsible, so it fits into a pretty small package for traveling.

FIGURE 11.17
A 42 " diffusion panel from Westcott.

You'll find more information on Westcott diffusion panels at www.fjwestcott.com.

CAMERA BAGS

This topic is tricky because I have yet to find the perfect bag for my own gear. All I can do here is tell you what I like to use and let you base your opinions on that.

First of all, I like to travel with my photo gear. Typically, my travel involves flying. This means that all of my camera equipment will be traveling in the cabin with me, not in the luggage compartment. I can't emphasize this enough: *Do not pack your camera in your checked luggage!* Thousands of cameras, lenses, and accessories are lost and

or stolen from checked luggage each year. The best way to ensure this doesn't happen to you is to bring it on board and place it in the overhead storage. I like to travel with my laptop as well, so I have found a couple of backpack camera storage systems that allow me to fit a camera body, several lenses, some accessories, my laptop, and even some snacks into one backpack-style bag that still fits under the seat in front of me. I also prefer a backpack because I like the freedom of slinging the bag over my shoulder, leaving my hands free for other luggage. I am currently using a Lowepro Fastpack 250 for most of my travel needs (**Figure 11.18**). The thing that I really like about this bag is that it doesn't look like a camera bag so it doesn't automatically scream, "Steal me, I'm worth thousands!"

The other bag that you should look into is a more traditional, shoulder-style bag. These bags are made to handle all sorts of camera bodies, lenses, and accessories, and they're usually completely configurable with moveable padded partitions so that you can completely customize the bag for your own needs. My current bag of choice is the Lowepro Pro Mag 2 AW (**Figure 11.19**). This small-looking bag just swallows up my gear and never quite seems full.

These two bags are the ones that I am using currently, but finding the perfect camera bag is truly the Holy Grail for photographers. The fact is that you can go through a lot of them searching for one that perfectly fits your every need and never find it. I know; I have about six bags presently taking up residence in my closet.

You can check out the full line of Lowepro camera gear at www.lowepro.com.

FIGURE 11.18
The Fastpack 250 from Lowepro.

FIGURE 11.19
The Pro Mag 2 AW from Lowepro.

BITS AND PIECES

Since I just covered camera bags, let me share with you a couple of items that always travel in my bag.

The battle against dust is always a losing one, but that doesn't mean that you can't have your small victories. To help in the war against the dust speck, I carry three weapons of cleanliness.

THE LENS CLOTH

A good microfiber lens cleaning cloth always comes in handy for getting rid of those little smudges and dust bunnies that seem to gravitate toward the front of my lens.

I use one called a Spudz, which folds into its own pouch and has the added benefit of being gray (**Figure 11.20**). This means that I can use it as a gray card to get meter readings in Spot metering mode, or as a way to correct the white balance in my images down the road when I bring them into my imaging software.

FIGURE 11.20
The Spudz microfiber cleaning cloth.

More information on Spudz cleaning cloths can be found at www.alpineproducts.com.

THE LENSPEN

For really stubborn smudges on my lens, I pull out my trusty LensPen (**Figure 11.21**). This nifty little device has a soft, retractable dust removal brush on one end and an amazing cleaning element on the other that uses carbon to clean and polish the lens.

More information on LensPen products can be found at www.lenspen.com.

FIGURE 11.21
The LensPen lens cleaning tool.

AIR BLOWERS

Some folks prefer to use canned, compressed air to blow away dust but they can sometimes release fluid when the can is tilted. For this reason, I always use my Rocket-Air Blower from Giottos (**Figure 11.22**). This funny-looking device is great for getting rid of tough dust, and it uses a clean air path so that the dust that you are blowing away doesn't get sucked into the ball and re-deposited back on your equipment the next time you use it.

BETTER LCD VISION

Having a large LCD screen is an amazing thing. The only problem is that it can be very hard to see in bright daylight conditions. The way I overcome this is by using a Hoodman Loupe (**Figure 11.23**). The loupe doesn't magnify your screen; it just provides a light-tight little tent for you to get a better look at your rear LCD. It has a handy little lanyard so you can just let it hang around your neck and keep it within easy reach for checking out those great shots you just took. If you are going to work out in the bright sun, you will definitely want to get yourself one of these for your camera bag.

To check out all of the Hoodman accessories, head to www.hoodmanusa.com.

FIGURE 11.22
The Giottos Rocket-Air dust blower.

FIGURE 11.23
The Hoodman Loupe lets you see your LCD screen even in bright sunlight.

CONCLUSION

You can spend a lot of time worrying about having the right gadget, filter, or accessory to make your photography better. It can become an obsession to always have the latest thing out there. But here's the deal. You already have almost everything you need to take great pictures: a good camera and the knowledge necessary to use it. Everything else is just icing on the cake. So, while I have introduced a few items in this chapter that I do think will make your photographic life easier and even improve your images, don't get caught up in the technology and gadgetry.

Use your knowledge of basic photography to explore everything your camera has to offer. Explore the limits of your camera. Don't be afraid to take bad pictures. Don't be too quick to delete them off your memory card, either. Take some time to really look at them and see where things went wrong. Look at your camera settings and see if perhaps there was a change you could have made to make things better. Be your toughest critic and learn from your mistakes. With practice and reflection, you will soon find your photography getting better and better. Not only that, but your instincts will improve to the point that you will come upon a scene and know exactly how you want to shoot it before your camera even comes out of the bag.

INDEX

WATCH
READ
CREATE

Unlimited online access to all Peachpit, Adobe Press, Apple Training and New Riders videos and books, as well as content from other leading publishers including: O'Reilly Media, Focal Press, Sams, Que, Total Training, John Wiley & Sons, Course Technology PTR, Class on Demand, VTC and more.

No time commitment or contract required! Sign up for one month or a year. All for $19.99 a month

SIGN UP TODAY
peachpit.com/creativeedge